Women on the Verge of Home

WOMEN ON THE VERGE OF HOME

edited by

BILINDA STRAIGHT

with a foreword by

RUTH BEHAR

STATE UNIVERSITY OF NEW YORK PRESS

Cover photograph of Marie Stover, circa 1930.

Published by
STATE UNIVERSITY OF NEW YORK PRESS
ALBANY

© 2005 State University of New York

For information, address
State University of New York Press
90 State Street, Suite 700, Albany, NY 12207

Production, Laurie Searl
Marketing, Anne M. Valentine

Library of Congress Cataloging-in-Publication Data

Women on the verge of home / edited by Bilinda Straight.
 p. cm.
Includes bibliographical references and index.
ISBN 0-7914-6353-2 (alk. paper) — ISBN 0-7914-6354-0 (pbk. : alk. paper)
 1. Women. 2. Home—Psychological aspects. I. Straight, Bilinda, 1964–

HQ1233.W5974 2005
305.4—dc22

2004045338

10 9 8 7 6 5 4 3 2 1

In memory of my grandmother,

Ida Marie Stover Miller Vance.

And for all women who have had to question

the "ideal comfort" of Home.

Contents

Foreword

In classical anthropology, the ethnographer traveled to "the field," a place always elsewhere, to bring back stories of how life was lived way over there. Of course, "the field" existed in relationship to a place we were supposed to already know, the place we called "home." We continually interrogated "the field" and the project of "fieldwork," assuming there wasn't any need to question what "home" and "homework" might signify. But now this distinction between "the field" and "home," which was at the center of our intellectual paradigm, no longer holds because the world order on which it was based has ceased to exist. Borders are crossed and recrossed daily, as exile, migration, expulsion, displacement, diaspora, homelessness, and the trauma they bring about describe the human condition for millions of people.

Anthropologists can't have an exclusive claim on the dialectic between "elsewhere" and "home" because it's rampant in contemporary life. As a result, something vexing and exciting has happened in anthropology. Going to the field now often means taking a return trip to a lost home, or staying where you are and trying to figure out what's there in front of your eyes, or examining the broken home down the road to understand our complicity in its brokenness. Anthropology, once only able to reflect on exotic locales, is lately becoming an area where some of us, at least, are giving ourselves permission to interrogate the sweetness and terror of our homecomings.

If I had to summarize the essence of this book, that's what I'd say it's about—the sweetness and terror of our homecomings. These essays—all by anthropologists, except for one by an English literature specialist who specializes in women travel writers—are haunted by an inescapable sense of ambivalence about home. This is to be expected because anthropologists, if I can generalize about a group of people who are especially uneasy about making any social generalizations, are folks who come to the discipline because they're searching for home. Many are unsure about where home is or what it is; others are critical of the home they come from and seek the purifying ritual of

unsettling themselves that anthropology demands. Add to their identity as anthropologists that the authors of this book are also women informed by the reflections of feminist anthropology, and it becomes clear why they refuse to be comforted by the platitudes about home's inherent niceties. Home, as shown by the authors, is cut through with privilege, illusory feelings of safety, the crassest forms of consumerism, harrowing memories, and unfulfilled long-ings for the emancipation promised by Virginia Woolf's "room of one's own." That is why the women in this book choose to be—have no choice but to be—"on the verge of home."

Doing "homework," turning one's eyes to homes near and far, becomes a wrenching exercise that unveils more sorrows than joys. The positive side of this work is that it pushes the ethnographer to write in ways that chal-lenge conventional forms of academic expression. Not surprisingly, the essays in this book range from historical pieces, to surrealist collages, to life narratives, to poetry that dances breathlessly and asks to be performed rather than read. Strikingly present are the memory and spirits of black female slaves, reminding us of the way the concept of home is marked in our history by the cruel orphanhood of the soul that slavery called forth. Ethnography becomes, in the hands of the authors of this book, not a genre for the explo-ration of faraway exotic places, but a tool to be used by the broken-hearted ethnographer to expose the shameful inequities and unforgivable sorrows to be found at home.

For many years, I was grateful that anthropology allowed me to postpone the decision of where home is for me. Born in Cuba, raised in the United States, a Spanish speaker and an English writer, I felt happy being able to spend long periods of time legitimately expatriated in Spain and Mexico. More recently, in my role as a "diasporic anthropologist" (rather than a "native anthropologist"), I keep returning to visit Cuba, defending these trips as a means to say something about the meaning of home in an age of unprece-dented travel, mobility, and deterritorialization. In the name of anthropology, will I return to Cuba indefinitely, continuing to delay the ultimate decision of where I belong? Maybe, in the end, I don't want to have to decide, nor should I be forced to decide. Hasn't the battle for homes located in fixed places and lands been the cause of too much misery? If peace is at stake, let's try to think of home as multiple and portable and sharable.

In the meantime, I live in Michigan and travel frequently to Cuba. This coming summer—I find it hard to believe—I will have been in Michigan for eighteen years. How is this possible? I always wanted to live near the ocean and I can't bear northern winters. My mother, still in New York, commiser-ates with me. Every winter, we wonder how we stand the cold, year after year. At least, my mother's got an ocean, but it's a cold one, she says, even in the summer. My grandmother, who died in Miami three years ago, escaped win-ter and that felt like a victory. But the apartment in which she grew old

lacked a view of the ocean. Her brother and sister-in-law, who acquired much more wealth than she in America, had the ocean view she so longed for. She tried not to feel jealous. When I'd visit, I'd tell my grandmother it didn't matter that you couldn't see the ocean from her apartment. Even sixteen blocks away, you could smell the ocean. You could smell the salt. Unmistakable. That salty ocean smell.

You could smell the salt from the ocean. You could smell the solitude of the ships floating to their destinations.

<div align="right">

RUTH BEHAR
UNIVERSITY OF MICHIGAN

</div>

Acknowledgments

Edited volumes, true to rumor, are almost always difficult endeavors, and, like old houses, they are full of surprises as soon as the first layer is lifted. This collection is no exception, and I would not have gotten through the process without the kind assistance of many people. I would like, first of all, to thank all the contributors to this volume for their enormous patience in getting this book into print. I am also indebted to the participants of the American Anthropological Association panel "Can't Leave Home Without It: Narrating Identity in Women's Transgressive Travels," which was the basis for this collection. Niko Besnier and Michael Jackson were particularly helpful and encouraging, and Angelika Bammer offered helpful advice early on.

Sue Kenyon has been a great support in the years this volume has been underway, and Robert Ulin, the Chair of the Anthropology Department at Western Michigan University, has likewise been supportive and ready with advice when called upon. I am grateful to Bruce Mannheim for invaluable comments and advice on this project in its earliest stages and Ruth Behar for advice and encouragement as the project got underway. I would also like to thank Jon Holtzman, Rosario Montoya, and Katherine Zirbel for comments on the introduction and chapter five.

I would like to express my appreciation to University of Chicago Press for permission to reprint chapter two, Kathleen Stewart's "Still Life," which originally appeared in *Intimacy*, edited by Lauren Berlant (2000). I would also like to express warm thanks to Jane Bunker and to Laurie Searl and her staff for a wonderfully smooth editorial process.

Finally, I would like to thank my husband, Jon Holtzman; my mother, Marilyn Miller Dobos; my uncle, Gerald Miller; and my long-term mentor, Paul Adler, for their love, encouragement, and contributions of both the tangible and intangible variety.

ONE

Introduction

Women on the Verge of Home

BILINDA STRAIGHT

There's no place like home.
There's no place like home.
There's no place like home.
—Dorothy,
The Wizard of Oz, 1939

HOW DO WOMEN EXPERIENCE "home"? What does "home" mean to women in different social, class, sexual, ethnic, and racial contexts at different times and in different places? Is there more at stake for some women in identifying themselves through their ideas of home than others? Can women lay claim to home even when they are literally homeless, on the move, or when home is neither cozy nor secure? Conversely, can women strategically lay claim to the idea of home as a way of asserting their right to home and a secure identity?

While men and women may equally need the stability of home, "men" and "women" as contextually shifting categories differ enormously with respect to home. Thus, the modernist idea of home as stable center of safety and domestic virtue often assumes women as the very embodiment of that center while men offer the financial support to enable women to uphold home's ideal qualities. How do real women relate to these idealized notions of home when their positions "on the ground"—as poor women, as slaves, as

1

non-Westerners, for example—conflict with the dream? What do women do with a fictional set of categories—"home," "man," "woman"—that erases crucial differences between themselves, men, and other women? What do they do with a fictional idea of home that may be so distant from their reality as to make the safety of home almost unimaginable? In other words, what do women do when home always seems to lie elsewhere, when a trip over the rainbow may make the necessity of home transparent to some while for others, home is no more obtainable than Oz?

The papers in this volume explore the immediacy with which women create the possibilities for their own existence out of the dense narrative fabric of home. In telling or retelling women's stories of home, these essays suggest the richness with which home is imagined against its antithesis: movement as a foil for staying in place, the urban as a foil for homely tradition, anti-home or inaccessibility of home as a foil for an idealized version of home. As these essays reveal, women often have a peculiarly intimate relationship to home because they are constrained by its borders as keepers of tradition, as material symbols of home that protect or control it, or as the primary consumers of homely desires. Idealized in modernist narratives as the protective site of warmth and security against a cold outside world, women approach the fictions as well as the lived-in realities of home with ambivalence, nostalgia, or terror, depending on biographies forged in the crucible of multiple identity-shaping differences. To borrow Homi Bhabba's (1994) strategic translation of Freud's *unheimlich*,[1] these essays are "unhomely" narratives, revealing the forgotten but familiar strangeness of home as a site that elicits enigmatic longing, control, or outright violence.

While home as a discursive production is not new, colonialism, industrialization, slavery, and, more recently, globalization have made home into a precious and rare imaginative space in contrast to displacement and other precarious realities. In such a context, it is not surprising that the displaced should view home with a more urgent longing than the elite and secure (Spivak 1988). The force of such longing can be great indeed, and as Mohanty and Martin (1986) have argued, desires for an idealized home may even suppress crucial differences within local communities (or, one might add, between subaltern groups). In spite of this, Mohanty and Martin, and more recently Dorinne Kondo (1997), suggest that it is crucial that marginalized people craft home (cf. Alarcon 1996). With this I would agree, adding more precisely, in Angelika Bammer's phrasing, the need for a "move between marking and recording absence and loss and inscribing presence" (1994:xiv). This volume effects that move, both as a whole as well as within many of its essays, describing women's crafting of themselves within and against their desires and understandings of home as they variously experience or imagine it. Moreover, these essays address, from a variety of perspectives, the important questions of how women's stories should be read and how they might be spoken.

Nevertheless, women's unequal status as measured within patriarchal systems and other disciplining (or, worse, terrifying) structures must not be forgotten in attesting to their creativity in crafting their identities through home. This is not least because women's different positionings with regard to home's discursive fictions do more than attest to the starkness of such differences; modernist versions of home are subtle truths by which individuals *reveal to themselves* their places in a global hierarchy. Moreoever, if those at the bottom have no choice but to desire home (Spivak 1988), the home they desire is more often than not an "other" home which doesn't merely elude them: It was *imagined* in order to exclude them.[2]

This volume foregrounds these exclusions in two ways. First, it does so by placing side by side the "unhomely" narratives of women whose experiences are incommensurate with one another.[3] Thus, the women described in these essays range across global power hierarchies, conveying the stories of elite white U.S. and Canadian women (Stewart and Brettell), rural poor and peasant white women in the U.S. and France (Stewart, Straight, and Reed-Danahay), Southern Egyptian women (Zirbel), and West African women (Rosenthal), as well as the stories of a Haitian woman scholar (Ulysse) and a British Caribbean freed slave woman (Bohls). Secondly, the contributors attend to local, regional, or global structures of difference and/or exclusions through which women idealize home. These range from the differences inscribed within urban *vs* rural discourses, to subtle local patriarchal idioms shaping, constraining, or preventing women's search for home, to colonial structures which force women to reclaim their humanity as well as their rights to home.

Underlying the volume's concern with women's constructions of home and identity is a commitment to narrative as a means of conveying these women's experiences. Here, the contributors respond to the need for new ways to translate the dynamic immediacy of individual women's lives. Thus, many of the volume's contributors draw upon women's own life narratives to examine those women's attempts at self-definition. In some cases, these contributors are simultaneously experimenting with forms of autoethnography (Behar 1993; Reed-Danahay 1997),[4] serving as interlocutors to their own mothers, grandmothers, friends, or selves. At the same time, several contributors explore the potential of narrativity for grasping the strategic force by which individual and collective stories shape reality (Mannheim and Tedlock1995). In this case, contributors examine the ways in which women's experiences or stories of home are framed against the prevailing hegemonic discourses which affect them.

POSITIONING WOMEN IN THE FEMINIST CANON

A number of feminist theories pertaining to women's identities have increasingly adopted a circumspect avoidance of unifying or totalizing narratives and

an awareness of plurality and contradiction. While this represents an impor-
tant trend in Euro-American feminist discourses, it has not been without
struggle. The naivete of the assumption of global sisterhood by feminism's
second wave is by now familiar. Inspired by the pioneering work of Simone
de Beauvoir on Otherness as it pertains specifically to the relationship
between men and women, second-wave feminists examined in multitudinous
ways how Otherness was formed and how and where it operated. Yet their
attempts to export their formula for equality met with ambivalence or even
hostility on the parts of women of color at home and in the so-called Third
World: If inequalities were global, white western women were culpable along
with white western men. Moreover, in the area of political praxis, any hopes
for global coalitions of sisterhood were shattered by the realization that their
goals were as varied as their positions within global structures of power.

The shocks and aftershocks of the crisis continue to be felt. As feminist
theory gave way to feminist theories, "woman" has given way to women and
gender, to the politics of identity and difference, and, intriguingly, back to
"woman"—this time as an unstable, historically shifting signifier. Most femi-
nist scholars would tend to agree that, to borrow Rosi Braidotti's (1997)
phrasing, the "feminist subject is multiple, discontinuous, and internally con-
tradictory." Thus, rather than replicating hegemonic constructions of gender
differences by offering unifying frameworks of (unqualified) womanhood or
manhood, one option has been to attend to the ways in which gender is per-
formed—repeatedly, punitively—within those hegemonic constraints (Butler
1990)—as well, perhaps, as against them, at the margins, as playful, momen-
tarily liberatory acts (Lancaster 1997). Gender in this sense is both perfor-
mative and constructive, *creating* discrete categories of (heterosexual) woman
and man.

At the same time, and not to lose sight of the feminist subject's multi-
pleness, since the 1980s, another (sometimes simultaneous) option has been
to pay heed to identity as positioned at the confluence of race, class, as well
as gender without subsuming any one of these sources of difference within the
Other (Amos and Parmar 1984; Minh-ha 1987). Yet for some "Third World"
theorists, this is not enough because gender may not be a crucial organiza-
tional metaphor, and "woman" as a specific category may not exist in some
cultural contexts (Oyewumi 1998). Nevertheless, while they do not neces-
sarily attend to the heady problem of whether woman exists, feminist schol-
ars have been attending to the discursive categories woman/man and femi-
ninity/masculinity as historically and spatially contingent. The crisis in
specifically white Western feminist theorizing, then, has resulted in richly
problematized approaches to both gender and women. Thus, a growing num-
ber of studies are trying, in different ways, to analyze sex-gender systems and
describe feminist subjectivities while conceding to the contestations
involved in producing them and to the necessarily partial truths that such

studies are limited to deciphering (see, for example, Ong 1988; Grewal and Kaplan 1994; Tsing 1993; Kapchan 1996).[5]

Unfortunately, besides the messiness of this state of affairs, other difficulties remain in the area of theory/praxis. Angelika Bammer (1994) has astutely pointed out that the celebration of differences and multiple positionings has often obscured the varieties of concrete lived-in experience. On a similar note, Smadar Lavie and Ted Swedenburg (1996) have pointed out that postmodern attention to fragmentation has ignored differentials of power, both from center to margin as well as within the margins. Finally, Inderpal Grewal and Caren Kaplan (1994) likewise decry the homogenizing effects of Euro-American theorizing but add a critique of forms of feminism that misrecognize Euro-American feminists' own participation and stake in modernity, thus contributing to women's oppression.[6]

The essays in this volume tread cautiously on this fragile terrain, concretizing women's lives in their specific historical, spatial, cultural, and biographical contexts while simultaneously deploying a variety of ethnographically informed approaches that use narrative as their medium or method of telling. In so doing, these essays avoid treating all marginal or all elite women as if they were equal, yet simultaneously nurture the possibilities for a dialogue across incommensurate experiences. Additionally, in their ethnographically informed attention to narrative, the contributions to this volume attempt to grasp the elusive shadow cast by women's bodies-on-the-ground. Here, these authors do not follow the modernist move of presuming to represent the lives of the women who are their textual and/or ethnographic interlocutors. Instead, they recognize their own positionings in dialogic encounters that produce new tellings of their interlocutors' lives, tellings that simultaneously speak women's experiences and foreground for us in the present the ways imaginings about home illuminate the often troubling aspects of modernity through which women have differently understood and created themselves anew.

UNHOMELY HOME(S)

By attending to women's narratives about home ethnographically (or narrativizing home, in some cases), the contributors to this volume position themselves at a tellingly stormy crossroads between discourses about women and domesticity elaborated forcefully within feminist theorizing, and Euro-American elite modernist conceptions of home with which anthropology has a singular and sometimes problematic relationship. The problem of difference is common to both, making the convergence a symptom of a long-standing debate in western philosophical history (see Bell 1998) but, moreover and more importantly, a symptom corresponding to often stark material realities.

While their antecedents can be found in a philosophical tradition which the so-called West has inherited (and reinvented) from the ancient Greeks,[7] the dichotomous permutations of self/other and subject/object, which have held such problematic inscriptions of difference for postmodern scholarship, are more recent.[8] That is, even if they owe much to the eighteenth century and Descartes,[9] these dualisms are most fruitfully read in the context of shifting geo-politics and as a solution to Europe's own cosmological and philosophical problems as they surfaced in that global arena.[10] If we begin in the nineteenth century—closer to problems of worldview that are our own—the legacy of Cartesian dualism gave rise to modernisms that not only separated mind/soul/ body, but that—in the context of accelerated colonial expansion and capitalist development—self-consciously pursued the differences between magic and science, primitive and modern, Self and a myriad of gendered, raced, and classed Others.

Such modernist renderings of reality are fundamentally linked to the rise of anthropology in tandem with other social as well as natural sciences, on the one hand, and feminist theories underscoring gender difference, on the other. For anthropology's part, its explicit focus on "primitive" (usually colonized) peoples made it peculiarly culpable in helping elite, white American and Europeans construct notions of themselves and of home in contrast to their Others. While critiques of anthropology have long since pointed to the discipline's role in this mythmaking (for example, Gough 1968; Said 1978; Fabian 1983; Lavie and Swedenburg 1996), recent scholarship has broadened its analytic range and exposed additional sites for collective Otherizing. Thus, a growing and richly varied literature is examining the myriad ways in which the "West" has imagined itself in relation to the "rest" right into the twenty-first century (see for example, Stoler 1989; Comaroff and Comaroff 1991; Pratt 1992; Stewart 1993; Appadurai 1996; di Leonardo 1998). These works examine the construction of Euro-American subjectivity in relation to an exotic that was understood in racial, sexual, gendered, religious, as well as temporal terms. Thus, on the positive side, the exotic may inspire bodily transcendence (Torgovnick 1997) or a nostalgic past (Stewart 1993, Appadurai 1996, di Leonardo 1998); or more negatively, the exotic may embody fertile ground for civilizing social engineering (Comaroff and Comaroff 1991), signifying timelessness (Wolf 1982) or, more dangerously, challenging the hierarchical order assumed in these exoticizing tendencies by transgressing racial and sexual boundaries (Stoler 1989).

Well before anthropology's self-critique, of course, the mapping of the self/other dichotomy so prevalent in Euro-American thought from the nineteenth century forward had led to brilliant illuminations in feminist thought. However, as noted in the previous section, the literature stemming from insights such as de Beauvoir's (1949) notion of woman as the Other of man failed to take account of exclusions beyond gender. Thus, even as

(Euro-American) feminist scholarship produced rich work illuminating the underside of home and motherhood for women, including its heterosexism (Rich 1976), this literature often neglected to note how failures to attain the promises of home were complicated not only by gender and sexuality, but by race, class, ethnicity, and nation. However, the raised voices of women from the margins infused much-needed critical insights into both feminist theorizing and anthropology. Within anthropology, this led to the recognition of white, Euro-American women's culpability in forging a subject/object relationship that positioned them as subjects in relation to marginal men and women (Mohanty 1984, Ong 1988). Subsequent scholarship in the 1990s and 2000s has thus brought feminist theories pertaining to the domestic and to home to bear on anthropological and cultural studies work on exotic Otherizing.

Recently, some scholars have drawn upon this crucial convergence to turn some attention to the notion of travel and at times, more specifically, to the notion of home as strategic sites of imagining (white, Euro-American) self in relation to (exotic and miscegenistic) Other. Such work goes far in showing us the dire material concomitants of some discursive tendencies. For example, Wendy Webster (1998) examines ideas of home in Britain between 1945 and 1964 as accessed through film and narrative as well as in official policies. Her book is a melancholy portrait of ideals of home clearly designed to exclude on the basis of race, ethnicity, sexuality, nation, and class. At the close of British imperialism, the British home was white, heterosexual, and middle- to upper-class, with a woman at the domestic helm, and the discourses that constructed home in this way often accompanied policies that helped to effect its exclusions as on-the-ground reality. Dorinne Kondo (1997) has charted some of the exclusions of American home likewise arising in the period of the Second World War. Clearly, U.S. notions of home did not allow for the inclusion of Japanese Americans, and this silence in American hegemonic imaginings of home erupted forcefully and poignantly in the incarceration of Japanese Americans.

If the white, Euro-American version of home has implied stability both as a fixed point in space and as an emotionally safe pivot for individual and collective memories, that very stability has been denied to marginalized groups.[11] Individuals in such groups have found themselves literally and figuratively pushed to the margins of safe home. On the one hand, then, colonial and postcolonial geopolitics have translated into the massive displacement of people at and on the edge while simultaneously Euro-American understandings of home have been imagined to exclude these, their Others. On the other hand, however, marginalized groups comprise living, breathing individual human beings who *continually imagine themselves at home.* Thus, "home" *can* destabilize itself: "'Home' can serve to encapsulate, but also to link and transcend, traditional classifications . . . it can and must be

sensitive to numerous modalities, conventional and creative, and to allo-
catings of identity that may be multiple, situational and paradoxical" (Rap-
port and Dawson 1998:8; see also Behar 2000). Whether longing for home
or pointing to home's failures to live up to what it ought to be, individuals
speak the possibilities of an "other" home, their home, a home that would
embrace and nurture them. If necessary (or even desirable), such possibili-
ties of home can be spoken, and in the midst of literal or figurative move-
ment, exclusionary visions of home can be destabilized from positions of
exile, from points-in-between.

SPEAKING HOME

If the modernist home was imagined to the exclusion of its Others—the slave
as not human enough, the poor as not fit enough, for example—its contours
have been tantalizing both to those who could have it as well as those who
could not. Indeed, if exclusionist imaginings accompany and give moral force
to exclusionist material practices,[12] the work of the imagination is undoubt-
edly a crucial part of the process of breaking those barriers. Here we see pre-
cisely the simultaneous longing for and ambivalence on the part of a middle-
class, white, Canadian woman for whom modernist discourses about home
were created (Brettell's essay) and how tantalizing those discourses could be
for rural white women who were in a position to actually imagine attaining
home (Reed-Danahay's and Straight's essays). The appeal of home is no less
tantalizing to a nineteenth-century slave woman, however, who was least
positioned to realize the dream of home but who dared to imagine and claim
it anyway (Bohls's essay). Similarly, a southern Egyptian woman in the 1990s
shows us the higher stakes for women in a context in which modernity is a
complex border phenomenon straddling both Egyptian national as well as
global fractures (Zirbel's essay). Finally, and remarkably, the spirits of slaves
from the ex-Slave Coast who were purchased by Ewe and Mina lineages in
southern Ghana, Togo, and Benin continue to lay claim to the homes of their
former owners by the southerners whose bodies they inhabit and whose
homes they protect. The force of home is palpable in these essays, in its recur-
ring failure to deliver on its promises (seen especially in the essays by Bohls,
Stewart, and Straight and in Ulysse's poem), but most strikingly perhaps in
the consistency with which marginal women engage with those promises.

That engagement is rendered more challenging by these women's multi-
ple positionings with regard to home, however. Thus, in their juxtaposition,
these essays give voice to home's silent exclusions: By asking the questions
"Where is race? Where is class? Where is sexuality? Where is gender?" for each
of these essays, we begin to see in powerful terms the *heaviness of home* for
women who must consider many or all of these exclusionary structures. We see
the weight of being a middle-class white woman forced to think home through

the gendered expectations of her cultural and historical context, which calls her homeward when her nationalist home is under siege (Brettell's essay). At a different extreme, however, we see the *multiplied* weight of being a slave who thinks home through race, class, gender, as well as sexuality (Bohls's essay). The gloominess of this configuration must be balanced, however, by the fact that the women in this volume actively engage in making themselves subjects of their own stories, stories that include critically evaluating the promises of home and imagining it as a space they had a claim to.

The contributors to this volume are sensitive to the importance of storytelling both for individuals in their daily lives and for us. For individuals, stories are a means of claiming the space of home, for example, but they are also crucial to the everyday creation (and justification) of self, community, and world. Similarly, scholars can glean people and their world-making from everyday and extraordinary stories; moreover, stories are powerful in their ability to convey, in textual form, the sensuousness, suffering, and joy of being alive. The latter benefit of storytelling is important in the use to which scholarship is put: The greater immediacy of women's own stories makes it more difficult to forget that even if stories create self and world anew, they do so based on experiences marked by physical pain, hunger, and other deprivations; by pleasurable touch; and by emotive responses such as shock, delight, fear, and joy. We may question the varieties of perception, but it is morally dangerous to question the presence or absence of *life*. It is crucial, in other words, that we eschew approaches that are so text-bound as to call into question the embodied, prelinguistic reality of the people whose lives are being analyzed.

How do stories create self and world? Numerous anthropological scholars,[13] particularly within linguistic anthropology, have drawn upon the work of Bakhtin (e.g., 1981) to suggest that cultural practices and understandings emerge out of dialogues (including dialogues with self). These scholars have found Bakhtin's thought to be inspirational in suggesting the importance of stories to the creation and continual re-creation of cultural understandings. Indeed, scholars like Bruce Mannheim and Dennis Tedlock (1995) have drawn upon Bakhtin and Julia Kristeva in order to suggest the ways in which culture itself emerges out of the dialogic encounter. Integrated with the seminal works of theorists that include Michel Foucault (e.g., 1970; 1979; 1980), Anthony Giddens (e.g., 1984), and Pierre Bourdieu (e.g., 1977), Tedlock and Mannheim address the difficulty of understanding the continually vexing problem of how individual understandings become collective understandings, of how individuals constrained within institutional structures and sets of practices put their understandings of those structures to (potentially transforming) use in the act of telling stories.

Tedlock and Mannheim's approach to narratives then, emphasizes the importance of storytelling to the continual creation and re-creation of culture—

to the process whereby individual and collective stories make a world. In contrast, Michael Jackson (1996) has examined storytelling specifically in relation to understanding individual lives engaged in the ongoing process of being-in-the-world. Bourdieu's work is key here as well, particularly in his stress on the importance of individuals' own bodies to the disciplining of cultural practices. While Bourdieu may at times underestimate individual agency, his notion of the habitus provides a blueprint for understanding the mechanisms by which individuals are irreducibly connected to the sets of cultural practices that comprise their worlds. Thus, in his phenomenological approach to storytelling and human experience, Michael Jackson finds in Bourdieu the opportunity to understand "the way human experience vacillates between a sense of ourselves as subjects and as objects; making us feel sometimes that we are world-makers, sometimes that we are merely made by the world" (Jackson 1996:21).

Of course, the tension between self and world continues to be at the center of numerous scholarly approaches within and beyond anthropology. While Jackson attends to that tension by exploring the experiential side of individual being-in-the-world, and Tedlock and Mannheim emphasize world-making as it emerges out of dialogic interaction between individuals, collectivities, and texts, Thomas Csordas (1994) explores another possibility. Likewise concerned with experience as Jackson is, Csordas grapples with the thorny issues posed by approaches to the body. Criticizing the tendency (within anthropology particularly) to treat the body as a text from which cultural phenomena can be deciphered, he asks: If individuals tell stories of pleasure, pain, suffering, and joy, what indeed is the relation between body and text in those tellings?[14]

The problem of representation and experience is crucial to approaching these women's stories. Csordas' well-placed critique of course takes us back to the dualist legacy of Descartes, drawing attention to how even some of the most influential and otherwise inspirational approaches within philosophy and anthropology have failed to adequately deal with representationalist dualisms. Thus, as Csordas points out, hermeneutic approaches influenced by Ricoeur tend to emphasize Ricoeur's more text-centered works, Foucaultian approaches treat the body as a site of inscriptions of domination, anthropologists influenced by Geertz invoke the metaphor of the text, while Derridean post-structuralists subsume everything under the text. However scholars have attempted to navigate the mind/soul/body problem, then, the tendency has been to read the body as an object apart from and driven by a mindful subject. While Csordas' solution to this conundrum of offering a notion of embodiment as a "dialectical partner to textuality" is promising, the task remains of unchaining story from objective text,[15] particularly when the issue at hand is not the body itself. How, in other words, should we speak these women's stories? How should we read them?

As Swamiji told Kirin Narayan, "All stories are told for some purpose" (Narayan 1989:37). The stories told in these essays have multiple purposes,

not all of which can easily be unfolded. In their variety, these stories do indeed unchain story from objective text at particular moments, while self-consciously putting text to work as an illuminating, liberatory object at others. At times, then, these essays work alongside rather than within text in an attempt to convey the immediacy of a life—a life of a person whose experiences are embodied, sensuous, and mindful. When Kathleen Stewart tells us, "My earliest memories are fragments of trauma and beauty. . . . My kindergarten class walking back from Woolworth's carrying a box full of furry yellow chicks, the warming spring sun on our backs. . . . There were fingers crushed in doors, blood spurting out while wild pet rabbits ran around the cellar in secret," this sensuous immediacy of living a life is conveyed eloquently. Similarly, that immediacy comes to us when Katherine Zirbel tells us that "'Aziza asked me if I didn't think she looked like Naʿima ʿAkef, to which her sister responded, teasing that she didn't know henna flowers came in black, as ʿAziza had dark skin, while Naʿima ʿAkef did not." And when the narrator in Ulysse's poem says, "we'd throw rocks like boys at the zanman / until we knocked them onto the ground / we would wipe them off our uniforms / and stuff them into our mouths." When women speak their stories, their bodies spring to life as does the sensuous world around them. In such tellings, the objective text is forced to confront the tension between the nearly unassailable claim that experience is mediated by language and text, and the moral imperative that, indeed, there is a Kristevan convulsive moment[16] prior to such mediation. Were there not, stories of domination would lose their force and their meaning.[17]

At times, some of the essays in this volume do indeed allow these women's stories to disclose domination, exploring the tension between control and freedom (see Wesley 1999). Here, the stories inhabit their objective text, bringing us closer to understanding the confining dimensions of women's life-worlds as well as their world-creating engagement with those worlds. Here, it is possible for us to read the revelations these essays offer of how women make sense of their life experiences—experiences located in a web of connections (Haraway 1991) that are orienting without wholly imprisoning the women.

Finally, besides moving between the difficult poles of understanding self and understanding world—of understanding story as objective text and as indentation left by embodied experience—these essays speak women's imaginings of home for the contributors' personal reasons. Such reasons range from tenderly pausing over the life of a loved one to earnestly seeking to understand forms of control and domination while recuperating the freedoms snatched from the wind by those experiencing them. On the balance, these essays ask to be read as open-ended and varied possibilities for understanding and experiencing women's imaginings of home. They ask to be read together, comparing the incomparable; to be read apart, experiencing the singularity of a life; and to be read as a series of questions raised from within the life-world imagined by their authors without being bound by it.

THE CONTRIBUTIONS

This book offers a collection of stylistically varied essays that grapple with the contradictions of voice and locatedness in a variety of contexts. Ruth Behar's preface and this introduction open onto seven essays that explore the volume's issues critically and often lyrically. The volume then closes with an eloquent poetic reflection by Gina Ulysse that leaves the book open to multiple readings/writings, voices, and possibilities for engagement.

Kathleen Stewart tells a poignant, confining story in "Still Life," a poetic meditation on the "ordinary" effects of the stilling and distilling process of contemporary U.S. public consumptive culture. Stewart's still, like the moonshine still that distills liquor, is the public consumptive machine that moves the images—both the idyllic and terrifying—of the American Dream along. In this process, a barrage of images proceed in a "jumpy logic," the intimate and the public become continuous, desire and knowledge become eerily juxtaposed, and "ordinary" life is "stilled."

Stewart tells her own story of home from within but also across this (dis)stilling process. Yet Stewart's story, her mother's story, and her West Virginia friend Sissy's story, are in a constant state of interruption—submerged or set aside temporarily for the sake of the constant play of images processed through the still. In this play of images, the "dream of an unhaunted home" constantly meets its opposite. Thus, images from the television show "America's Most Wanted" is interrupted by a brief vignette: "Houses painstakingly kept up, yards kept trim and tended, the little family stands beside their sports utility vehicle in the driveway looking up. . . ." Martha Stewart reminds American women of what they would like to have and be, while news stories and reality TV interpose the shock of what they really have or of what they most fear.

In this series of images, vignettes, and Stewart's own home-tellings, home is a cozy refuge for women, against the "still life," against the images of horror we consume. Yet, paradoxically or ironically, home is itself an amalgamation of still lifes—those images and objects of consumption that construct home as a site of unattainable desire. The play on "still" evokes the passivity of this process of construction—the image machine feeds us, feeds on us, and the liquor of desire streams out but is undrinkable.

The potential terror of home is also realized in Elizabeth A. Bohls's essay "A Long Way from Home: Slavery, Travel, and Imperial Geography in *The History of Mary Prince*." Here, Bohls tells us the tale of Mary Prince, a nineteenth-century slave whose published autobiography lays bare the contradictions between the modernist home and its violent antithesis—the anti-home of slavery—which provided the material as well as discursive fabric for the cozy home of empire. If the American Dream is undone in its own convulsive images in Kathleen Stewart's essay, Elizabeth Bohls reminds us of the exclu-

sions that made the American Dream imaginable in the first place. Indeed, the specifically racialized exclusions muted or forgotten in the auto-tellings Brettell and Reed-Danahay explore later in the volume are the very ground upon which Mary Prince's journey home is based.

Bohls tells us that Mary Prince's autobiography was mediated through editors who had their own agenda. In this case, Mary Prince dictated her story to a white woman abolitionist in collaboration with the Secretary of the Anti-Slavery Society. The resulting publication, then, was a joint effort between Mary Prince and her abolitionist sponsors, and, as Bohls tells us, we should "try to understand its [the text's] words and silences as the product of tacit negotiation between the semi-literate slave and those who took an interest in her story." If Mary Prince's authentic voice is not easily recoverable (if at all), Bohls suggests we attend to the collaboration between Prince and her sponsors for what it can tell us about "the cultural incommensurabilities between the slave woman and her sponsors," but also about the "imaginary mapping of abolitionist assumptions onto the transatlantic geography of British Empire."

As Bohls tells us, those assumptions included checking the veracity of Prince's story— including seeing the scars on her body. Once verified, the telling of Prince's tale required careful editing with attention to those elements that were, in Bohls's terms, culturally incommensurable. Here, Bohls describes what was at stake for abolitionists as they tried to give humanity to a population so far denied it. The most palpable silences of the text are those events and topics, then, the telling of which would have offended white, genteel sensibilities and risked the abolitionist project altogether. Mary Prince's sexuality and her Caribbean-inflected language for example, are excluded from the text and the portrait of Mary Prince matches, as closely as possible, that of a pious, enlightened Christian woman.

If abolitionist assumptions are legible in the silences of the text, Bohls finds in the words themselves Mary Prince's creativity in laying imaginative (and then physical) claim to home despite its seeming impossibility for a slave. Indeed, in Bohls's essay, it would seem that Prince's voice is at least partly audible—speaking her mother's grief over the loss of her children as well as speaking her own sufferings. It seems to be audible, too, in Prince's telling of home against the grain as it were—as she tells a counterstory to white, middle-class, genteel home. If home is a haven for the white metropole and colonies, it is so at the expense (and because) of slaves. As Bohls describes, for Mary Prince, home is in the company of loved ones, while white, middle-class home is a fiction that forgets the cold reality of whippings, displacements, and the forcible partings of its excluded inhabitants.

In "My Shafiqa: Concerning the Travels and Transgressions of a Southern Egyptian Woman," Katherine Zirbel tells another story of the journey to freedom, but in this case it is freedom from the patriarchal control of home.

Zirbel's essay juxtaposes the story of her ethnographic encounter with ʿAziza, a young Egyptian woman who "transgressively traveled" to Cairo, with Egyptian narratives about the dualities of home/travel, honor/shame, south/north, and country/city. Posing the questions, "Can there be honor and freedom? Must the road to women's increasing autonomy merge with debauchery?" Zirbel finds ʿAziza's freedom written in the gap between competing, contradictory narratives about honor and shame, and ʿAziza's interpretations of them.

As Zirbel tells us, honor killings still occur in Upper Egypt, and men steadfastly circumscribe their female relatives' movements outside the home. Such control is echoed in tales like that of "Shafiqa and Mitwalli," which end in the honor killing of the transgressive woman. If Southern Egyptian women pay heed to these stories in understanding themselves and their place in the world, Zirbel points out that there are other, more liberatory narratives competing for women's (and men's) attentions. Indeed, there is a counternarrative to the story of Shafiqa and Mitwalli itself, and it is between such narratives and counternarratives that Zirbel's young friend, ʿAziza, seizes some degree of freedom from the authority of her own male relatives.

Zirbel's story of her somewhat complicitous relationship with ʿAziza illuminates the readerly/writerly nexus of storytelling. As we come to understand, ʿAziza and her female relatives performatively draw upon the repertoire of tales and poetry available to them to comment on their everyday lives and choices. Giving fresh readings of old tales and offering narratives of one's own small adventures provides a means of communicating mutual collusion in wrenching temporary freedoms from vigilant male control. If that freedom was narrativized, however, it was also lived. In this respect, Zirbel's essay is a comment on the interpretative force of narratives in juxtaposing self and Other (in Zirbel's essay, north/south as well as men/women) tempered by the caveat that lives understood and lived through narrative are not bound by the neatness of narrative convention.

The unruliness of everyday lives in comparison to local narrative convention is also apparent in Bilinda Straight's essay, "Cold Hearths: The Losses of Home in an Appalachian Woman's Life History." Straight's essay tells two tales, one about Marie Miller, a white woman who traveled in the 1940s to escape her Appalachian home following the loss of her infant daughter, and another about the telling of the tale itself. In Marie's self-narration, a home of coldness, poverty, and loss is implicitly juxtaposed with the warm comforts iterated in U.S. modernist discourses, while the telling of a poignant tale to her granddaughter (Straight) becomes a performative journey through which Marie's and Straight's understandings of one another and of Marie's life choices are transformed.

As in the case of ʿAziza that Zirbel describes, Marie understands her life experiences and choices through local and national narratives. In this case, the narratives Marie draws upon are about home, and Marie emphasizes her

expectations of what a home should be in contrast to what she remembers experiencing. Thus, Marie's understandings of an ideal home entail a husband providing the material necessities that would enable her to make a home—including a warm house. Marie contrasts this image with that of an anti-home of violent conflict within a drafty shanty in West Virginia's hills. Marie's own ideal notions of home and of women's domestic roles also conflict, however, with Marie's choice to leave home, husband, and children, ultimately to migrate north to Ohio. However, in Marie's self-narration, the theme of the cold house eventually culminates in Marie's relating the story of her infant daughter's death from pneumonia—a loss she attributes to the coldness of the house itself.

As Straight illuminates, then, modernist narratives of home become powerful vehicles for the self-understanding and justification of Marie's life's decisions to her self and her granddaughter/ethnographic interlocutor. Whether or not stories of the American dream of home informed Marie's understanding of her life experiences and decisions in the 1930s and 1940s, they clearly informed her understanding of those experiences and decisions as a woman in her eighties. For Marie, the failure of her home to live up to the material merits of the modernist American concept of home made it the antithesis of home and reduced her existence to a brutish one. If Marie herself failed, then, in her attempts to be homemaker, her transgressive travels away from husband and children were inspired by a search for the ideal home—revealing the remarkable strength of that modernist fiction.

Caroline Brettell's essay, "Liminal Space and Liminal Time: A Woman's Narrative of a Year Abroad, 1938–1939," tells the story of Brettell's Canadian mother, Zoë Browne-Clayton, during a year she spent abroad when she was twenty-three years old. As Brettell tells, Zoë's letters home during that period reveal her yearnings to re-create herself and the meaning of home during a moment when the modernist nation and home were in crisis.

Zoë Browne-Clayton's journey began at home following her mother's death from cancer. Thus, it is, Brettell tells us, a "wistful" departure, blending both desire and transgression as Zoë overcomes the pull of duty towards her father and brother and sets off with money her mother left her to explore the alternatives to a Canadian woman's place in the home. Once off, Zoë's letters home are at once testimony to her inner journey, a collection of witty, gender-conscious descriptions of the people she meets, and an intimate portrait of Britain and France on the eve of war. As her year proceeds, Zoë's liminal journey is matched by the liminality of the world around her: Her own free-spirited yet uncertain experimenting is echoed by a seemingly unbridled freedom in Paris, but by a more subdued "false gaiety" in Britain, as the tension of war looming "loosened English reserve."

Brettell's narration of Zoë Browne-Clayton's letters home reveal home as a comforting site of "safety, security, and rootedness"—a place that anchors

her journey of imaginative freedom. Even if the modernist home was threatened in 1939, Zoë herself was only temporarily adrift, in a liminal period rather than a marginal predicament. For her, the modernist home was always a possibility, and she was able, ultimately, to create an empowering version. If some of her contemporaries were limited by the constraints imposed on women in Canada and the United States, Zoë Browne-Clayton succeeded in using her journey abroad to create a liberatory version of home.

If the rural French women whose stories Deborah Reed-Danahay tells freshly for us were more modest in the means at their disposal, they were at least similarly positioned to imagine attaining a positive dream of home. In her essay "Desire, Migration, and Attachment to Place: Narratives of Rural French Women," Reed-Danahay compares the life stories of three rural French women, revealing how these women's published biographies reflect "transcendent French values of place and home" even as the women turn those values to their advantage in powerfully (re)creating their identities.

Reed-Danahay accomplishes at least three things in her examination of these published autobiographies. First, she addresses the issue of mediated tellings. While Caroline Brettell becomes her mother's interlocutor, weaving her own telling of her mother's story within a tapestry of quotes from her mother's own letters, the issues of narrativity in Reed-Danahay's essay are more complicated, taking us even further from the illusion of unmediated experience. Reed-Danahay tells twice- and thrice-told tales, with hidden agendas slipping unbidden from between the lines of the text, as it were. In the texts Reed-Danahay examines, three rural French women tell their stories from the perspective of old age—with a variety of personal motives one might assume for constructing their life stories into organized narratives as they do. They tell these stories to a variety of male interlocutors, each with his own motives for writing them down. Finally, the stories have been published, Reed-Danahay informs us, in the larger context of a highly gendered French nostalgia for the home of the countryside.

Second, in contexualizing the tellings of three French rural women's life stories, Reed-Danahay accomplishes at once, a nuanced examination of the inherently mediated nature of narrativity—which is always laden with individual and collective cultural understandings and intentions—as well as her stated goal of "understanding images of rural women, and ideologies of family and gender in French popular culture during the late twentieth century." Third, in drawing upon these published autobiographical texts to elucidate ideologically heavy images of French rural women, Reed-Danahay brings these women's own desires to bear on their stories. Here, their own ideas of and desires for home emerge—however mediated by the passing of time, changing personal circumstance, and editing by others' hands. If their autobiographies are publically consumed nostalgically, the details effervescing from these three women's narratives attest to lives lived through everyday

sensuous and emotional experience, and to their attachment to the idea that not only were choices available to French rural women, but that the ones they made were good.

In "Foreign Spirits inside the Family: Vodu Home on the Ex-Slave Coast," Judy Rosenthal explores the play of the homely (heimlich) and unhomely (unheimlich), the movement across oppositions as spirits of formerly enslaved persons from the north make themselves at home in southern hosts descended from the same southerners who once owned them.

Rosenthal's portrait of Gorovodu and Mama Tchamba spirit possession is moving and beautiful, weaving lines from a poem composite/interpretation of Gorovodu evocations with Rosenthal's narrativized tellings of the (un)canny lives she found ethnographic home with. For the Gorovodu and Mama Tchamba (women) spirit hosts Rosenthal came to know, home is always "in-the-midst," always a haven in movement. Indeed, Rosenthal foregrounds such movement in her chapter, treating the essay's sections as movable pieces in an ethnographic translation of a traveling-home. That is, these women who host northern spirits constantly make home between house and zogbe (Gorovodu sacred space), between woman and spirit host; more pointedly, they make home by bringing the foreign into the familiar, the spiritual into the corporeal.

The women spirit hosts Rosenthal remembers for us in this volume live a transgression of boundaries, enunciating difficult oppositions—that is, speaking paradoxes—yet leaving them trailing unfurled but not explained away. One of the most troubling oppositions is that of echoing slavery in the act of spirit possession. The spirits of formerly enslaved persons were real, named people—victims of the Atlantic slave trade who were purchased by members of Ewe and Mina lineages in southern Ghana, Togo, and Benin. While the southern lineages incorporated "bought persons" into their homes, eventually making them at home in the broadest sense, southerners continue to remember the inequalities of this process and their debt by making the spirits of slaves at home in their beings. In this way, the past—another binary—is brought into the present, and its most troubling aspects re-imagined, re-lived and re-cognized. While earlier chapters in this volume attest in different ways to the way in which home is realized against its unhomely antitheses, including the notion that the modernist home was made possible through the imagining of others and their disenfranchisement, Rosenthal's spirit-adepts bring such issues into brutal conscious awareness. Thus, Rosenthal's narrativized tellings of women whose spirit-husbands accompany them admidst their daily struggles to make a home and financial difficulty is an evocation of home that always dwells with its opposite. More than that, it is a home that recognizes that its real and imagined antitheses are what affords it a cozy space to dwell.

In her haunting poem "Concepts of Home," Gina Ulysse tells intertwining stories of home and anti-home, home and exile, thus reminding us of the

play of oppositions we have witnessed throughout the volume. Indeed,
Ulysse's concepts of home are troubled by exile and intrusion throughout her
story. She begins with a memory of her grandmother, disturbed by the con-
tents of Milan Kundera's novel *Immortality*, and she ends lost in a search for
home that itself threatens the possibility of finding it.

Within the poem's exilic framing, Ulysse speaks memories of home with
the dexterity of the best local color writer: "I skipped about in my yellow
flowered dress / the blue bay / the escovitched fish / small strips of kan in a
plastic bag tied with a twist / for the tourist price of 30 J / the smell of and the
taste of blue mountain coffee. . . ." Yet she does not let us forget that race is
a bitter and often violent intrusion that cannot let home be quite realized.
Postcolonial race intrudes in the faces of tourists relaxing beneath the
almond tree that Ulysse's narrator claims ownership to, that Ulysse's narrator
"wanted to climb / I jumped trying to catch extended branches / jumped
again." It intrudes in the sugar that must be white and refined on hotel tables
rather than raw and brown and in the deaths of unborn children that con-
trast so bitterly with white tourists talking pleasantly beneath almond trees.

Ulysse speaks the longing of home eloquently and lucidly, but in coun-
terpoint to the modernist imaginings of Marie in Straight's essay, for exam-
ple, Ulysse's narrator does not seem to be seeking a home of "white, refined
sugar," a home conjured in the minds of privileged Others, but instead a
home free of the intrusions of postcolonial violence and poverty. Ulysse's nar-
rator seems to want to reach the branches of her own trees, taste fruits "soft
enough to let spots of juice seep through," hold the stones of home "tightly
within closed fists." Her desire for home possesses her as she tries to possess
it, and yet, tragically, she can neither find home nor want it as long as it strug-
gles in blood that kills children "in their mother's womb."

Idealized notions of home, especially, though not exclusively, Euro-
American modernist versions, surface forcefully throughout these essays. Yet
the variety of women's understandings of home in these essays reveal the
profound complexity of individual experience. Certainly, useful comparisons
can be drawn between the narratives explored in these essays: The contrast
between home and travel is of continuing salience, and a critique of home is
often crucial as well. While such themes are useful in organizing our own
understanding, however, often what is most interesting and important is see-
ing how individual women bring a unique vision to the task of action and
self-understanding. Thus, for Zoë Browne-Clayton in Brettell's essay, under-
standing requires a journey away from home. For Yvonne, Emilie, and
Antoinette in very different ways in Reed-Danahay's essay, contentment
with one's life choices requires a coming to terms with the contrast between
home and travel, rural and urban life. For Stewart, everyday experiences are
understood through home as a set of fictional, imagistic promises competing
with its dark, at times terrifying antithesis. In Bohls's essay, Mary Prince like-

wise critiques home as a Euro-American modernist fiction in relation to a home of "heart" realized in relation to the people one loves. Gina Ulysse speaks her Haitian home vividly, but contrasts it with the racial exclusions and violence that are simultaneously part of its making and its undoing. Rosenthal brings enslavement into the unstable core of homemaking itself. Zirbel's ᶜAziza finds home to be a place of patriarchal control and yet one she can leave clandestinely and safely return to. Straight's Marie likewise leaves home, but in her case she leaves what she perceives to be a home failing to attain the modernist fictions. Yet those very fictions seemingly send Marie on a transgressive journey to find ideal home. Home, then, is often experienced as unhomely—as stifling, controlling, traumatic, or terrifying, and thus as Other to its imagined realness. The unsettling feelings and dialectical contrasts that various ideal versions of home have the potential to reveal should not be permitted, however, to upstage unique experience. Multiple readings/writings of these women's stories are necessary, including (but not only) those that foreground the incommensurabilty of their experiences as differently positioned human beings; those that remember that the pain, joy, and longing through which women understand home once had a reality for them as living, breathing, paradoxical beings; and those that keep in mind that these pages are filled with stories the authors told themselves awhile before this book came to print.

NOTES

1. *Unheimlich* is customarily translated as "uncanny."

2. There is a vast literature that points up the ways in which Euro-American whiteness, bodies, home, and nation were conceived in racialized and sexualized terms. Edward Said (1978) is seminal. See also, for example, Taussig 1984; Mosse 1985; Gilman 1985; Stoler 1989. Also important is Partha Chatterjee's (1990) work on the ways in which Indian nationalists constructed understandings of world and home that critically responded to British understandings of world and home.

3. See also Romero and Stewart 1999 concerning the importance of women telling stories to one another across sameness and difference to effect liberatory social change.

4. See Reed-Danahay 1997 for a history of this term.

5. Although the notion of partial truths has gained ascendancy in recent anthropological scholarship, Margaret Mead (1949) was probably among the first, if not the first, anthropologist to frame the ethnographer's limited position as a problem in need of attention (see Lutkehaus 1995).

6. See also Mary E. John (1996) for an engaging, critical examination of the tense problematics associated with locating home for feminists internationally, and Caren Kaplan (1996) for a feminist critique of the tropes "home," "exile," and "travel."

7. Julia Kristeva's exploration of the foreigner is a tour-de-force that indeed takes us back to ancient Greece. It is inspirational in illuminating the West's preoccupation with self in relation to others. A word of caution is needed, however, to underscore that Kristeva's is a presentist archeology of Otherness that does not take cultural difference into account. Notwithstanding the legibility of discourses about citizen and foreigner in ancient texts, it is challenging at best to decipher ancient Greek understandings of self as they pertained to such discourses.

8. It is possible to find the crucible of humanistic thought in the fascination with human history that coincided with Europe's sixteenth-century colonial "discoveries" of soon-to-be colonized peoples and objects—discoveries that, moreover, raised philosophical and theological questions concerning the (cartographic) universal order of things. The seventeenth century put these discoveries to more dramatic effect, culminating in the undermining of medieval Christian cosmology, most notably in the person of Galileo. It is Descartes, however, to whom we owe the greatest debt for the dualistic fictions we continue to grapple with presently.

9. Ironically, Descartes was attempting to reconcile physics and Christian theology. In dividing humans into two beings—one physical and subject to natural laws, and the other a soul who thinks—Descartes helped make humans an object of scientific measure and study. Thus, when empiricism based on observation and measurement came into its own in the eighteenth century, human minds became as "real" as human bodies. This perhaps strange twist on Descartes seems to have added to Descartes' mind/body distinction a separation between a mind of which we can only ask "How?" from a soul of which we can only ask "Why?"

10. Moreover, those problems were ever transforming in historical context, making dualistic thinking impossible to pin down from one context to the next. This renders problematic the premise of Jeffrey Bell's (1998) otherwise thoroughly illuminating study of the problem of difference. Bell does a wonderful job of explicating the thought of Husserl, Merleau-Ponty, and Deleuze but homogenizes the problem of difference as it transforms over time and perhaps misses the ways in which they and other thinkers (most notably Charles Sanders Peirce) might open a space for an alternative to rather than a solution for the problem of difference.

11. See especially Ruth Behar 1993 for a creative and compelling narration of the crossings between women at the margin, center, and points-in-between.

12. Indeed, I would suggest that there is no easy separation between discursive and material realities, while simultaneously adding the caution that such a statement should not lead us to write as if people were texts, lacking in sensuous experience, suffering, and joy. See Michael Jackson's point (1996) that "the domain of knowledge is inseparable from the world in which people actually live and act" (4).

13. See, for example, Bauman 1977, 1986; Daniel 1984; Briggs 1988; Briggs and Bauman 1992; Tedlock and Mannheim 1995.

14. Csordas is in excellent company on this, following rich feminist scholarship on this issue, including Haraway (1991). He also mentions Julia Kristeva's (e.g., 1980, 1991) radical critique of representation. See Csordas 1994 for an excellent critical review of anthropological and feminist approaches to the body.

15. I am using "objective text" with an oblique nod to Csordas' (following Barthes) distinction between "text" and "textuality" (Csordas 1994:12). In that formulation, text is the object, treated as such, while textuality refers to a multivalent methodological field. Csordas twins this with body (as object) and embodiment (as methodological field). By "objective text," I mean to cross Csordas' "text" and "textuality," emphasizing that our best attempts to disclose the text as a rich methodological field still treat narrativized human experience as textual objects. It may be that our best route to remembering the *person* would be to lay claim to and evoke prelinguistic experience (within which body and mind are irreducible). See Tyler (1987) and Kristeva (1986), both of whom Csordas mentions.

16. I am referring to prelinguistic experience here. See Kristeva 1980, 1991.

17. A theory of perception capable of taking immediate experience and its relationship to moral action is necessary here. I take this issue up in "World-Making and Belief" (forthcoming in *Talking About Religion*, ed. James White, University of Notre Dame Press).

BIBLIOGRAPHY

Alarcon, Norma. 1996. Anzaldua's Frontera: Inscribing Gynetics. Pp. 41–53 in Smadar Lavie and Ted Swedenburg (eds.), *Displacement, Diaspora, and Geographies of Identity*. Durham: Duke University Press.

Amos, Valerie, and Pratibha Parmar. 1984. Challenging Imperial Feminism. *Feminist Review* 17:3–19.

Appadurai, Arjun. 1996. *Modernity At Large: Cultural Dimensions of Globalization*. Minneapolis: University of Minnesota Press.

Bakhtin, Mikhail M. 1981. *The Dialogic Imagination*. Trans. C. Emerson and M. Holquist. Austin: University of Texas Press.

Bammer, Angelika. 1994. Introduction. Pp. xi–xx in Angelika Bammer (ed.), *Displacements: Cultural Identities in Question*. Bloomington: Indiana University Press.

Bauman, Richard. 1977. *Verbal Art as Performance*. Rowley, Mass.: Newbury House.

———. 1986. *Story, Performance, and Event: Contextual Studies of Oral Narrative*. Cambridge: University of Cambridge Press.

Behar, Ruth. 1993. *Translated Woman: Crossing the Border with Esperanza's Story*. Boston: Beacon Press.

———. 2000. Foreword. In Caroline Bettinger-López, *Cuban-Jewish Journeys: Searching for Identity, Home, and History in Miami*. Knoxville: University of Tennessee Press.

Bell, Jeffrey A. 1998. *The Problem of Difference: Phenomenology and Post-Structuralism*. Toronto: University of Toronto Press.

Bhabha, Homi. 1994. *The Location of Culture*. London: Routledge.

Bourdieu, Pierre. 1977. *Outline of a Theory of Practice*. Cambridge and New York: Cambridge University Press.

Braidotti, Rosi. 1997. Comments on Felski's "The Doxa of Difference": Working through Sexual Difference. *SIGNS* 23(1):24–40.

Briggs, Charles L. 1988. *Competence in Performance: The Creativity of Tradition in Mexicano Verbal Art.* Philadelphia: University of Pennsylvania Press.

Briggs, Charles L. and Richard Bauman. 1992. Genre, Intertextuality, and Social Power. *Journal of Linguistic Anthropology* 2:131–72.

Butler, Judith. 1990. *Gender Trouble: Feminism and the Subversion of Identity.* New York and London: Routledge.

Chatterjee, Partha. 1990. Colonialism, Nationalism, and Colonized Women: The Contest in India. *American Ethnologist* 16:4.

Comaroff, Jean, and John Comaroff. 1991. *Of Revelation and Revolution: Christianity, Colonialism, and Consciousness in South Africa.* Chicago: University of Chicago Press.

Csordas, Thomas J. 1994. Introduction: The Body as Representation and Being-in-the-World. Pp. 1–24 in Thomas J. Csordas (ed.), *Embodiment and Experience: The Existential Ground of Culture and Self.* Cambridge: Cambridge University Press.

Daniel, E. Valentine. 1984. *Fluid Signs: Being a Person the Tamil Way.* Berkeley: University of California Press.

De Beauvoir, Simone. 1974 [1954]. *The Second Sex.* Trans. and ed. H. M. Parshley. New York: Vintage Books.

Di Leonardo, Micaela. 1998. *Exotics at Home: Anthropologies, Others, American modernity.* Chicago: University of Chicago Press.

Foucault, Michel. 1970. *The Order of Things.* New York: Vintage Books.

———. 1979. *Discipline and Punish: The Birth of the Prison.* New York: Vintage Books.

———. 1980. *The History of Sexuality, Volume 1: An Introduction.* New York: Vintage Books.

Giddens, Anthony. 1984. *The Constitution of Society: Outline of a Theory of Structuration.* Berkeley: University of California Press.

Gilman, Sander L. 1985. *Difference and Pathology: Stereotypes of Sexuality, Race, and Madness.* Ithaca: Cornell University Press.

Gough, Kathleen. 1968. Anthropology and Imperialism. *Monthly Review Press.* April:12–24.

Grewal, Inderpal, and Caren Kaplan. 1994. Transnational Feminist Practices and Questions of Postmodernity. Pp. 1–33 in Inderpal Grewal and Caren Kaplan (eds.), *Scattered Hegemonies: Postmodernity and Transnational Feminist Practices.* Minneapolis: University of Minnesota Press.

Haraway, Donna. 1991. *Simians, Cyborgs, and Women: The Reinvention of Nature.* New York: Routledge.

Jackson, Michael. 1996. Introduction: Phenomenology, Radical Empiricism, and Anthropological Critique. Pp. 1–50 in Michael Jackson (ed.), *Things As They*

Are: New Directions in Phenomenological Anthropology. Bloomington: Indiana University Press.

John, Mary E. 1996. *Discrepant Dislocations: Feminism, Theory, and Postcolonial Histories*. Berkeley: University of California Press.

Kapchan, Deborah. 1996. *Gender on the Market: Moroccan Women and the Revoicing of Tradition*. Philadelphia: University of Pennsylvania Press.

Kaplan, Caren. 1996. *Questions of Travel: Postmodern Discourses of Displacement*. Durham: Duke University Press.

Kondo, Dorinne. 1997. *About Face: Performing Race in Fashion and Theater*. New York: Routledge.

Kristeva, Julia. 1980. *Desire in Language: A Semiotic Approach to Literature and Art*. New York: Columbia University Press.

———. 1986. *The Kristeva Reader*. Ed. Toril Moi. New York: Columbia University Press.

———. 1991. *Strangers to Ourselves*. New York: Columbia University Press.

Lancaster, Roger. 1997. Guto's Performance. Pp. 559–74 in Roger N. Lancaster and Micaela di Leonardo (eds.), *The Gender Sexuality Reader: Culture, History, Political Economy*. New York: Routledge.

Lavie, Smadar, and Ted Swedenburg. 1996. Introduction: Displacement, Diaspora, and Geographies of Identity. Pp. 1–25 in Smadar Lavie and Ted Swedenburg (eds.), *Displacement, Diaspora, and Geographies of Identity*. Durham: Duke University Press.

Lutkehaus, Nancy. 1995. Margaret Mead and the "Rustling-of-the-Wind-In-the-Palm-Trees School" of Ethnographic Writing. Pp. 186–206 in Ruth Behar and Deborah A. Gordon (eds.), *Women Writing Culture*. Berkeley: University of California Press.

Mannheim, Bruce, and Dennis Tedlock. 1995. Introduction. Pp. 1–32 in Dennis Tedlock and Bruce Mannheim (eds.), *The Dialogic Emergence of Culture*. Urbana and Chicago: University of Illinois Press.

Martin, Biddy, and Chandra Talpade Mohanty. 1986. Feminist Politics: What's Home Got To Do With It? Pp. 191–212 in Teresa de Lauretis (ed.), *Feminist Studies/Critical Studies*. Bloomington: Indiana University Press.

Mead, Margaret. 1949. *Male and Female: A Study of the Sexes in a Changing World*. New York: Morrow.

Minh-ha, Trinh. 1987. Difference: A Special Third World Women Issue. *Feminist Review* 25:5–22.

Mohanty, Chandra Talpade. 1984. Under Western Eyes: Feminist Scholarship and Colonial Discourses. *Boundary 2* 12:333–58.

Mosse, George L. 1985. *Nationalism and Sexuality: Middle-Class Morality and Sexual Norms in Modern Europe*. Madison: University of Wisconsin Press.

Narayan, Kirin. 1989. *Storytellers, Saints, and Scoundrels: Folk Narrative in Hindu Religious Teaching.* Philadelphia: University of Pennsylvania Press.

Ong, Aihwa. 1988. Colonialism and Modernity: Feminist Re-presentations of Women in Non-Western Societies. *Inscriptions,* no. 3/4:79–93.

Oyewumi, Oyeronke. 1998. De-confounding Gender: Feminist Theorizing and Western Culture, a Comment on Hawkesworth's "Confounding Gender." *SIGNS* 23(4):1049–62.

Pratt, Mary Louise. 1992. *Imperial Eyes: Travel Writing and Transculturation.* New York: Routledge.

Rapport, Nigel, and Andrew Dawson. 1998. The Topic and the Book. Pp. 3–17 in Nigel Rapport and Andrew Dawson (eds.), *Migrants of Identity: Perceptions of Home in a World of Movement.* New York: Berg.

Reed-Danahay, Deborah E. 1997. Introduction. Pp. 1–17 in *Auto/Ethnography: Rewriting the Self and the Social.* New York: Berg.

Romero, Mary, and Abigail J. Stewart. 1999. Introduction. Pp. ix–xxi in Mary Romero and Abigail J. Stewart (eds.), *Women's Untold Stories: Breaking Silence, Talking Back, Voicing Complexity.* New York: Routledge.

Said, Edward. 1978. *Orientalism.* New York: Pantheon Books.

Spivak, Gayatri. 1988. Can the Subaltern Speak? Pp. 271–313 in Cary Nelson and Lawrence Grossberg (eds.), *Marxism and the Interpretation of Culture.* Urbana and Chicago: University of Illinois Press.

Stewart, Susan. 1993. *On Longing: Narratives of the Miniature, the Gigantic, the Souvenir, the Collection.* Durham: Duke University Press.

Stoler, Ann. 1989. Making Empire Respectable: Race and Sexual Morality in Early Twentieth Century Colonial Cultures. *American Ethnologist* 16(4):634–60.

Straight, Bilinda. Forthcoming. World-Making and Belief. In James White (ed.), *Talking About Religion.* Notre Dame: University of Notre Dame Press.

Taussig, Michael. 1984. Culture of Terror-Space of Death. *Comparative Studies in Society and History* 26(3):241–79.

Tedlock, Dennis, and Bruce Mannheim, eds. 1995. *The Dialogic Emergence of Culture.* Urbana and Chicago: University of Illinois Press.

Torgovnick, Marianna. 1997. *Primitive Passions: Men, Women, and the Quest for Ecstasy.* New York: Alfred A. Knopf.

Tsing, Anna Lowenhaupt. 1993. *In the Realm of the Diamond Queen: Marginality in an Out-of-the-Way Place.* Princeton: Princeton University Press.

Tyler, Stephen A. 1987. *The Unspeakable: Discourse, Dialogue and Rhetoric in the Postmodern World.* Madison: University of Wisconsin Press.

Webster, Wendy. 1998. *Imagining Home: Gender, 'Race,' and National Identity, 1945–1964.* London: University of Central Lancashire Press Limited.

Wesley, Marilyn C. 1999. *Secret Journeys: The Trope of Women's Travel in American Literature*. Albany: State University of New York Press.

Wolf, Eric. 1982. *Europe and the People Without History*. Berkeley: University of California Press.

TWO

Still Life

KATHLEEN STEWART

THE MOMENT OF SHOCK is a modern habit born of circulation and impact.[1] The still life: there are the little shocks of recognition that awaken us, and there is the trauma time that draws us close to the uncanny presence of what is not directly encountered, remembered, or imagined only to lull us to a restless sleep.[2] Signs, capital, and the sensoriums of public culture surge through circuits of exchange, seducing us with the look and smell of an incipient vitality.[3] A striking image enters the senses and literally "makes sense" of the restless obsessions of modernity's simultaneous overstimulation and numbness, alarm and anaesthesia.[4] Benjamin's optical unconscious grows sensuously vibrant in scenes of compulsive beauty[5] "which dwell in the smallest things, meaningful yet covert enough to find a hiding place in waking dreams. . . ."[6] Then something tempts a sidestep in perspective,[7] reverberates through "the inaccessible to which we have always already had access,"[8] and comes home to roost in the daydream of an ordinary life.

In the posttraumatic cultural landscape of the 1990s,[9] public specters have grown intimate.[10] The American Dream chants a mantra of ideals that are as serious as business itself and as thin as the talk at a supermarket.[11] Everyday life is doubly charged with the daydreams of nostalgic amnesia, utopic greed, and technophilia, and with the specter of the burst bubble when the dreamy subject is literally touched by the fear or memory of impact. Little shocks of recognition make their presence felt as seductions and intoxications, as symptoms and warning signs and repetitions in daily routine.

The still life becomes both the seductive representation of inanimate objects at rest and the still itself—the machine that distills the viscous fluids of forms of feeling, sociality, power, contingency, and agency into a concrete

but elusive substance. Encompassing the dual movements of anxiety and pleasure, abjection and warm recluse, totalization and fragmentation, it culls the dense intertextualities of our everyday to a state of continual excitement in which desire is indistinguishable from dread.[12] It promises the copy that is also contact, matter shifting into image shifting into matter.[13] Yet its jumpy logic bears the traces of the gaps, contiguities, and nervous interconnections of the discourse networks out of which its still-ness emerges.[14]

The still life is an act of consumption launched on the charged border where private intensities appear as images on public stages and the public representations we use to lay claim to self, family, nation, and law are made sensate with intimate force. Roosting in the nests of family talk, therapy talk, and mass culture, it articulates a kind of knowing unhinged from the clear opposition between reality and fantasy, or public and private realms.[15] Freud called it epistemophilia—not just the desire for knowledge but rather knowledge in the service of desire[16] where "the thought process itself becomes sexualized, for the sexual pleasure which is normally attached to the content of thought becomes shifted onto the act of thinking itself, and the satisfaction derived from reaching the conclusion of a line of thought is experienced as a *sexual* satisfaction."[17] Or if not sexual satisfaction necessarily, then the promise and threat of the scene where the public meets the intimate. It is the arresting image on a public stage that whispers to us, in an inaudible murmuring, "Love me."[18] "I'm yours." "Be mine."

INTIMATE SCREEN SCENES

My earliest memories are fragments of trauma and beauty. Still lifes that hinge on a grainy detail and open onto luminous scenes of impact. My kindergarten class walking back from Woolworth's carrying a box full of furry yellow chicks, the warming spring sun on our backs; the smell of shimmering red tulips in my mother's garden married to the taste of found raspberries and tart rhubarb ripped out of the ground while she wasn't looking and eaten with a spoonful of dirt. My mother dressing to go out in a beautiful black dress and red lipstick cuts to the brilliant red blood that exploded from the face of the boy next door as he fell from a cliff and landed face down on the cement in front of me and then to the rhythm of shocks, days later, as my father and the other men tore the cliff apart boulder by boulder, and each giant rock hit the ground and shook the glasses in the kitchen cabinet of the quiet, shaded pantry with an impact that seemed transformative.

I remember a spectral scene of my little brother hunched over something in the pine trees that hugged the house and then, walking back from school a few hours later, the sight of the house engulfed in flames and the driveway full of fire trucks with flashing red lights and ear-piercing sirens. The phrase "playing with matches" seems to be written across the blue sky.

Or there was the day when all of my grandparents came to visit and they were floating up the treacherous driveway in a big wide car as I stood on the side and watched. Then the right wheels were sliding off the icy edge and the big car hung suspended over the cliff. The white heads in the back seat sat very still while I ran, yelling for my father.

Sunday drives were ice cream cones dripping down our fingers as we sat crowded into the back seat, a complex order of silent conspiracies, betrayals, and realignments as the youngest were wordlessly defrauded of their ice cream without setting off the alarm that would alert the front seat. I remember this as a scene of sticky fingers and huge, silent tears running down fat baby cheeks.

There were fingers crushed in doors, blood spurting out while wild pet rabbits ran around the cellar in secret.

There were dreamy, jarring performances like the one at the VFW hall where my sister was the "can can" girl covered in clanking cans and I was the "balloon girl" dancing in floating plastic spheres to the lyrics of "the itsy bitsy, teeny weeny, yellow polka dot bikini" while everyone laughed.

My early Catholic school years are literally articulated in screen images of sensate shock: my little brother scared to the point of vomiting every day on our walk to school, the big leather strap in the back of the room, the ruler coming down on knuckles, the voice of the priest behind the dark confessional curtain asking if I had ever been impure, alone or with others, and the bishop's giant ruby ring as he slapped my face at the altar of my confirmation. I know "family" as a viscerality through screen images of walking through neighborhoods with my mother as night fell, peering together into picture windows to catch a glimpse of a lamp by a reading chair or a shelf of knick-knacks on the wall—still lifes of modernity at rest. Or as Saturday mornings spent sitting around my grandmother's table while she and her daughters told graphic stories under the guise of kinship reckoning when the simple effort to recall married names would key the sudden, repetitive, eruption of images of alcoholism, accidents, violence, cancers and other disastrous ends.

Or there is the scene of my father trying to hand-feed me all through my life as if he were a bird dropping food into the open mouth of his young. Or the shocking moments of his helpless panic like the dark, bitter-cold morning he crawled on his old hands and knees up the steep icy driveway in a desperate effort to get me to the airport on time.

HOME IS WHERE THE HEART IS

At odd moments of spacing out a strange malaise may come over you. A secret voice whispers in your ear, haunting the solidity of civility, free agency, and progress with the shock of the phobic, the abject, the betrayed, and the

unspeakable. Progress drifts into trauma in the flick of an eye until you can't think one without the other. Things seem to be simultaneously leaping forward and falling back. One step forward and two steps back, or two steps forward and one step back; the difference marks the line between winners and losers. Push out the losers, expel them from the national banality of strip malls and master-planned communities, and they only come back to haunt, splayed on the networks as news of the weird.

> All those bodies and voices lined up on the talk show stages, outing their loved ones for this or that monstrous act. Reality TV shows like "Cops," "Unsolved Mysteries," and "Untold Stories" bust in on the intimate dramas of whole families addicted to sniffing cans of white paint in their living rooms and drifting through desperate days wearing tell-tale rings of white that encircle their cheeks and chins like some kind of tattooed stigmata.

There is the shock that comes when something happens; some people live in a constant mode of crisis. But there is also the shock of trauma inscribed in the very regimes designed to guard against it: risk society,[19] professionalization, surveillance, cocooning, and therapeutic self-help. The fear of burst bubbles breeds disciplines (the healthy diet, the tended lawn, the daily lottery ticket) and compulsions (the scanning for news, the need for the new and improved, fetishisms of all kinds).

> The bubble man holes up in his house, free from contaminants, but he needs the airwaves to keep the information about contaminants flowing. A warning leaks in in the very effort to keep risk at bay.

The dream of an unhaunted home dredges up the dread of social entropy and the vicious blank-screen affect of other people "out there" who just don't care. The labor of looking is retooled as the circulations of late capitalism cut back and forth between ads and stories and news and the scene in your house and on the street.[20]

> "America's Most Wanted" prints photos of bank robbers with and without beards so you can scan the faces at the 7–11 for a match.

"Inside," the American Dream takes the form of a little vignette where time stands still.

> Houses painstakingly kept up, yards kept trim and tended, the little family stands beside their sports utility vehicle in the driveway looking up, stocks portfolios in hand, everything insured, payments up to date, fat free diet under their belts, Community Watch systems in place. Martha Stewart offers advice on the finishing touches.

The ideal scene conflates a dreamy nostalgia with a resurgent modernist image-affect of the new and clean and up-to-date. But anxiety is the ground over which it marches.

At the knock on the door or the jangling ring of the phone at night we can feel the uncanny resemblance between the dazed state of trauma and the enforced cluelessness, or cocooning, we now call "home." Intimate spaces are revealed to be spaces of hidden corruption, catastrophe, stifling banality, and crime. The airwaves are filled with horror stories of children on welfare beaten to death in their homes between visits from the social worker, or the man who bursts into his ex-girlfriend's trailer, shooting her and her new lover in their bed, or the "educated couple" who calmly goes away on vacation, leaving behind a hundred cats—some dead, some alive, wild ones living in the walls. On the nightly news we see the arrested image of the trailer wrapped in crime scene tape and the cat cages and cans of unopened cat food all over the house.

> Then it is reported on the news that a recovery movement guru suggests we simply stop watching the news, listing it as one of five major causes of stress today.

The American Dream fights back from the womb of the middle class where forms of optimism, sentimentality, and a longing for interiority become tactile.[21] Embodied prosthetic landscapes stage the hegemonic project to channel shock into beauty and banality: franchise culture, exhilarated consumerism, sensible accumulation, family values, colorful decor, instant communication, ever new techno-gadgets. Laying claim to a constant stimulation of the senses through synaesthetic images, sounds, touches and smells, the OK middle ground has become the state of being both "inside" and hooked up, privy to the enabling technologies and circuits of desire.[22]

> Reality TV gives us still lives of the poor and outcaste or the rich and famous. And then a car ad breaks in. The big shiny object whisks you along a beautiful wilderness road and sweeps to a quick stop; the camera pans back to ponder the big shiny car in a quiet moment of fantasy realized. In the end, you picture yourself both "in" the car and just where you are, watching, inhabiting the power of the tuned-in spectator.

The objects of mass desire now enact the very affects of circulation itself—travel, the stock market, information networks, movies, the accumulation of money and life-stages, and the consumption of the big, beautiful, basic, intensely sensate commodity-to-live-in like the country farmhouse getaway or the picture perfect bathroom done in the textures of old stone and precious metals. Movies in brilliant technicolor and surround sound take us behind the scenes and give us access to the very fantasy of watching things unfold. Action movies of masculinity play out a fast-switching dialectic of pending disaster and last-minute reprieve in which agency awakens and takes on a muscled mass. Movies made for women imagine a picture-perfect scene of an "inside"—a Home filled with tangible objects that have meaning or a Self filled with the intricate dramas of dreams launched,

wounded, and finally satisfied or left behind. Affect itself is laid out on the carpet like a beautiful fetish it's OK to love.

"Outside" is that which is refused access: the "wilding" scene of abjection, crime, chaos, danger, disease, decay, suffering. "The streets" are littered with cryptic, half-written signs of personal/public disaster like the daily sightings of homeless men and women holding up signs of abjection and will while puppies play at their feet.

> *The hand-held sign pleads the passing attention of passing cars. WILL WORK FOR FOOD. Too desperate for inclusion in the winds of circulation. For those "inside" the cars, it holds only the contagion of abjection.[23] The half-panicked glance out of the corner of the eye finds no power of positive thinking, no tips to imbibe for safety or good health. Instead, something sticks out of the side of things like the shock of the Real—Zizek's blot on the camera,[24] Lyotard's inhuman,[25] Lacan's unassimilated something.[26] A dollar bill stuck out of a car window gets a quick surge forward from the one with the sign and the heightened, but unassimilated, affect of a raw contact. "God bless you."*

"Inside," nerves jangle and surge toward the still life that holds promise and threat in the nest of a home-like scene. "Self" and "Home" lunge, through fits and starts, toward the still that distills affect and potentiality into an intimate scene for easy viewing. Shock, like recluse, promises the satisfaction of haunted senses suddenly come to rest on a scene that gives pause. The scene of an accident can give distracting reprieve while the perfect cocoon room can get jumpy with the force of the fetish moving through circuits of repression and return, spectrality and concrete substance.[27] Affect swells and flexes its muscles as the habit of watching images touch matter grows.

> *Think of standing in line in a supermarket. You're already impatient but then you get desperate when something goes wrong with the register and you're stuck there, unable to either go forward or to move to another register. Caught in a system of circulation but unable to move, you pick up a magazine to zone out. You open to the picture-perfect centerfold of a scene at rest in* Country Living *or* Home and Garden *and relax into the invented aura. Or, alternatively, you skim the tabloid headlines for the thrill of shock. This is another way of doing the same thing. The tactile image literally relaxes the jumpy move of affect to actualize something that is tempting or haunting.*
>
> *Glamour magazines do this too. They give you not so much a model of how to look and what to wear, as the magic of affect itself. Models frozen in time and space stare back at you in a scene that stages the jump from fantasy to actual body image and back. Image meets matter. An ideal becomes flesh.*

In the womb of the middle ground, the transmogrification of spectral ideals and materiality is both axiomatic, it seems, and a desperate goal—all that matters. There are big projects like remodeling. Or daily projects like

shopping, keeping a diary, taking pictures, making lists, cleaning house, and reading "how-to" books. Martha Stewart gives us the picture-perfect producer of the picture-perfect scene. In charge, obsessive without the pain of hyper-vigilance, sensible even in her excess, she is the icing on the state of readi-ness (house in order, beautifully prepared hors d'oeuvres all ready in the freezer should anyone stop by), the technology of having time, making time, making do with what is literally at hand. A guiding light technology of the still life.

> Today she's making real Mexican salsa. She says if you chop the vegetables in a blender you're not making real Mexican salsa. She has a chef with her and he's chop-ping the tomatoes and onions expertly, professionally, as you and I never could.

She's a nostalgia machine for the authentic and the handmade and a future flyer into progress and modernity (again). She produces pleasure, parody, laughter, envy, anxiety, despair, hope, and little projects that give people something to do. She's comforting, light and entertaining (not like the stock market, for instance), unless, of course, your life happens to depend on pic-ture-perfect scenes of efficient beauty.

Hidden in her still life is the promise and threat of what Svetlana Boym calls "graphomania"—the incessant practice of recording the details of the everyday in order to gain access to it.[28] Here, hypervigilance lurches onto cen-ter stage, seeking out its own fulfillment in scenes that justify the effort. It finds a home, meets its match, and spreads, out of bounds.

> A story in the paper tells of a guy who spends his whole life recording every-thing he does.". . . Got up at 6:30 AM, still dark, splashed cold water on my face, brushed my teeth, 6:40 went to the bathroom, 6:45 made tea, birds started in at 6:53. . . ."
>
> Or there was my graphomaniac neighbor in Michigan when we lived on a lit-tle lake surrounded by woods. He was retired from the Ford factory and his hobby was recording everything on video. Once I watched one of his videos and was mes-merized. In it, you're walking with him on a set path around the lake. You hear his every breath and foot step. He notes a pile of deer droppings on the path, and the shape of snow piles. His run-on narrative voice over tells you everything including the temperature of the air, the fact that he is walking, stopping, starting again, whose cabin he is walking by, who's in Florida for the winter, and when they are expected back. Then he comes to a cabin with black plastic wrapped around its base and zooms in on what looks like a large protrusion pushing out against the plastic on one side of the house. Uh oh. It's trauma time. He speculates: maybe it's ice from a broken water pipe inside the house, maybe the whole house is full of ice. Untold damage. The still life brings the pause and pleasure of graphomaniac satis-faction. Too late to do anything about it now. What will happen with the thaw? He says maybe he'll send a copy of the tape to Bob and Alice down in Florida.

Then he shrugs and moves on. What else can he find? Back to his breathing and the icicles on trees and footsteps in the snow. Tracking the banal, scanning for trauma. . . .

Scenes of life glimpsed through picture windows at night or splayed all over the nightly news hold promise and threat together in the dreamy mix of the search for the perfect ending and the fascination it tempts with the little detail out of place. Ordinary lives become figures rising on the intimate stage where secret interiority is fashioned into a scenic object.

My mother's painting class has decided to think of itself as a therapy group and my mother says it really is because there are really interesting people in it, meaning they have "interesting" lives, meaning they've all had their troubles.

Beth was always the quiet one—never said a word and everything was always fine with her. But then one day someone made a comment about some guy and Beth made a "funny" remark that everyone noticed: "He sounds just like my first husband." Then she said, "Oh, I shouldn't have said that," but the story came out. The first night they were married, they were on a cruise and he left her and went out gambling the whole night. "That should have given me a clue." Later, after the divorce, she had a "seriously" abusive boyfriend. She started talking to a friend of his about the abuse and eventually she married the friend. Now they're very happy. They have one child together (he has other kids too). But they're health fanatics; they eat a low fat, vegetarian diet, take all kinds of pills, and measure and weigh everything. She says they just want to go on living in this happy relationship forever.

Jana was a young girl from Groton when she met a guy from Sweden, got married, and went over there. She was the only daughter and very close to her parents so it was surprising she would go, but she loved her mother-in-law and she loved it over there and was happy for a short time. But her husband didn't want her to spend money on anything and didn't want to go anywhere and he became very depressed. She came back, but she's still friendly with his mother. She thought that was it, and she'd never marry again, but then only three or four months later she met a man and married him right away and now she's SO happy. She thinks he's wonderful and they have three or four children. But the day she got remarried, her first husband committed suicide. She doesn't think it had anything to do with her but he DID know she was getting married that day and he HAD wanted to come over for the wedding. But his mother doesn't blame her. Now she has a ten- or eleven-year-old daughter who suffers from depression. My mother thinks the group must be therapeutic for her because she seems to go to every class and every lunch even though she cleans houses and works as a dental hygienist and has the kids. She must be hyper; she talks fast and doesn't ever seem to sit down.

Ann is sixty-five and owns a big home in a wealthy old yankee town. They suspect she comes from money. She's always had very good, executive jobs and

she's traveled all over. She's a very fast painter but her work is not particularly good; she just likes to get something finished and she's happy when she's all done. At first, her husband criticized her (was she going to sell any of this? what was she going to do with it?), but now she brings home the rough boxes and wooden slabs and he does the prep work for her. She's doing the classes because her son, twenty-seven years old, was killed in a car crash a couple of years ago right down here on route 128. Her husband is very bitter about it. She's nice talking but every once in a while she'll swear—"that son of a bitch" or "goddamn" this and that. The group doesn't really seem part of her; she seems to belong more to the garden club and all that. She's had sugar all her life but her father and uncles were doctors and they managed her so she's really never had any bad problem with it.

Sue is studying at the community college to be a nurse or a social worker. She resents never having gone to college. She lived in Bermuda for a while and her son is in Europe doing his service (they're Mormons). She complains a lot: the painting classes cost too much, she hates her mother-in-law, her husband's sick all the time, her daughter got caught giving out test answers to some of the other kids in the class, and now Linda's mad at the school because she thinks they'll never let her daughter back on the honor roll. At first, nobody liked her; she whined and was abrupt. But she seems to have warmed up to the group now.

The new girl from Newburyport doesn't work; her husband's an engineer at Raytheon. They have a vacation trailer up in the mountains and a handicapped son who has to communicate through a computer. (They don't ask too many details about him but he can't be too bad because she talks about him going out at night—he's twenty now). She's very talented but her husband doesn't like her paintings. Things got much worse between them after he started having mysterious pains and decided to quit work for a while and stay home. One night, out of desperation, she lit a romantic fire in the fireplace and asked him to come sit with her and he said, "NO." (Someone in the group said, "Isn't it sad? We all have so many missed opportunities!" and others picked up on that and they all talked about it later over coffee.) When her husband went back to work, he got better, he said, because nobody bothered him there. He told her that MOST of his stress was from HER. Then he started carrying a notebook around and writing down everything she did that caused him stress.

Sandy is a teacher; her husband is a private investigator; she doesn't like her mother-in-law at all. They were moving out of their house into a condo and the others said, "Oh, that's a problem, getting rid of everything." But she said, "not when you have GREEDY KIDS like I do." She talks about slapping them when they were growing up. She says she wasn't a great parent but sometimes they need to be slapped.

Linda's husband left her and their four kids for another woman. She was devastated and finally found another man, but the others are all suspicious of him because he told her that she was so beautiful and that she was going to turn his life around and save him once and for all. (The eyes roll). She has his ring and he's

*moving in with her, but now it's coming out that he's quit his job and he wants her
to sell her house and buy another one because he doesn't want to have anything to
do with her former husband and it looks like he drinks (Sue's counting—looks like
it's four cocktails a night at least).*

*My mother is a good listener and doesn't like to air her own problems. So, as
she says with a wink, the others think she's the one with the picture-perfect life.
When she gave them all a copy of Nicholas Sparks's romantic novel The Note-
book,[29] one of them said, "You know, I bet that's what Claire and her husband are
like." They think it's wonderful that she's seventy one and still skis. And one day
when someone was talking about somebody doing something daring they said,
"Well I would never do that, but I bet Claire would."*

Home is where the heart is. The American Dream takes its dreamy place,
all the more luminous for the moments of trauma it stages and screens. Spec-
tacular graphics of disaster, monstrosity, and strangeness literally bring the
mass subject and the very notion of a public to life.[30] National still lifes set
the stage for the common watching of a national longing. The promise of see-
ing what goes on behind closed doors frames the seductive search for the tell-
tale sign.

*An A & E Special Investigative Report, "Behind Bars," chronicles the lives
and loves of prison inmates.*

*The video of the Rodney King beating rises on the horizon as a scene of raw,
violent contact that no framing and reframing can undo.*

*The O. J. Simpson story captures a national attention with the opening scene
of the Ford Bronco driving down the L.A. highway and then fastens onto the tell-
tale graphics of the glove, the blood stains, the barking dog, the racist words of the
detective captured on tape.*

*Andrew Cunanan's killing spree unfolds through the traveling details of lives
and deaths and then flashes into luminous substance in multiple sightings; some-
one spots him in Lebanon, New Hampshire, in a gray Mercedes with Florida
plates, his pockets stuffed with money.*

*The Clinton-Lewinsky scandal spreads through the involuntary fascinations
of the stained dress, the thong panties, the ties, and the touches (his lips on her
breasts, his hand down her pants, his cigar stroking her).*

*A Frontline special, "The Farmer's Wife," gives us six unrelenting hours of
the intimate details of a failing marriage on a failing farm.*

Meanwhile, the "good economy" ushers in a dreamy new millennium.
Citizens invest in the stock market, riding the wave of sudden inclusion in
the magic of capital accumulation. Next day it crashes and the day after that
it surges back, hardly missing a heartbeat. Those with no money to invest in
the wild-ride stodginess of stocks and bonds wait for another kind of magic
that comes in a flash.

The sweepstakes cameras appear at your door while you're still in your house
dress. Big bunches of balloons in primary colors are released into the air and the
music plays in surround sound.
 . . . Or UFOs come in the night and lift you up in an out-of-this-world lev-
itation trick. . . .

We Wait for the Knock on the Door.

I clipped a notice from the *New York Times:*

Life Sentence Is Imposed In 3 Kidnapping Killings
WHEATON, Ill. June 23, 1998—A jury on Monday sentenced a man to life in
prison for killing his pregnant ex-girlfriend and two of her children, and kidnapping
his nearly full-term son from her womb. The man, Levern Ward, 26, denied tak-
ing part in the killings. Mr. Ward had been found guilty of the 1995 slayings of
Debra Evans, 26, and her daughter, Samantha, 10, and her son, Joshua, 7. He
was also convicted of kidnapping the baby, who survived and is being cared for by
Ms. Evans's father.

It took me back to 1996. A visit to the field in West Virginia, down Tommy
Creek Holler.

> *I'm in Sylvie's house for the week. She's got the pneumonia and refuses to*
> *stick her head out. The phone is ringing off the hook and everyone is stopping*
> *by to visit. No one ever knocks; they just walk in and sit down in the over-*
> *stuffed chairs in the dark little room at the back of the house. Sylvie claims*
> *they're only coming because I'm in visiting. I'm taking notes. The big story is*
> *the multiple murders in Illinois. They're piecing together the details. They say*
> *a pregnant woman and some of her kids has been murdered by her ex-husband*
> *or ex-boyfriend or whatever he was and this other woman. There were other*
> *men there too, they say—some kind of gang on drugs. They cut the baby right*
> *out of her belly and left her to die. Took the baby home, claiming the woman*
> *had given birth the night before, like no one would notice. What kind of mon-*
> *sters? Nothing in THIS WORLD would make you or me do something like*
> *THAT THERE.*
> *Someone is reminded of this guy right down here in Winding Gulf who stole*
> *from his father and his father sent him to the pen. So when he got out he killed him*
> *and chopped him up in twenty-some pieces and raped his stepmother and took her*
> *and the car. But she got away from him and called the POlice.*
> *Then back to the monsters in Illinois. WHAT were they THINKING?[31] We*
> *keep coming back to the detail of them cutting the baby out of the belly. It's the*
> *woman, they decide, who wanted a baby and decided to get it by cutting. Instant*
> *baby, the dream comes true. Then she paraded around town with it like no one*
> *would figure it out. They decide she didn't really want a baby, just the luminous*
> *moment of motherhood, just the fifteen minutes of fame. It's a dangerous business.*

Then there was the act of the cutting itself. (Like this guy in Winding Gulf.) A demonic temptation? An act of revenge on the dream of cocooning intimacy itself? A moment of mad passion? Drugs.

It was as if "she" had been drawn, blindly and demonically, to the scene of desire turned into a literally compelling stage for the dramas of intimate publicity. Dramas of concealment and exposure, stardom and abjection, ownership and theft, penetration and retrieval. As if "her" act literalized not only the acts of reproduction and birth but the narrative act of making a picture-perfect life. And as if, in the act of literalizing, things got out of hand.

It was as if she thought the image could suddenly and finally be made flesh for her. As if she took the American Dream at its word and wanted to take it home. And look where it got her. She was "out of it" and WAY too far "into it." It's like a dream you can't wake up from and you're in it but it's not real. Everything's wacky. Dangerous and fascinating. Intimate and estranged. It lures you.

Sylvie's neighbor, Tommy, has been "into it" down there. He's got a woman down there—a drinker who sits in front of the tube and never sticks her head out. Sylvie's seen her down there drunk in the yard and the foulest language you've ever heard. One time last week it got so bad that Sylvie had to send Juanita down there to see about them. When Juanita got down there, he had her hand cuffed to the radiator and he was smashing her head against the floor. The police had to take him away and then, of course, she went right back to him. Sylvie says, "you'd only have to beat up on ME ONCE." Juanita told them she didn't care if they killed each other, she hoped they DID kill each other, but they better not do it in front of the little girl. Juanita took the woman's daughter to stay with her up on the mountain until things settled down.

Once, in Las Vegas, I got caught in the scene next door. I was living in a trailer park outside Nellis Air Force base, doing fieldwork. No one knows their neighbors in Las Vegas, which makes it a breeding ground for intimate public stages.

I would hear fights at night through the thin walls of the trailer. He'd yell, something would go thud against the walls, she'd scream, teenagers would skulk out of the trailer and hang around outside, despondent.

Then one day he was having a cigarette on the cheap little porch like we all had when the imitation railing broke and he fell face down into the gravel expanse that was the "yard." He lay there face down in the gravel without moving. I watched from my kitchen window as his family came out and looked at him, keeping their distance. His wife asked, tentatively, from a good twenty feet away, "Are you OK?" The long pause became vibrant with the tension. "NO. I'm NOT OK." Everyone kept their places, frozen in a public private vignette that literalized a violent intimacy rooted in injury.

Not long after that I suddenly realized the family was gone. No moving vans or waves good-bye, just there one day and gone the next. But I began to notice that the guy was still in there. One night I heard him laughing maniacally. Full beer cans thudded against the walls. Then I began to notice the TV turned up loud at night, its blue light flashing in the darkened trailer, him laughing loud at the wrong moments. One night I caught him standing at his living room window staring out at me. I got heavy curtains and kept them closed. Peeking out, I saw him peering out of the little decorative square of glass high up on his front door, visible only as the dark shadow of the top of his head.

Then someone broke into my trailer in plain daylight. They hurled a brick through a window on the side of the trailer, rifled through everything, stole a worthless old stereo, and left a note stuck into a wall with a large pair of scissors—"Yeah, boy." A week later there was a "community meeting" where the park manager made a speech claiming that all the burglary trouble was over, so I told my story. It became clear that people had long ago decided the thieves were teenagers from the run down, "trashy" trailer park next to ours. A line of stern looking, bulky young military men leaning against the back wall of the Quonset hut made claims that they could put a stop to it once and for all. And as we were filing out, one of them caught my eye with a hard stare I couldn't quite read. Promise? Threat?

Over the next two weeks people started noticing a late model, brightly colored party jeep patrolling up and down the streets at all hours of the night with its headlights off. One night when I woke to the sound of it slowly passing, I looked out and saw the dark shapes of four or five men hanging off the sides of the jeep with semi-automatic guns and spotlights in their hands. We called an emergency community meeting to insist that they stop their secret patrols before they shot somebody's teenager.

"Community" and "action" became visceral—literal—in the scripted public/private scenes of meetings and darkened jeeps drifting by in the night as the repetitions of trauma TV inscribed themselves in the everyday.[32] Things got out of hand.

When I was back in West Virginia, my old friend Sissy was calling all week with the horror stories of trying to save her daughter from a bad addiction. She says it's like Crystal's in a dream world and she just doesn't care. She realized how bad things were one night when she went to bail Crystal out of jail but she refused to leave her girlfriend and demanded that Sissy go get diapers for the baby and bring them back to the jail like that was the only thing she cared about. But now she had a job and she was saying she wanted to get straight so she and her girlfriend could get a place of their own. Her license had been revoked so Sissy was spending four hours a day driving her over the mountain to work and picking her up at midnight.

The road is bad, especially at night, and twice that week she was followed by the same truck and car. The first time they were shooting and she didn't know if

they were shooting at her, at each other, or at the road signs. But they finally passed her. The other time they appeared out of the fog behind her but after a while they just cut out their lights and disappeared.

 One day Sissy called one of the hospitals that advertise addiction programs but they told her it would be four hundred dollars a day. She said, "Are you CRAZY? Those ads are wrong that say if you need help you can get it. The rich people can help their kids but not the poor people. Now if I thought I could get off cigarettes, I'd stand naked in the four-lane to Beckley. But now wait 'til YOU have kids; you can just kiss your MIND goodbye."

We scan the airwaves for news of the weird or for help. The cultural landscape grows vibrant with promise and threat. Sylvie sleeps with a phone under her pillow, literalizing social connection and access to the power of media, circulation, new technology. With the phone under the pillow, she can call someone if something happens. But when there's trouble, its shrill ring wakes her in the still of the night.

 Sylvie hates it when they put the "naked" people on talk TV. Their way of literalizing intimate publicity comes as a shock.

 I'm sometimes a little taken aback when her neighbors just open the door and walk in and gently sit without saying a word, waiting politely for the talk to begin.

A POSTCARD

One day I get a postcard from Sissy, which says, simply,

 Just a word to let you hear from me. Your house burned down in a terrible fire and three babies burned up. It's all gone now.

I call to get the story. They never wanted to rent to those people to begin with but they begged them. They had all been in the bed together and the father just saved himself. Somehow squeezed himself through the tiny half-window and left the children inside. You'd think he would have passed the children out first but seems like he just didn't care. You could hear one of the babies crying at the door and the men tried to break in but they couldn't get to them in time. All the father cared about was this beat-up plastic stereo he had in there, and when they finally let him get back inside, he carried that melted thing out like it was the crown jewels. Nobody knows how the mother ever got out but she never was "right" and the next morning she was spotted wandering around stark naked, completely out of it. Sissy's husband Jimmy just tore the house right down to nothing and they don't even like to go OVER there.[33]

 The still life persists as a residue, "inside" the process of signification but alien to it too. It distills nightmarish vulnerabilities and seductive dreams into a potent intoxicant. It marks a mode of attention at once deeply distracted and scanning for revelations, driven by the furious desires it pursues and makes, still.

NOTES

1. See, for instance, Gunning 1999; Lutz 1991; Schivelbusch 1986; Singer 1995; and Stewart 1999.

2. On traumatic epistemology see Caruth 1996. See also Herman 1992 and Antze and Lambek, eds., 1996.

3. See Deleuze 1990.

4. See Berlant 1997; Buck-Morss 1993; Ivy 1993; Rogin 1993.

5. Foster 1997.

6. Benjamin 1979:244. See also Buck-Morss 1991 and Taussig 1992.

7. See Zizek 1995 and Lyotard 1991.

8. Blanchot 1987:17.

9. Farrell 1998. See also Edmundson 1997 and Massumi, ed., 1993.

10. On the spectral see Derrida 1994; Gordon 1997; and Foster 1996.

11. Trow 1997:22.

12. Shaviro 1993:2.

13. Taussig 1993.

14. Kittler 1990.

15. Mellencamp 1992.

16. Joyrich 1993.

17. Freud 1957, vol. 20:245.

18. Metz 1982.

19. Beck 1992.

20. Beller 1994.

21. See Archer 1997 and DeJean 1996.

22. See Ronell 1994.

23. Davis 1998.

24. Zizek 1995.

25. Lyotard 1991.

26. Lacan 1977.

27. Foster 1996:197.

28. Boym 1994.

29. Sparks 1998.

30. See Berlant 1997; Foster 1996; Seltzer 1998; and Warner 1993.

31. Of course, the *New York Times Magazine* section now has a column that presents a tantalizing photograph of someone caught in a pose. The column is called "What They Were *Thinking*."

32. Ronell 1994.

33. Stewart 1996.

BIBLIOGRAPHY

Antze, Paul, and Michael Lambek, eds. 1996. *Tense Past: Cultural Essays in Trauma and Memory*. New York: Routledge.

Archer, Matthew. 1997. *Gated Governmentality*. Master's Thesis, Anthropology, University of Texas, Austin.

Beck, Ulrich. 1992. *Risk Society: Towards a New Modernity*. New York: Sage.

Beller, Jonathan. 1994. Cinema, Capital of the Twentieth Century. *Postmodern Culture* 4:3.

Benjamin, Walter. 1979. A Short History of Photography. Pp. 224–57 in *One Way Street, and Other Writings*. London: Verso.

Berlant, Lauren. 1997. The Face of America and the State of Emergency. Pp. 175–221 in *The Queen of America Goes to Washington City*. Durham: Duke University Press.

Blanchot, Maurice. 1987. Everyday Speech. *Yale French Studies* 73:1–20.

Boym, Svetlana. 1994. *Common Places: Mythologies of Everyday Life in Russia*. Cambridge: Harvard University Press.

Buck-Morss, Susan. 1991. Dream World of Mass Culture. Pp. 253–86 in *The Dialectics of Seeing: Walter Benjamin and the Arcades Project*. Cambridge: MIT Press.

———. 1993. Aesthetics and Anaesthetics: Walter Benjamin's Artwork Essay Reconsidered. *New Formations* 20:123–43.

Caruth, Cathy. 1996. *Unclaimed Experience: Trauma, Narrative, History*. Baltimore: Johns Hopkins University Press.

Davis, Mike. 1998. *Ecology of Fear*. New York: Vintage Books.

DeJean, Joan. 1996. Did the Seventeenth-Century Invent our Fin-de-Siecle, or the Creation of the Enlightenment that We May Be at Last Leaving Behind. *Critical Inquiry* 22(4):790–816.

Deleuze, Gilles. 1990. *The Logic of Sense*. Trans. Mark Lester. New York: Columbia University Press.

Derrida, Jacques. 1994. *Spectres of Marx: The State of the Debt, the Work of Mourning, and the New International*. Trans. Peggy Kamuf. New York: Routledge.

Edmundson, Mark. 1997. *Nightmare on Main Street: Angels, Sadomasochism, and the Culture of the Gothic*. Cambridge: Harvard University Press.

Farrell, Kirby. 1987. *Post-Traumatic Culture: Injury and Interpretation in the Nineties.* Baltimore: Johns Hopkins University Press.

Foster, Hal. 1996. Death in America. *October* 75:37–59.

————. 1993. *The Return of the Real: Art and Theory at the Turn of the Century.* Cambridge: MIT Press.

————. 1997. *Compulsive Beauty.* Cambridge: MIT Press.

Freud, Sigmund. 1957 [1926]. Inhibitions, Symptoms, and Anxiety. *The Standard Edition of the Complete Psychological Works of Sigmund Freud,* trans. and ed. by James Strachey. Vol 20. London: Hogarth.

Gordon, Avery. 1997. *Ghostly Matters: Haunting and the Sociological Imagination.* Minneapolis: University of Minnesota Press.

Gunning, Tom. 1999. An Aesthetic of Astonishment: Early Film and the (In)Credulous Spectator. Pp. 818–32 in Leo Braudy and Marshall Cohen (eds.), *Film Theory and Criticism: Introductory Readings.* Oxford: Oxford University Press.

Herman, Judith. 1992. *Trauma and Recovery: The Aftermath of Violence—From Domestic Abuse to Political Terror.* New York: Basic Books.

Ivy, Marilyn. 1993. Have You Seen Me? Recovering the Inner Child in Late Twentieth-Century America. *Social Text* 37:227–52.

Joyrich, Lynn. 1993. Elvisophilia: Knowledge, Pleasure, and the Cult of Elvis. *differences* 5(1):73–91.

Kittler, Friedrich. 1990. *Discourse Networks, 1800/1900.* Trans. Michael Metteer. Palo Alto: Stanford University Press.

Lacan, Jacques. 1977. *Ecrits.* Trans. Alan Sheridan. London: Norton.

Lutz, Tom. 1991. *American Nervousness, 1903: An Anecdotal History.* Ithaca: Cornell University Press.

Lyotard, Jean-Francois. 1991. *The Inhuman.* Trans. Geoffrey Bennington and Rachel Bowlby. Palo Alto: Stanford University Press.

Massumi, Brian, ed. 1993. *The Politics of Everyday Fear.* Minneapolis: University of Minnesota Press.

Mellencamp, Patricia. 1992. *High Anxiety: Catastrophe, Scandal, Age, and Comedy.* Bloomington: Indiana University Press.

Metz, Christian. 1982. *The Imaginary Signifier: Psychoanalysis and the Cinema.* Trans. Celia Britton, Annwyl Williams, Ben Brewster, and Alfred Guzzetti. Bloomington: Indiana University Press.

Rogin, Michael. 1993. "Make My Day!": Spectacle as Amnesia in Imperial Politics. In Christoph Lohman (ed.), *Discovering Difference.* Bloomington: Indiana University Press.

Ronell, Avital. 1994. Trauma TV: Twelve Steps Beyond the Pleasure Principle. Pp. 305–27 in *Finitude's Score: Essays for the End of the Millennium.* Lincoln: University of Nebraska Press.

Schivelbusch, Wolfgang. 1986. *The Railway Journey: The Industrialization of Time and Space in the Nineteenth Century*. Berkeley: University of California Press.

Seltzer, Mark. 1998. *Serial Killers: Death and Life in America's Wound Culture*. New York: Routledge.

Shaviro, Steven. 1993. *The Cinematic Body*. Minneapolis: University of Minnesota Press.

Singer, Ben. 1995. Modernity, Hyperstimulus, and the Rise of Popular Sensationalism. In Leo Charney and Vanessa Schwartz (eds.), *Cinema and the Invention of Modern Life*. Berkeley: University of California Press.

Sparks, Nicholas. 1998. *The Notebook*. New York., NY: Warner Books.

Stewart, Kathleen. 1996. *A Space on the Side of the Road: Cultural Poetics in an "Other" America*. Princeton: Princeton University Press.

———. 1999. Conspiracy Theory's Worlds. Pp. 3–17 in George Marcus (ed.), *Paranoia Within Reason: A Casebook on Conspiracy as Explanation*. Chicago: University of Chicago Press.

Taussig, Michael. 1992. Physiognomic Aspects of Visual Worlds. *Visual Anthropology Review* 8(1):15–28.

———. 1993. *Mimesis and Alterity: A Particular History of the Senses*. New York: Routledge.

Trow, George. 1997. *Within The Context of No Context*. New York: Atlantic Monthly Press.

Warner, Michael. 1993. The Mass Public and the Mass Subject. Pp. 234–56 in Bruce Robbins (ed.), *The Phantom Public Sphere*. Minneapolis: University of Minnesota Press.

Zizek, Slavoj. 1995. *Looking Awry: An Introduction to Jacques Lacan Through Popular Culture*. Cambridge: MIT Press.

THREE

A Long Way from Home

Slavery, Travel, and Imperial Geography in *The History of Mary Prince*

ELIZABETH A. BOHLS

Sometimes I feel like a motherless child,
A long way from my home,
A long way from home.

—Spiritual

I.

CAN A SLAVE HAVE a home? Can a slave be a traveler? Slavery, by definition and as historically practiced in the nineteenth-century British Caribbean, troubles and tests our understanding of both of these concepts. This essay will work through these challenges on the basis of *The History of Mary Prince, a West Indian Slave, Related by Herself* (1831), the only known published autobiography by a British slave woman. Slavery functions in some sense as a limit case. It pushes each concept toward or over the boundaries of its accepted use and helps us think through the history of that use, with its implications for our thinking about varieties of movement and constraint for unprivileged populations in a postmodern world. Gender also matters deeply for the woman slave, but quite differently than for her free white contemporaries, as we will see.

Mary Prince's historical moment—she dictated her story in the final, bitter phase of the political struggle for slave emancipation, which was won in

1833—situates her amid the early development of forces that continued to shape Western modernity. The profits of colonial slavery may or may not have provided the crucial fuel for capitalism's nineteenth-century triumph, as Eric Williams controversially argues. The institution of slavery may or may not have been essential to the development of the concept of freedom, as Orlando Patterson asserts. But it is certainly true that the movement of persons on a massive scale from Africa to the Americas over nearly four centuries of New World slavery was the first of those large-scale, involuntary modern dislocations that have been at the center of postmodern debates about identity, place, and nation.[1] Mary Prince's life story narrates her individual experience of displacement, culminating in a transgressive movement toward freedom. But before following her account of her movements and her strategic treatment of the word *home*, we will need to consider the circumstances that brought her *History* into print.

Mary Prince dictated her life story to a white woman abolitionist, Susanna Strickland, in the London home of Thomas Pringle, the Secretary of the Anti-Slavery Society, where Prince was employed as a servant after having walked away from her owners, Mr. and Mrs. John Wood of Antigua.[2] *The History of Mary Prince* was thus the product of an unequal collaboration between Prince and her abolitionist sponsors, both invested in the political goal of slave emancipation, though presumably with rather different visions of what that might entail. Close attention to the process of producing the *History*, and the forces that shaped Prince's telling of her life and its editing for publication, can tell us something about the complex cultural negotiation involved. In particular, we need to attend to the editors' normative assumptions, which also represent the rhetorical imperatives of the abolitionist propaganda they set out to produce. Mary Prince probably shared these assumptions to some extent; in any case, she would have judged it prudent to conform to them. The proportion of censorship to self-censorship involved in producing the *History* is, of course, not fully knowable. What we can do is to read the *History* alongside other evidence of abolitionist agendas and worldviews and try to understand its words and silences as the product of tacit negotiation between the semiliterate slave and those who took an interest in her story.

Extreme caution is warranted (as Gayatri Spivak and others have warned) for any feminist project aimed at the recovery of subaltern women's lost voices through history. It seems advisable to start by putting aside unrealistic notions of authenticity and addressing instead what we do have: the necessarily inauthentic, impure product of historical, social, and political pressures, unequal power relations, and an awkward collaboration. In Ruth Behar's words,

> Reading a life history text . . . calls for an interpretation of cultural themes
> as they are creatively constructed by the actor within a particular configu-

ration of social forces and gender and class contexts; and, at the same time,
a closer analysis of the making of the life history narrative as a narrative,
using critical forms of textual analysis and . . . meditation on the relation-
ship between the storyteller and the anthropologist. (Behar 1995:152)

Mary Prince's life story, of course, was written down and produced in print
not by an anthropologist, but by abolitionists whose political motives, if
benevolent, were certainly overt. By considering these motives and the
assumptions they entailed, we may be able to learn more not only about the
cultural incommensurabilities between the slave woman and her sponsors,
but also about the imaginary mapping of abolitionist assumptions onto the
transatlantic geography of the British Empire. We may begin to imagine
Prince negotiating between West Indian slave culture and metropolitan abo-
litionist culture, a displaced person navigating treacherous shoals as she cre-
atively constructs the cultural themes of "home" and "travel."

Moira Ferguson and Jenny Sharpe have explored some of the possible
consequences of abolitionist mediation for the shape of Prince's narrative.
Foremost among these is its silence about sex. The sexual morality of metro-
politan middle-class evangelical Protestants like Pringle and Strickland and
their projected readers would not accept sexual activity of any kind by a
woman outside marriage (Paton 1996·169). In addition, any representation of
a black woman was forced to contend with racial stereotypes of black people
in general and black women in particular as hypersexual or congenitally
immoral.[3] The History does not mention Prince's voluntary, possibly finan-
cially rewarding liaisons with free black and white men, nor her probable sex-
ual exploitation by at least one of her owners, Mr. D——.[4] Allegations of
immoral conduct, used by her former owner Wood in attempts to discredit
her, must be met with the narrative projection of a virtuous Christian woman
to maintain Prince's credibility with this readership.

Rather than let readers interpret her silence to her detriment, Pringle
counters Wood's suggestions in a supplement to the published History. As he
does so, he makes use of an imaginary geography of empire. Describing her
efforts to get the money to buy her manumission from Wood, Prince has men-
tioned, "A gentleman also lent me some to help me buy my freedom—but
when I could not get free he got it back again. His name was Captain Abbot"
(Prince 1997:81). Sharpe speculates that Prince may have made an arrange-
ment with Abbot to serve as his housekeeper (the euphemism for concubine)
in return for her purchase price (Prince 1997:44). Joseph Phillips, an Antigua-
based abolitionist enlisted by Pringle as a character witness, comments,

Of the immoral conduct ascribed to Molly [Prince's slave name] by Mr.
Wood, I can say nothing farther than this—that I have heard she had at a
former period (previous to her marriage) a connexion with a white person, a
Capt. ——, which I have no doubt was broken off when she became seriously

impressed with religion. But, at any rate, such connexions are so common, I might almost say universal, in our slave colonies, that except by the missionaries and a few serious persons, they are considered, if faults at all, so very venial as scarcely to deserve the name of immorality. (Prince 1997:111)

Pringle strategically chooses to introduce a discussion of colonial morality as different from, and inferior to, metropolitan morality in order to preserve Prince's assimilation to the "abolitionist construction of the slave woman as socioethical being," in Sharpe's phrase (Sharpe 1996:42). Her story is told with constant reference to the only endpoint abolitionists would accept: a person both free and morally enlightened. Sharpe insightfully discusses a number of other subtle elisions that contribute to maintaining this construction of Prince, but she does not focus on this use of geography. It requires in effect that Prince shed one dimension of her West Indian identity in favor of metropolitan morality if she is to serve as an abolitionist spokeswoman.

Another aspect of her Caribbean identity largely censored out of the published version of her life story to make it more palatable to metropolitan readers concerns language itself. Her spoken language would have been patois, "the creolized speech of slaves that combined English, Spanish, French, and West African languages" (Sharpe 1996:38). As Pringle and Strickland rendered Prince's narration in standard English, grammar itself imprinted the editors' class, racial, and geographical (imperial) dominance on her words. Pringle's preface explains that her story was first

> written out fully, with all the narrator's repetitions and prolixities, and afterwards pruned into its present shape; retaining, as far as was practicable, Mary's exact expressions and peculiar phraseology. . . . It is essentially her own, without any material alteration farther than was requisite to exclude redundances and gross grammatical errors, so as to render it clearly intelligible. (Prince 1997:55)

The intelligibility that had to be served was clearly metropolitan, white, and middle-class. Sandra Pouchet Paquet finds traces of black West Indian vernacular remaining in the published History even after Pringle's pruning, a "distinct voice" that she claims triumphs over Prince's victimization (Paquet 1992:131). To her white contemporaries in England, however, this was merely "peculiar phraseology," a quaint tinge of local color subsumed within a sanitized version of her story. If anything, it helped confirm the need for the treatment she received after her initial dictation, when Pringle grilled her "on every fact and circumstance detailed" with the help of the Antiguan, Phillips (Prince 1997:55). The perceived need for this cross-examination by her supposed allies speaks eloquently of prevailing assumptions about the truthfulness or reliability of black people and slaves. It is almost as eloquent as the request by the Birmingham Ladies' Society for the Relief of Negro

Slaves for verification of the whip scars on Prince's back before they would send her assistance. Their request was fulfilled by an examination performed by Pringle's wife along with Strickland and two other white women (Prince 1997:130–31; Midgley 1992:91).

Through attention to the collaborative production process that resulted in *The History of Mary Prince*, we can thus recognize some of the ways in which its text was shaped by the assumptions and agendas of its abolitionist editors to reflect the morality they shared with its projected readers. Mary Prince presented herself for the purposes of her published autobiography as a sexually virtuous, pious, hard-working victim of her owners' cruelty. She was aided in this effort by the overt censorship of her editors, more sophisticated in metropolitan morality, as well as by their translation or linguistic transformation. The cultural negotiation between these unequal collaborators was a geographical negotiation as well, as we have seen: the linguistic and moral strictures the editors imposed edited out colonial language and morality to substitute their metropolitan versions. As to what was lost in this process, beyond our evidence of Pringle's censorship of sex, we can only speculate. Sharpe turns to hostile sources such as James Macqueen's refutation of the *History* in *Blackwood's Magazine* and the court records of the libel lawsuit and countersuit between Pringle and Wood. Based on her reading of these, she suggests that the need to render Prince as "a decent and docile slave" forced the elision of "less morally upright forms of self-defense, such as verbal abuse or acts of insubordination." From the pro-slavery propaganda she reconstructs a picture of Prince as "an outspoken and resourceful woman who considered herself to be something more than simply a slave" (Sharpe 1996:42, 47). I will suggest further ways in which we may infer Mary Prince's purposes occasionally to have crossed those of her sponsors, or at least ways in which forms of personal control could be represented in the interstices, as it were, of their moral agenda. My central concern, however, will be with the *History's* treatment of place and movement in its rendition of the identity of a woman slave. To that end, we will first consider early nineteenth-century metropolitan constructions of a woman's place—the home—and then ask how compatible these were with colonial slave society.

II.

I will be concerned with the sense of "home" both as a dwelling—usually occupied by a family—and as a larger location, whether town, region, or nation. In both these meanings, "home" carries associations of emotional attachment or fulfillment as well as of comfort, familiarity, or ease. In the first sense, that of a domicile, "home" bears further connotations of safety or protection and nurturance, both physical and spiritual. These broad associations have persisted from early modern into postmodern Euro-American culture.

To specify further what Mary Prince invoked in 1831 when she used the word "home," as she does repeatedly throughout her *History*, we will need briefly to consider historical developments relative to the home in eighteenth- and early nineteenth-century England. This gets us into a somewhat vexed historiography, which is further troubled, as we will see, by the phenomenon of colonial slavery.

The history of the early nineteenth-century middle-class British home begins with the gradual but far-reaching economic and social reorganization that led up to the so-called Industrial Revolution. The removal of production from the home, or the separation between home and workplace, transpired unevenly throughout Britain's various localities and regions, depending on the needs of widely varied forms of production as well as (later) on individual choices guided by a sense of propriety or gentility.[5] The consequences of this reorganization for women have been widely debated. Middle-class women's role in productive labor probably did diminish, due also in part to the economic diversification that enabled them to buy basic household necessities formerly produced within a more self-sufficient household economy. But as recent revisionist accounts make clear, there is no proof that their declining role in production, either of household goods or in family workshops, necessarily caused a decline in women's status. That status continued to be relatively low within hierarchical, patriarchal households, as it had been since the Middle Ages.[6]

Without romanticizing a preindustrial golden age for women in the household economy, however, we can trace some of the important cultural and ideological consequences for women of the (uneven) establishment of the home as a site of consumption rather than production. The ideology of separate spheres was, until quite recently, the most widely used conceptual framework for interpreting nineteenth-century British and American women's history (Vickery 1993:385–86). According to Amanda Vickery, the work of Catherine Hall and Leonore Davidoff in *Family Fortunes: Men and Women of the English Middle Class, 1780–1850* "offers the most complex use of separate spheres as an organizing concept to date." I will rely on this "landmark in women's history" (Vickery 1993:393), presenting its findings in counterpoint with Vickery's recent critique, and with occasional reference to Hall's further work. Davidoff and Hall propose a key link between the rise of an ideology of domesticity and the emergence of middle-class cultural identity. In Hall's summary,

> Definitions of masculinity and femininity played an important part in marking out the middle class, separating it off from other classes and creating strong links between disparate groups within that class—Nonconformists and Anglicans, radicals and conservatives, the richer bourgeoisie and the petite bourgeoisie. The separation between the sexes was marked out at

every level within the society in manufacturing, the retail trades and the professions, in public life of all kinds, in the churches, in the press and in the home. The separation of spheres was one of the fundamental organizing characteristics of middle-class society in late eighteenth-century and early nineteenth-century England.[7]

Davidoff and Hall's research is based on a population who were serious Christians—part of the widespread Evangelical revival that had swept both Anglican and Nonconformist churches during this period—as well as prosperous bourgeois. In this respect their conclusions are especially relevant to Mary Prince's pious abolitionist sponsors.

Family Fortunes emphasizes the centrality of the feminized private sphere, the home, to the ideological foundation of this middle class. Evangelical religious ideology valued the home as "the one place where moral order could be maintained and recalcitrant time and nature be brought more securely under control" (Davidoff and Hall 1987:89). Pious domesticity "gave a proper basis for a truly religious life and . . . women were seen as naturally occupying the domestic sphere" (Davidoff and Hall 1987:90). Thus, much of the spiritual work of middle-class life was relegated to women, who were made responsible for exercising a beneficial moral influence over their husbands and families. Home was "a moral haven," a retreat from the dangers of the "world." "Women were more open to religious influence than men because of their greater separation from the temptations of the world and their 'natural' characteristics of gentleness and passivity. Home must therefore be the first and chief scene of their mission" (Davidoff and Hall 1987:115). Their "mission was by influence, tasteful economy, intelligent piety and faith to inspire and animate, soothe and resuscitate their men" (Davidoff and Hall 1987:118).

The woman at the center of such a pious Christian home and the family inhabiting it was ideally constructed as passive, submissive, nurturing, and above all morally pure. This ideal of femininity was certainly not new by the early nineteenth century, having roots in prescriptive writing dating back at least as far as the late seventeenth century.[8] The Victorian version of this gender ideology, however, was both more highly elaborated and at the same time more broadly disseminated than ever before: "the common sense of the English middle class" (Davidoff and Hall 1987:149). Emotional and physical nurturance—the affective dimension of family and home life—was increasingly entrusted to women as men (who in the later eighteenth century were licensed to display emotion to an extent foreign to the Victorians) came to be constructed as strong and silent, with a stiff upper lip.[9] "A good marriage rested on men and women bringing to it their complementary characteristics. The man would be the 'lofty pine,' the woman the 'slender vine,' the man would take responsibility for the stormy world of business and politics, the

woman would . . . 'sweetly smile' the cares of the world away" (Davidoff and Hall 1987:179). The home represented the physical site of familial affection, as in the proverb "Home is where the heart is." "Homes were contrasted with mere houses for a house could not be a home unless it were the site of love and care" (Davidoff and Hall 1987:178). One implication of separate spheres ideology with particular relevance to Mary Prince concerns middle-class women's mobility, which was obviously constrained by this set of beliefs. Restrictive clothing, issues of modesty, and the supposed dangers of public travel and public space discouraged women from movement, supplementing the positive duties or injunctions that tied them to their homes (Davidoff and Hall 1987:403–05).

Davidoff and Hall demonstrate at length how the ideology of gendered separate spheres worked itself out in the daily lives of the provincial middle-class population they researched. They also point out the ambiguities and contradictions that emerged as men, and particularly women, tried to put prescription into practice. Women's

> religion recognized their spiritual equality yet defended social and sexual subordination. Their class applauded self-assertion yet the feminine ideal was selflessness. Their supposed dependence and fragility was continually stressed yet they were expected to manage the 'business' of motherhood and the efficient organization of the household. Many women contributed directly to the family enterprise throughout their lives, yet received no public, or indeed, economic recognition. (Davidoff and Hall 1987:451)

Yet despite these and other contradictions uncovered by their research, Davidoff and Hall assert the centrality of separate spheres ideology to the emergence and consolidation of the English middle class. Vickery's critique questions this conclusion, citing recent research that appears to undermine various aspects of it. The central objection to using the separate spheres model as an analytical framework for writing history (as distinguished from just recognizing its prominence in middle-class thinking) concerns the dubious relation between prescription and practice. To what extent did the actions and everyday lives of actual middle-class men and women really reflect the didactic strictures promulgated in the conduct literature that has been such a prominent source for historians? Some recent research corroborates that of Davidoff and Hall, indicating a considerable correspondence between lived experience and prescribed ideals (though also noting methodological difficulties); other historians instead highlight divergences.[10] While Vickery emphasizes that nineteenth-century women did labor under "great disadvantages: legal, institutional, customary, biological and so on," she concludes that "the metaphor of separate spheres fails to capture the texture of female subordination and the complex interplay of emotion and power in family life." Historians' preoccupation with separate

spheres, moreover, "may have blinded us to other languages in play in the Victorian period" (Vickery 1993:401).

Whatever the efficacy of separate spheres as an analytical framework for metropolitan British society, however, its shortcomings appear much more glaring when we try to apply it to the colonial West Indies. One of the tensions noted by Davidoff and Hall concerns middle-class ladies' relation to household manual labor and to the domestic servants who performed much or all of it. It was first "uncertain how far the housewife should delegate, particularly in critical areas like cooking and childcare" to comply with the competing agendas of gentility, seen as exemption from manual labor, and femininity defined in terms of domestic roles (Davidoff and Hall 1987:391). Another troubling concern was servant management: "Personally and daily, [middle-class women] experienced the contradictions of operating across class in a family setting." A woman running a household "had to be firm and business-like, yet these qualities were the opposite of that feminine softness, gentleness, and submission of self which constituted the claim to feminine influence" (Davidoff and Hall 1987:395). In the colonial setting, where the domestic workers were black slaves, this contradiction between an idealized femininity and the reality of mistress-slave relations became acute, as we will see in the case of Mary Prince and her mistresses. The exercise of absolute authority, and of corporal punishment in particular, by a woman belies any idea of softness or submission.

Home and family as experienced by a West Indian slave like Mary Prince look very different from the prescriptive idealizations of separate spheres ideology. I will look first at the effect of slavery on her relationship with her own family—her family of origin and later her husband—and then at her experience in the houses in which she worked as a domestic slave. In the context of historical research on slave women and families, Prince's skeptical treatment of "home" in her narrative makes rhetorical sense as an attempt to bring home to her readers the profound incongruity between the institution of colonial slavery and their most cherished beliefs about gender, home, and family. I'll first briefly summarize the events of her life. Mary Prince was born about 1788 in Bermuda and lived her first twelve years as a slave in a Capt. Williams' home along with her mother and siblings; her father lived and worked nearby. About 1800 her owner sold her and two of her sisters separately, breaking up the family and causing great grief. In the house of her new owners, Captain and Mrs. I—— (Pringle uses initials to protect their families), she watched a pregnant slave flogged to death and herself endured floggings and other abuse as she worked tending animals and children and doing household chores. I—— eventually sold her to the sadistic Mr. D——, who took her to the salt ponds of the remote Turks Island where she endured ten years of hard labor and saw fellow slaves murdered with impunity. D—— then brought her back to Bermuda where she hints that he sexually abused her.

At her own request, Prince was then sold to Mr. and Mrs. John Wood of Antigua. She worked hard and saved money for her manumission; the Woods repeatedly told her to find a new owner, but then refused to sell her. She converted to Christianity, guided by missionaries who also taught her to read, and married a free black man without her owners' permission. For this she was flogged. The Woods took her to London, where, after continued maltreatment, she finally walked away from her owners, which was permissible under English law, though returning to Antigua would have re-enslaved her. She found work as a servant in the London home of Thomas Pringle, the Secretary of the Antislavery Society, where she dictated her life story for publication.

One historian comments, "In contrast to the nineteenth-century ideal of family life in which the family was a discrete unit, enclosed within the private home, slave families were of necessity open and permeable, their members vulnerable to separation and unable to protect each other from violence" (Paton 1996:169). The events of Prince's girlhood illustrate this well. The ongoing debate among historians and sociologists about the slave family forms part of the broader debate over what Marietta Morrissey calls "the phenomenological status of slaves." In her summary, "the social and cultural status of slaves has been debated [between] those who favor a structural explanation based on symbolic and legal orders and . . . those advocating a study of the culture of working peoples," or "history from below" (Morrissey 1989:15, 13).[11] The structural approach is perhaps most strongly exemplified by the sociologist Orlando Patterson in his comparative study *Slavery and Social Death*. Patterson posits natal alienation as an essential constituent of slavery. The slave, he explains, is "a genealogical isolate" (Patterson 1982:5), denied any claims on or obligations to living or dead family members. The occasional reality and constant threat of forced family separation "transform[ed] significantly the way [slaves] behaved and conceived of themselves" (Patterson 1982:6). The slave's natal alienation entailed being an outsider in a larger sense as well: a "loss of native status," "deracination," and "alienation . . . from any attachment to groups or localities other than those chosen . . . by the master" (Patterson 1982:7). Because he or she has no legitimate power to form or maintain attachments to people or places, Patterson implies, a slave cannot have a home in the way that a free person can.

More recently, historians' focus has shifted away from such an exclusive emphasis on the oppressive structures imposed on slaves "from above." While acknowledging the force of these structures—"slaves' culture and struggles were always impeded and framed by symbolic and legal orders" (Morrissey 1989:13)—researchers emphasize slaves' active, creative responses to them, and in particular the strength and endurance of the informal relationships that challenged the master's power of "natal alienation."[12] Mary Prince's narrative of her parting from her mother and siblings responds to Captain

Williams's cruel decision by using language that brings out slaves' ability to feel emotional pain, contrary to stereotypes of blacks as insensitive,[13] and makes clear the strength of these slaves' family ties.

> Oh dear! I cannot bear to think of that day,—it is too much.—It recalls the great grief that filled my heart, and the woeful thoughts that passed to and fro through my mind, while listening to the pitiful words of my poor mother, weeping the loss of her children. I wish I could find words to tell you all I then felt and suffered. The great God above alone knows the thoughts of the poor slave's heart, and the bitter pains which follow such separations as these. All that we love is taken away from us—oh, it is sad, sad! and sore to be borne! (Prince 1997:61)

Her feelings extend to her white mistress, Mrs. Williams, whose death she has mourned (not just because it occasioned her sale), as well as to her white owner/playmate, Miss Betsey, and even to "the house in which I had been brought up" (Prince 1997:61), which she unironically calls "home" (Prince 1997:60). She makes clear, however, that her perceptions throughout this section are those of a child, based on ignorance: "I was too young to understand rightly my condition as a slave" (Prince 1997:57). She also notes that Captain Williams's reason for selling her and her sisters was to finance his remarriage, implying that (as Patterson puts it) the white family is parasitical, built at the expense of the slave family (Patterson 1982:334–37).

Prince describes her arrival at the house of her new owner, Captain I——, in pointed contrast to the relative happiness of her childhood. "It was night when I reached my new home. The house was large, and built at the bottom of a very high hill; but I could not see much of it that night. I saw too much of it afterwards. The stones and the timber were the best things in it; they were not so hard as the hearts of the owners" (Prince 1997:64). Slaves, as Prince has already established, feel pain. These owners, by contrast, are emotionless and in that sense inhuman. Slaves were widely spoken of as commodities, mere objects, rather than human beings; she counters this conventional objectification by rendering slave owners as petrified objects like sticks or stones. And in contrast to the affective richness of her early home with her own family and Mrs. Williams, her description makes clear that this is a mere house. It has stones and timber, but certainly no love and care. By using the association-laden word *home* in a context that effectively strips it of the meaning familiar to white, middle-class, metropolitan readers, Prince highlights the disjunction between home as idealized in separate spheres ideology—the foundation of civilization as those readers knew it—and as institutionalized in colonial slave society. This was in line with a common and effective tactic of abolitionist propaganda, noted by Diana Paton: "A crucial component of the critique of slavery was that it created a society in which gender relations diverged horribly from English bourgeois norms" (Paton

1996:163). Those norms, as we have seen, defined home as a site whose private and feminine character was expressed through elevated morality and emotional nurturance, both markedly absent from the I—— household.

The harsh life in that household eventually pushes Mary Prince to the breaking point. She is still in Bermuda, not far from her parents and their respective owners (Mr. Trimmingham and Mr. Richard Darrel). When she feels she can no longer stand life with Captain and Mrs. I—— , she runs away to her mother: "She dared not receive me into the house, but she hid me up in a hole in the rocks near, and brought me food at night" (Prince 1997:70).[14] When her father hears of this, he fetches her and escorts her back to her owners:

> When we got home, my poor father said to Capt. I—— , 'Sir, I am sorry that my child should be forced to run away from her owner; but the treatment she has received is enough to break her heart. The sight of her wounds has nearly broke mine.—I entreat you, for the love of God, to forgive her for running away, and that you will be a kind master to her in future.' Capt. I—— said I was used as well as I deserved, and that I ought to be punished for running away. I then took courage and said that I could stand the floggings no longer; that I was weary of my life, and therefore I had run away to my mother; but mothers could only weep and mourn over their children, they could not save them from cruel masters—from the whip, the rope, and the cow-skin. (Prince 1997, 70)

This incident highlights the permeability and vulnerability of the slave family. Not only is this family dispersed among various owners, but the parents can do little to protect their child. The mother can offer only rocks as shelter; the father chooses to cooperate in enforcing slave ownership and family separation in an attempt to avoid worse. Neither parent has the power to avert their daughter's punishment by her sadistic owner. We may infer a limited success for the joint rhetorical intervention of father and daughter from her remark that she was not flogged that day, but she goes on to say that she remained with Capt. I—— five more years "and almost daily received the same harsh treatment" (Prince 1997:70). Again, as she narrates this complex compromise between resistance and accommodation, Prince begins by using the word *home* in a context that chafes against its cozy associations.

If parent-child relationships were thus impeded by the institution of slavery, what about those between adult couples (whether or not formalized by religious or legal marriage)? Historians disagree as to the general prevalence of stable conjugal pairing among slaves.[15] Some planters came to encourage Christian marriage in the belief that it served their interests by boosting fertility after the abolition of the slave trade (Beckles 1989:121–22). In Mary Prince's case, however, her owners, Mr. and Mrs. Wood, clearly did not view her marriage as being in their interest. She married without first asking their

permission, presumably knowing it would be denied, and did not voluntarily tell them after the fact. When he found out, Mr. Wood "flew into a great rage," and

> Mrs. Wood was more vexed about my marriage than her husband. She could not forgive me for getting married, but stirred up Mr. Wood to flog me dreadfully with his horsewhip. I thought it very hard to be whipped at my time of life for getting a husband—I told her so. She said that she would not have nigger men about the yards and premises, or allow a nigger man's clothes to be washed in the same tub where hers were washed. She was fearful, I think, that I should lose her time, in order to wash and do things for my husband. (Prince 1997:85)

Utilitarian concerns may have contributed to Mrs. Wood's rage, but its exorbitance suggests a less rational basis. The hinted fear of pollution by mixing clothes in a tub might speculatively be read as sexual rather than merely racial—a hysterical denial of the mistress's sexual jealousy of her female slave. Or she may have sensed in Mary Prince's marriage to a free man a sexual self-expression tantamount to a bid for her own freedom.[16] The spiritual equality suggested by Prince's presumption to Christian marriage may have been another ground for the Woods' fury (Beckles 1989:122). In any case, the owners clearly viewed the needs of the white family as superseding the slave's desire for a family of her own. The labor power needed to support middle-class domesticity limits or precludes domesticity among the laboring class. Davidoff and Hall note a similar phenomenon back in England among the Birmingham bourgeoisie, who had "difficulty in acknowledging claims of servants' own family and friends," preferring to hire country girls who were cut off from their community ties (Davidoff and Hall 1978:389).

The crisis precipitated by Mary Prince's marriage underscores the difficult position of the domestic slave who lived and worked in her owner's home. Compared to the plantation field labor that was the fate of the majority of Caribbean slaves, women as well as men, Prince's position as a household slave would have been viewed as privileged, near the top of the occupational hierarchy (Bush 1990:34). This privilege, however, brought with it increased contact with masters and mistresses and hence greater vulnerability to physical punishment through "sadistic whims and personal caprice" (Bush 1990:44). Plantocratic writers often cite domestic servants as being especially difficult, complaining of their laziness, inefficiency and disobedience. "Paradoxically," according to Barbara Bush, on larger plantations, "the most favored slaves, the house slaves and skilled elite, were often in the vanguard of slave resistance at all levels" (Bush 1990:61). Mary Prince's sharp tongue, presumably much muted in her narrative by the demands of middle-class decorum, emerges occasionally, as in her forthright response to being flogged for getting married. The trajectory of her life, culminating in her

transgressive seizure of a limited freedom, suggests a persistent tactical resistance against the indignities of slavery, as I will argue more fully below.[17]

Prince's position as a domestic slave highlights the incongruity between the state of slavery and the concept of "home." The house as home should be a place of relaxation, safety, comfort, nurturance, and family togetherness. But for Prince her owners' houses are places of near-incessant labor where she is at the mercy of her masters' and especially her mistresses' sadistic impulses. Her first night in the I—— house she lies awake listening to the screams of a fellow slave being beaten (Prince 1997:65). She awakens to a harsh routine of work and punishment:

> The next morning my mistress set about instructing me in my tasks. She taught me to do all sorts of household work; to wash and bake, pick cotton and wool, and wash floors, and cook. And she taught me (how can I ever forget it!) more things than these; she caused me to know the exact difference between the smart of the rope, the cart-whip, and the cow-skin, when applied to my naked body by her own cruel hand. And there was scarcely any punishment more dreadful than the blows I received on my face and head from her hard heavy fist. She was a fearful woman, and a savage mistress to her slaves. (Prince 1997:66)

This depiction of the colonial home squarely counters the idealized home of separate spheres ideology on several fronts. By foregrounding household labor, Prince dispels the aura of relaxation and resuscitation that was supposed to pervade the home. Certainly, for Mary Prince, this home is in no sense a haven. And by setting the list of household tasks in parallel with a list of punishments administered by the mistress of the house, Prince subverts the image of the middle-class lady—crucial anchor of the middle-class home—as gentle, nurturing, pious, and morally pure. Mrs. I——'s domestic sadism and her "hard heavy fist" utterly belie her prescribed feminine role. As Tassie Gwilliam comments on an earlier writer's preoccupation with mistresses' violence toward female slaves, "Women as bearers of domesticity best represent the destruction and perversion of home" in colonial slave society (Gwilliam 1998:666).

III.

To turn now to the significance of movement, displacement, or travel in Mary Prince's life is not to turn away from her troubled treatment of "home." Must one have a home in order to experience displacement as hardship? The geographer Doreen Massey points out that the meaning of home is profoundly differential for diverse individuals, largely a function of relative privilege. Postmodern critics bemoan the disorientation that accompanies globalization and space-time compression, treating it as a recent phenomenon. But those "who today worry about a sense of disorientation and a loss of con-

trol must once have felt they knew exactly where they were, and that they *had* control . . . a predominantly white, First World take on things" (Massey 1994:165). Not everyone ever had a home, "a place not only where they belonged but which belonged to them": "in those parts of the world where the majority of its population lives . . . it is centuries now since time and distance provided much protective insulation from the outside." Massey cites bell hooks's contention that "the very meaning of the term 'home,' in terms of a sense of place, has been very different for those who have been colonized." Not everyone "can afford to locate their identities" (Massey 1994:165–66). Even within a single location or community, people who occupy diverse positions will have widely varying senses of place, determined in part by such variables as gender, class, or age (Massey 1994:153–54). Mary Prince certainly experienced her owners' dwellings differently than they did and developed a critical perspective on home in the sense of domicile, as I have shown. We might expect her to turn a similarly jaundiced view on home in the larger sense of an attachment to a particular town, island, region, or even nation.

Before turning to Prince's own references to home in this larger sense, let us look at an exchange between her white contemporaries over a slave's attachment to place. In a "Supplement" to the published *History of Mary Prince,* the editor Pringle includes a letter written by her former master, Mr. Wood, to the secretary of the Governor of Antigua, responding to the Governor's request (instigated by the abolitionists) for help in bringing Prince back to Antigua free. Among his list of reasons why this should not happen, Wood claims that she "is not a native of this country and I know of no relation she has here" (Prince 1997:100). (He claims her husband has taken another wife.) Pringle counters, "True: but was it not her home (so far as a slave can have a home) for thirteen or fourteen years? Were not the connexions, friendships, and associations of her mature life formed there? Was it not there she hoped to spend her later years in domestic tranquillity with her husband, free from the lash of the taskmaster? These considerations may appear light to Mr. Wood, but they are every thing to this poor woman" (Prince 1997:104). Abolitionist rhetoric emphasized the slave's ability to form emotional bonds and enjoy "domestic tranquillity," just like middle-class Britons (and more authentically than debased slave-owners) as part of its drive to establish slaves as human beings rather than livestock. In this the abolitionist movement had apparently been successful enough by 1830 to force a slave-owner like Wood to argue on its terrain, denying specific facts rather than disputing a slave's ability to claim native status or to want to be near family members.

In this context, Mary Prince's own claims to such a status take on a tactical air, in line with this aspect of abolitionist rhetoric. For example, narrating her departure from Turk's Island, where she labored for ten years in the salt works, for Bermuda, she explains that not only is she sick of the harsh

work regime but "my heart yearned to see my native place again, my mother, and my kindred" (Prince 1997:75–76). To articulate this yearning asserts human dignity by denying the slave's natal alienation. But we are never told whether she did see her family in Bermuda, only that life there "was not so very bad as Turk's Island" (Prince 1997:77).

A later invocation of an attachment to place appears within a charged political context. Having walked away from her owners in London, Prince was left in a difficult bind. By British law, based on the 1772 Mansfield decision, the Woods could not forcibly take her into custody or transport her to Antigua. If she were to go back of her own volition, she would again be a slave, as Anti-Slavery Society lawyers advised her (Ferguson 1992:116–17). Pringle, the Secretary of that society, had attempted to use her case to challenge this legal precedent, recently upheld in the case of Grace Jones, a slave returned to Antigua against her will (Sharpe 1996:37). Though the Society's petition to Parliament on Prince's behalf had failed, she and her backers may nonetheless have held out hope of influencing future change in the precedent by which her freedom entailed permanent exile (as it has for millions of refugees since). Living with the Pringles, she says, "I . . . am as comfortable as I can be while separated from my dear husband, and away from my own country and all my friends and connections" (Prince 1997:92). Linking family with "country" in this way again asserts the speaker's full humanity and her similarity to her white metropolitan readers. But it seems to appeal to a sense of place more characteristic of comfortably rooted middle-class Britons than of someone whose life as a slave had uprooted her repeatedly from an early age.

To speculate on the significance of these displacements for Mary Prince's construction of her identity, let us begin by remembering that a diverse range of labels is applied to geographical movement, largely according to who it is that moves. The term *travel*, as James Clifford points out, carries with it "a history of European, literary, male, bourgeois, scientific, heroic, recreational, meanings and practices"; it is marked "by gender, class, race, and culture" (Clifford 1997:33, 31). Even bourgeois women have seldom been taken seriously as travelers, let alone women and men of the laboring classes. "The traveler, by definition, is someone who has the security and privilege to move about in relatively unconstrained ways"—at least, that is the myth of travel (Clifford 1997:34).[18] Mary Prince clearly does not qualify as a traveler within these narrow definitional constraints. And yet, Clifford observes, travel, even by the least privileged individuals and under the harshest conditions, has proved to be a source of power and knowledge of a different kind from that which has lent prestige to more traditional travelers. Rich and complex "cultures of displacement and transplantation"—notably the black diaspora cultures of Britain, the Americas, and the Caribbean—have been forged by "specific, often violent histories of economic, political, and cultural interaction," like the history of transatlantic enslavement, involving the geographical

movement of entire populations. These histories generate what Clifford calls "discrepant cosmopolitanisms," setting aside "the notion that certain classes of people are cosmopolitan (travelers) while the rest are local (natives) . . . as the ideology of one (very powerful) traveling culture" (Clifford 1997:36).

In this sense, I will argue, Mary Prince is indeed cosmopolitan: learning and growing through her involuntary or quasi-voluntary travels, each journey moving her further toward the sense of self she will need to narrate her life story for publication. The knowledge or wisdom she gains through travel—specifically, her geographic awareness of various West Indian locations and finally of the metropole—serves her in various situations and finally contributes to the sense of self-possession that allows her to walk away, free, from her owners in London. Prince's journeys begin with the early sale that breaks up her family and takes her from her childhood home, teaching her among other things the irrelevance of emotional ties between owner and slave. "When I left my dear little brothers and the house in which I had been brought up, I thought my heart would burst," she laments (Prince 1997:61). She uses the word *heart* throughout her narrative to invoke a network of affective connections and community values, attacked but never destroyed by slavery—connections and values that ground her identity amid maltreatment and repeated displacement. This usage is congruent with the language of her fellow slaves. After her sale, for example, her mother tells her to "keep up a good heart" (Prince 1997:63). On her arrival at the I—— house, two slave women at work in the yard commiserate: "'Poor child, poor child! . . . you must keep up a good heart, if you are to live here" (Prince 1997:64).[19] Her second sale, to Mr. D——, entails a journey to Turk's Island, hundreds of miles from her already dispersed family members. Despite this, Prince reports "great joy" at leaving a bad situation for one she hopes may be better (Prince 1997:70). It turns out to be worse. Her horrific experience in the salt works does, however, bring her to identify herself as a spokeswoman for fellow slaves like old Daniel, beaten with briars and rubbed with salt, and Sarah, dead after being beaten and tossed in the prickly pears. "In telling my own sorrows, I cannot pass by those of my fellow-slaves—for when I think of my own griefs I remember theirs" (Prince 1997:75).

Ten years later "my master left off business, and retired to . . . Bermuda . . . he took me with him to wait upon his daughters" (Prince 1997:75). The move back to Bermuda again occasioned joy at the prospect of getting out of Turk's Island, in addition to Prince's hope of seeing her family again. The work proved to be "not so very bad as Turk's Island," but Prince probably encountered an occupational hazard noted by historians of slave women to be especially prevalent for women domestic slaves: sexual harassment or coercion by white men (Robertson 1996:24).[20] Immediately preceding her elliptical description of D——'s sexual advances, Prince narrates another violent encounter with him in which her cosmopolitanism plays a

key role. This significant juxtaposition suggests how far she has come—in more than just miles traveled—since her earlier stint in the I—— household. I will quote at length.

> My old master often got drunk, and then he would get in a fury with his daughter, and beat her till she was not fit to be seen. I remember on one occasion . . . I found my master beating Miss D—— dreadfully. I strove with all my strength to get her away from him; for she was all black and blue with bruises. He had beat her with his fist, and almost killed her. The people gave me credit for getting her away. He turned round and began to lick me. Then I said, 'Sir, this is not Turk's Island.' I can't repeat his answer, the words were too wicked—too bad to say. He wanted to treat me the same in Bermuda as he had done in Turk's Island.
>
> He had an ugly fashion of stripping himself quite naked and ordering me then to wash him in a tub of water. This was worse to me than all the licks. Sometimes when he called me to wash him I would not come, my eyes were so full of shame. He would then come to beat me. One time I had plates and knives in my hand, and I dropped both plates and knives, and some of the plates were broken. He struck me so severely for this, that at last I defended myself, for I thought it was high time to do so. I then told him I would not live longer with him, for he was a very indecent man—very spiteful, and too indecent; with no shame for his servants, and no shame for his own flesh. So I went away to a neighboring house and sat down and cried till the next morning, when I went home again, not knowing what else to do.
>
> After that I was hired to work at Cedar Hills. . . . (Prince 1997:77–78)

In the beating incident, Prince's record of community recognition for her courageous act—"The people gave me credit"—prefaces D——'s grudging recognition of a kind of capital, a knowledge or worldliness, gained through her involuntary travel. Her retort when he starts to hit her—"Sir, this is not Turk's Island"—seems to succeed in checking his violence, a triumph grounded in the geographical awareness that her incredulously sarcastic comment celebrates. "He wanted to treat me the same in Bermuda as he had done in Turk's Island." Here a slave shares to some extent in the privilege of the more traditionally defined traveler, whose mobility yielded increased knowledge, prestige, and power.

This small victory sets the stage for Prince's subsequent self-defense from D——'s "indecency," a term that again invokes community standards which support her and condemn him. Here, too, her verbal (and possibly physical[21]) resistance is finally successful, resulting, as she tells it, in her no longer having to work in D——'s "indecent" household.[22] At Cedar Hills Prince also hears news of the Woods' upcoming departure for Antigua: "I felt a great wish to go there, and I went to Mr. D——, and asked him to let me go in Mr. Wood's service" (Prince 1997:78).[23] Arranging her own sale, possibly through

active persuasion ("Mr. Wood did not then want to purchase me"), and thus her move to a new island, the slave actively intervenes in the geographical trajectory of her life. The whole sequence presents us with a mature, tactically savvy slave whose limited power within the master-slave relationship is drawn in significant part from her cosmopolitanism. Another aspect of that cosmopolitanism—her awareness of her prospective readers' metropolitan morality—constrains her from revealing the full extent of D——'s "indecency." But she nonetheless manages not to portray herself as the passive victim that abolitionist ideology would ideally demand in its drive to locate the agency for change firmly in England (Sharpe 1996:40).

Prince's move to Antigua, which she actively solicited, led to several steps toward greater independence. There Prince began saving to buy her freedom, converted to Christianity, learned to read from Moravian missionaries, and married a free black man—initiatives to create safe affective and spiritual spaces. She left all this behind, however, for a chance at freedom. "I was willing to come to England," she emphasizes. She says (rather implausibly) that she thought the climate would help her rheumatism, and her husband had heard the Woods intended to free her. Both proved false (Prince 1997:86). Her owners worked her "without compassion" (Prince 1997:87), and when she spoke up, they threatened to turn her out of doors in a strange city: "I might go and try what freedom would do for me, and be d[amne]d," Wood snarls (Prince 1997:88). Eventually Prince "took courage" and left.

Her final journey (the last one we know of[24]) was short, but momentous: moving out of Wood's house and in with her friend Mash, the shoe-black, Prince openly transgresses the conceptual boundaries that had marked her owners' assumption of control over their slave. Their repeated threats to turn her out assume that her foreignness to London, as a black person, a slave, and a woman, would make it very difficult or impossible for her to survive there without their help. Indeed, without a character reference (or with the damning letter Wood had given her[25]), it would have been very difficult to find a job. There were between ten and twenty thousand black people in London at this time, but many if not most were destitute.[26] The Woods based their illusion of control over their slave on the assumption that slaves were "locals," not cosmopolitans like themselves—limited by only knowing their immediate colonial environment and threatened or immobilized by the strangeness of England. But Prince proves them wrong. She knows more and finds more resources than they had thought possible, garnering financial support, legal sponsorship, and eventually employment from missionaries and abolitionists, in addition to the initial solidarity of her white working-class friends, Mr. and Mrs. Mash. Her cosmopolitanism violates their expectations and transgresses the boundaries of their racialized map of the world. No wonder Mrs. Wood is "very much hurt and frightened when she found [Prince] was determined to go out" and tries to convince her that "if she goes the people will rob her, and

then turn her adrift" (Prince 1997:89). It is a final, futile effort to paint London as the hostile foreign territory that she wants Prince to experience.

Dictating her story for publication—sending it on its own journey around the British Isles via the institutions of the print marketplace—constitutes a further, scandalous transgression for the slave, as is evident in the reaction of the Scottish pro-slavery ideologue James Macqueen. His article in *Blackwood's Edinburgh Magazine*, entitled "The Colonial Empire of Great Britain," undertakes a detailed refutation of *The History of Mary Prince*, labeling her the "despicable tool" of "a set of mischievous moles" intent on "undermin[ing] our colonial empire" (Macqueen 1831:744). That Macqueen devotes a twenty-page attack to a slave woman's autobiography is a tribute to the political power he concedes to the abolitionist movement. In his cantankerous words (with original typography), "By tools like *Mary Prince* . . . PRINGLE, and the band of which Pringle is the tool and the organ, mislead and irritate this country, browbeat the Government, and trample upon, as they are permitted to trample upon, our most important transmarine possessions" (Macqueen 1831:752). The dire consequences Macqueen predicts if the abolitionists win include "the LOSS OF ONE HUNDRED AND FORTY MILLIONS STERLING of British capital and property, vested in and secured over these colonies" (Macqueen 1831:754) as well as "deep national humiliation and degradation" (Macqueen 1831:764).

Mary Prince's conclusion turns her cosmopolitan geographical awareness to the explicit support of the abolitionist cause. Addressing "good people in England" (Prince 1997:55), she delivers a personalized version of the moral geography of empire familiar in abolitionist rhetoric from the 1770s up until emancipation in 1833: "some people in this country say, that the slaves do not need better usage, and do not want to be free. They believe the foreign people, who deceive them, and say slaves are happy. I say, Not so. . . . I never heard a slave say so. I never heard a Buckra [white] man say so, till I heard tell of it in England" (Prince 1997:93–94). She had to cross the Atlantic—leaving behind a localized West Indian perspective for a broader cosmopolitan view—in order to learn the full extent of the deception that shields the colonists' bad behavior. "Since I have been here I have often wondered how English people can go out into the West Indies and act in such a beastly manner. But when they go to the West Indies, they forget God and all feeling of shame, I think, since they can see and do such things" (93). This division between good metropole and evil colony had been developed by such prominent abolitionist writers as Anthony Benezet (1788:69, 120), Thomas Clarkson (1788:86), William Wilberforce (1823:38, 41–42), and James Stephen (1824:180, 331). By backing it with her hard-won authority as slave and traveler, Prince lends it the weight of authenticity—a credibility obviously feared by pro-slavery activists like Macqueen.

But as she punctures the mystifications of one side of the debate over slavery, Prince leaves those of her own side intact. By presenting the colonies

as a wholly separate, degenerate world, abolitionist propaganda obscured the intimate links between worlds that were incommensurable, but nonetheless inextricable—joined by the constant transatlantic circulation of goods, ideas, and persons like herself. Her ironic predicament as she dictates her story, dependent on the political will of "good people in England" for the imperial legislation that would let her cross the Atlantic once more, underscores the colonial and global linkages whose violent history produced a subaltern cosmopolitan like Mary Prince.

NOTES

1. For ensuing debate on Williams, see Sokolow and Engerman 1987. On issues of displacement and diaspora, see Lavie and Swedenburg 1996, and Yaeger 1996; for a feminist perspective, see Kaplan and Grewal 1994.

2. Prince could legally leave her owners under the Mansfield precedent of 1772, which forbade forcible recapture of slaves on British soil or their transport back to the colonies against their will. This judgment has often been erroneously interpreted as meaning slaves were free on British soil, though its specifications were actually more limited. See Ferguson 1992:116–17.

3. See Long 1774:436.

4. See Ferguson 1992:281–98; Ferguson 1997; and Sharpe 1996.

5. The classic source for this shift is Clark 1992. Amy Erickson's introduction to the 1992 reissue of this 1920 study notes that although "Clark's description of the development from 'domestic' to 'family' to 'capitalistic' industry is still largely accepted today," historians now assign a later chronology. "Many of the issues that Clark allocated to the late seventeenth century . . . are related today to the eighteenth and early nineteenth centuries" (Clark 1992, ix–x). See Davidoff and Hall (1987:364–69) on voluntary separation between workshop and residential spaces. For speculations on the broader cross-cultural usefulness of the domestic-public division, see Rosaldo 1980.

6. Clark 1992:xv–xvii; Vickery 1993:401–412.

7. Hall 1992:106, qtd. in Vickery 1993:387.

8. Pollak 1985; Poovey 1984; Armstrong 1987.

9. Davidoff and Hall 1987:450–01; Johnson 1995.

10. Smail (1994) backs Davidoff and Hall (1987), while Hunt (1996) and Colley (1992:237–81) disagree.

11. Of course, historians of slavery have access to a rather different range of sources than do those of the nineteenth-century middle classes, since few slaves left behind testimony in their own words. The debate over the history of the slave family became politicized with attempts to blame present-day "black families, women members in particular, for African-American problems created by the dominant sector of society," notes Robertson (1996:12).

12. See e.g. Craton 1979; Gaspar 1985; Bush 1990; Higman 1984.

13. See e.g. the 1775 journal of the Scottish traveler Janet Schaw: "When one comes to be better acquainted with the Negroes, the horror of [whipping] must wear off. It is the suffering of the human mind that constitutes the greatest misery of punishment, but with them it is merely corporeal. As to the brutes it inflicts no wound on their mind, whose Natures seem made to bear it, and whose sufferings are not attended with shame or pain beyond the present moment" (Schaw 1934:127).

14. Darrel was a prominent citizen, soon to become mayor of Hamilton, and Ferguson speculates that Prince "might have surmised that her escape to Darrel's house would in some way intimidate Captain Ingham" (Ferguson 1992:7).

15. Craton 1979, Morrissey 1989, and Beckles 1989 believe such stable pairing was in fact fairly prevalent; Bush modifies their findings by cautioning, "The system of marriage and morality adhered to by slaves and the European proletariat differed considerably from that which prevailed amongst the middle and upper classes of eighteenth-century Europe" (Bush 1990:90).

16. Ferguson 1997:14; Sharpe 1996:45–46.

17. Ferguson 1997, passim.

18. Clifford notes, "I hang onto 'travel' as a term of cultural comparison, precisely because of its historical taintedness, its associations with gendered, racial bodies, class privilege, specific means of conveyance, beaten paths, agents, frontiers, documents, and the like. I prefer it to more apparently neutral and 'theoretical' terms, such as 'displacement,' which can make the drawing of equivalences across different historical experiences too easy" (Clifford 1997:36).

19. According to Paquet, "heart is an alternative to the material measure of the marketplace . . . a center of resistant subjectivity and interiority" (Paquet 1992:142).

20. Ferguson 1997:10–11; Ferguson 1992:286.

21. The BBC dramatization of this incident in *The Two Marys: Two Views of Slavery* imagines Prince menacingly putting the edge of a broken plate to her master's throat.

22. Sharpe cautions in relation to this incident, "As much as Prince's scolding of Mr. D —— shows a slave woman standing up to her master, one has to wonder whether morally upright speech could prevent a lashing from so ruthless a man. The episode has the *narrative* effect, however, of proving that a moral high ground can control the slaveholder's abuse of power. In doing so, it renders less morally upright forms of self-defense, such as verbal abuse or acts of insubordination, inappropriate as responses to slavery" (Sharpe 1996:42).

23. Ferguson contends that "Antigua was the most attractive island for any slave actively thinking of freedom. Free black men were permitted to vote there, and, although this law did not apply to Mary Prince, its relative liberality in the Caribbean islands was symbolically significant" (Ferguson 1997:12).

24. The last evidence of Mary Prince that Moira Ferguson has found in over a decade of searching is her testimony in the court case Pringle *vs* Cadell (Pringle is

suing the publisher of *Blackwood's* for libel over Macqueen's article) in February 1833. We do not know how long she lived or whether she returned to Antigua after Parliament voted to emancipate the slaves later that year.

25. Wood's letter reads, "I have already told Molly, and now give it her in writing, in order that there may be no misunderstanding on her part, that as I brought her from Antigua at her own request and entreaty, and that she is consequently now free, she is of course at liberty to take her baggage and go where she pleases. And, in consequence of her late conduct, she must do one of two things—either quit the house, or return to Antigua by the earliest opportunity, as she does not evince a disposition to make herself useful. As she is a stranger in London, I do not wish to turn her out, or would do so, as two female servants are sufficient for my establishment. If after this she does remain, it will be only during her good behavior; but on no consideration will I allow her wages or other remuneration for her services" (Prince 1997:96).

26. Fryer 1984:68.

BIBLIOGRAPHY

Armstrong, Nancy. 1987. *Desire and Domestic Fiction: A Political History of the Novel*. New York: Oxford University Press.

Beckles, Hilary M. 1989. *Natural Rebels: A Social History of Enslaved Black Women in Barbados*. New Brunswick: Rutgers University Press.

Behar, Ruth. 1995. Rage and Redemption: Reading the Life Story of a Mexican Marketing Woman. In Dennis Tedlock and Bruce Mannheim (eds.), *The Dialogic Emergence of Culture*. Urbana: University of Illinois Press.

Benezet, Anthony. 1788. *Some Historical Account of Guinea*. London.

Bush, Barbara. 1990. *Slave Women in Caribbean Society 1650–1838*. Bloomington: Indiana University Press.

Clark, Alice. 1992. *The Working Life of Women in the Seventeenth Century*. Ed. Amy Louise Erickson. London and New York: Routledge.

Clarkson, Thomas. 1788. *An Essay on the Slavery and Commerce of the Human Species, Particularly the African*. London.

Clifford, James. 1997. *Routes: Travel and Translation in the Late Twentieth Century*. Cambridge: Harvard University Press.

Colley, Linda. 1992. *Britons: Forging the Nation 1707–1837*. New Haven: Yale University Press.

Craton, Michael. 1979. Changing Patterns of Slave Families in the British West Indies. *Journal of Interdisciplinary History* 10:1–35.

Davidoff, Leonore, and Catherine Hall. 1987. *Family Fortunes: Men and Women of the English Middle Class, 1780–1850*. Chicago: University of Chicago Press.

Ferguson, Moira. 1992. *Subject to Others: British Women Writers and Colonial Slavery, 1670–1834*. New York and London: Routledge.

———. 1997. "Introduction." In Mary Prince, *The History of Mary Prince, A West Indian Slave, Related by Herself*, ed. Moira Ferguson. Revised edition. Ann Arbor: University of Michigan Press.

Fryer, Peter. 1984. *Staying Power: A History of Black People in Britain*. London: Pluto Press.

Gaspar, David Barry. 1985. *Bondmen and Rebels: A Study of Master-Slave Relations in Antigua With Implications for Colonial British America*. Baltimore: Johns Hopkins University Press.

Gwilliam, Tassie. 1998. "Scenes of Horror," Scenes of Sensibility: Sentimentality and Slavery in John Gabriel Stedman's *Narrative of a Five Years Expedition against the Revolted Negroes of Surinam*. ELH 65, no. 3 (Fall): 653–73.

Hall, Catherine. 1992. *White, Male, and Middle-Class: Explorations in Feminism and History*. New York: Routledge.

Higman, B. W. 1984. *Slave Populations of the British Caribbean 1807–1834*. Baltimore: Johns Hopkins University Press.

Hunt, Margaret. 1996. *The Middling Sort: Commerce, Gender, and the Family in Eighteenth-Century England*. Berkeley: University of California Press.

Johnson, Claudia. 1995. *Equivocal Beings: Politics, Gender, and Sentimentality in the 1790s*. Chicago: University of Chicago Press.

Kaplan, Caren, and Inderpal Grewal, eds. 1994. *Scattered Hegemonies: Postmodernity and Transnational Feminnist Practices*. Minneapolis: University of Minnesota Press.

Lavie, Smadar, and Ted Swedenburg, eds. 1996. *Displacement, Diaspora, and Geograpies of Identity*. Durham: Duke University Press.

Long, Edward. 1774. *History of Jamaica*. 3 vols. London.

Macqueen, James. 1831. The Colonial Empire of Great Britain. Letter to Earl Grey. *Blackwood's Edinburgh Magazine* 186 (Nov.):744–64.

Massey, Doreen. 1994. *Space, Place, and Gender*. Minneapolis: University of Minnesota Press.

Midgley, Clare. 1992. *Women Against Slavery: The British Campaigns, 1780–1870*. London: Routledge.

Morrissey, Marietta. 1989. *Slave Women in the New World: Gender Stratification in the Caribbean*. Lawrence: University Press of Kansas.

Paquet, Sandra Pouchet. 1992. The Heartbeat of a West Indian Slave: The History of Mary Prince. *African American Review* 26(1):131–46.

Paton, Diana. 1996. Decency, Dependency, and the Lash: Gender and the British Debate Over Slave Emancipation, 1830–1834. *Slavery and Abolition* 17:163–84.

Patterson, Orlando. 1982. *Slavery and Social Death: A Comparative Study*. Cambridge and London: Harvard University Press.

Pollak, Ellen. 1985. *The Poetics of Sexual Myth*. Chicago: University of Chicago Press.

Poovey, Mary. 1984. *The Proper Lady and the Woman Writer: Ideology as Style in the Works of Mary Wollstonecraft, Mary Shelley, and Jane Austen*. Chicago: University of Chicago Press.

Prince, Mary. 1997. *The History of Mary Prince, A West Indian Slave, Related by Herself*. Ed. Moira Ferguson. Revised edition. Ann Arbor: University of Michigan Press.

Robertson, Clare. 1996. Africa into the Americas? Slavery and Women, the Family, and the Gender Division of Labor. In David Barry Gaspar and Darlene Clark Hine (eds.), *More Than Chattel: Black Women and Slavery in the Americas*. Bloomington: Indiana University Press.

Rosaldo, Michelle Zimbalist. 1980. "The Use and Abuse of Anthropology: Reflections on Feminism and Cross-Cultural Understanding." *Signs* 5:389–417.

Schaw, Janet. 1934. *Journal of a Lady of Quality: Being the Narrative of a Journey from Scotland to the West Indies, North Carolina, and Portugal, in the years 1774 to 1776*. Edited by Evangeline Walker Andrews and Charles Maclean Andrews. Second edition. New Haven: Yale University Press.

Sharpe, Jenny. 1996. "Something Akin to Freedom": The Case of Mary Prince. *differences: A Journal of Feminist Cultural Studies* 8(1):31–56.

Smail, John. 1994. *The Origins of Middle-Class Culture: Halifax, Yorkshire, 1660–1780*. Ithaca: Cornell University Press.

Sokolow, Barbara L., and Stanley L. Engerman, eds. 1987. *British Capitalism and Caribbean Slavery: The Legacy of Eric Williams*. New York: Cambridge University Press.

Spivak, Gayatri Chakravorty. 1988. Can the Subaltern Speak? In Cary Nelson and Lawrence Grossberg (eds.), *Marxism and the Interpretation of Culture*. Urbana: University of Illinolis Press.

Stephen, James. 1824. *The Slavery of the British West India Colonies Delineated*. Vol. 1. London.

Vickery, Amanda. 1993. "Golden Age to Separate Spheres? A Review of the Categories and Chronology of English Women's History." *Historical Journal* 36: 383–414.

Wilberforce, William. 1823. *An Appeal to the Religion, Justice, and Humanity of the Inhabitants of the British Empire, in Behalf of the Negro Slaves of the West Indies*. London.

Williams, Eric. 1994. *Capitalism and Slavery*. Chapel Hill: University of North Carolina Press.

Yeager, Patricia, ed. 1996. *The Geography of Identity*. Ann Arbor: University of Michigan Press.

My Shafiqa

Concerning the Travels and Transgressions of a Southern Egyptian Woman

KATHERINE E. ZIRBEL

Women have their own histories of labor migration, pilgrimage, emigration, exploration, tourism, and even military travel— histories with and distinct from those of men. . . . [S]pecific histories of freedom and danger in movement need to be articulated along gender lines.
—James Clifford, *Routes: Travel and Translation in the Late Twentieth Century*, 1997:6

THE SOUTHERN EGYPTIAN folktale *Shafiqa and Mitwalli* is the story of an honor killing. The story begins when Mitwalli, son of a southern villager and a fast-rising star in the army, cuffs an enlisted man for repeated insubordination. The enlisted man retaliates by revealing to Mitwalli that he has been consorting with Mitwalli's sister Shafiqa. Appalled, Mitwalli returns to his village to find out the truth about his sister. His elderly father first tells Mitwalli that Shafiqa has died while Mitwalli has been in the army, but then admits that she ran off from the village and that he does not know where she went. Mitwalli travels north to the southern capital of Assiut, where he finds his sister Shafiqa, who is indeed consorting with men. He kills her and is vindicated by his commanding officer for doing the right thing. In dispensing with such immorality, as only he could, being Shafiqa's only able male

71

relative, Mitwalli has thus restored honor to both his family and the army. Shafiqa's reasonings remain forever unknown and the men with whom she consorted are not held accountable.

Can there be honor *and* freedom? *Shafiqa and Mitwalli* suggests that the road to women's increasing autonomy is paved by their fallen honor and serves as a warning about the fate of women who, left uncontrolled, escape to the city. If understood as a true reflection of southern Egyptian life, the story confirms northern, modernist Egyptian stereotypes about oppressed southern women, as well as similarly constructed Western stereotypes about oppressed Middle Eastern women. Indeed, among working- and craft-class families in the southern Egyptian town of Luxor, women's behavior in public reflects directly on family honor, and men *claim* absolute authority over the activities of the women in their family outside the home. These claims are explicitly counterpoised to negative stereotypes that southerners hold about the honor and activities of northern Cairene women.

Every time I took the train from Luxor north to Cairo, the father and brother of my twenty-two-year-old friend ʿAziza warned me to avoid contact with men, reminding me that there was no such thing as friendship between women and men in Egypt.[1] After almost two years of research, I operationally believed this ideology, despite all sorts of evidence to the contrary. Thus when ʿAziza was to begin a two-month operator's course in Assiut and her family asked me to escort her to the women's dormitory there, on my way to Cairo, I took my duty very seriously. So how should I explain that on her first day ever away from home, ʿAziza ignored her father's exhortations to act honorably and, abandoning the women's dormitory in Assiut where I had left her that morning, took the train to Cairo, the capital, where she'd never been? In part, it turned out that her short course had been delayed for a month. But notice that she did not immediately return home. What informed her flight north and how might this speak to current regional discourses concerning women's decision-making, autonomy, and travel in Egypt?

ʿAziza's story provides a view into some of the ways in which women from craft- and working-class backgrounds in Upper Egypt understand the relationships between freedom, honor, home, and travel. In this paper, I suggest, first, that ʿAziza's behaviors selectively drew from at least two salient, if contrary, narratives about women from the rural south who travel north to urban centers. Secondly, her activities in relation to these narrative and geographical loci reveals a gendered split in how women's honor is understood. Finally, in confluence with other narratives, her story traces a critical dimension of the cultural dialectic between the north and the south, the dynamics of which play into the current debates over national identity and Egypt's political future.

The night that ʿAziza arrived in Cairo, I saw that my adventures in protecting someone else's honor had just begun. ʿAziza called me from the train

station and when I went to pick her up, I saw that she had arrived with a young man—Ahmed—whom she had met on the train. When she introduced him and saw my reaction, she tried to back-pedal, telling me he had family in Luxor and they were therefore nearly related. I pointedly told him good-bye. In view of her southern upbringing, I was amazed at her audacity to jump on a train alone, strike up a friendship with a fellow, and come to Cairo. As we made a circuitous route to my neighborhood in order to lose Ahmed's cab, which tried to follow us, I found myself lecturing her, much like her father had lectured me about interacting with unrelated men. At the time, suddenly pressed into the position of the hegemon, I thought I saw precisely where the road to women's increasing autonomy merged with debauchery. I wondered how her unexpected appearance might reflect on my position in my working-class neighborhood, whose residents would surely take a dim view of her adventures. But more, having believed literally in the gender ideology espoused by southerners, I was nearly certain that her father and brothers would kill one or both of us if they ever found out.

NORTH AND SOUTH

So can there be honor and freedom for women in Egypt? This question, recurrently addressed within Egyptian folklore and national politics since before the turn of the last century, has more recently come under renewed scrutiny in association with the national debates over Egypt's cultural and political future. In the mid-1990s, such debates had moved far beyond just talk to armed conflict between the southern-based Islamic nationalist movement and Cairo's (relatively) secular government. Understandings of regional character and values are influenced by regional performances and performance genres, circulated via mass media and government representations of folk and popular culture. Such images cast Egypt's rural and southern peripheries as premodern within Cairene discourses on modernity, while by southern Egyptian standards, images from Cairene performance genres suggest untempered freedom and immorality (Zirbel 2000: 130, 132). Such stereotypes, both romanticized and antagonistic, influence the way home, travel, and destination are interpreted in relation to gender. This becomes clear when looking at the historical Cairene narrative counterpart to Shafiqa and Mitwalli.

According to Cairene folk myth, women who migrate to the city alone are usually from rural or small-town backgrounds—of course everyplace in Egypt is dwarfed by Cairo—often escaping backward and/or abusive circumstances. Such women arrive, work hard, overcome their backward upbringing and the pitfalls that lie in wait for single women, and through fortitude and talent, they achieve fame and success. This liberatory narrative, valorizing hard-won freedoms and pathologizing the hinterlands, structures the accounts in film and TV and in oral and written histories, of

famous and fictional women who have migrated from obscurity to Cairo since before the turn of the last century.[2]

Miriam al-Musriyya, founder of the first all-Egyptian circus in 1887, is an early and remarkable case in point. Miriam, whose real name was Almuth, came from a southern Fayyoumi bedouin tribe. Within Cairene modernist discourses, if the peripheries are premodern, bedouins are beyond the pale. They figure as mystical, romanticized peoples, somewhat comparable to Romany in the European collective imaginary. Miriam the bedouin came with her young son to Cairo, running away from an unhappy marriage to a much older man. On arriving, she cut her hair, joined a Turkish circus as an equestrian, as she had grown up with horses, and gave herself the Christian name Miriam. At some point, in a further move of reidentification, she appropriated the surname al-Musriyya, meaning both Cairene and Egyptian. When her husband searched her out in Cairo, either to bring her home or to kill her for the dishonor that she caused him, a fan of hers came to her rescue and vanquished her bedouin husband. A year later Miriam, along with this same fan, who now became her second husband, founded the "First All-Egyptian Circus." Miriam eventually gave birth to yet another circus, two more families of performers and a circus school, proving to be a performer-teacher-business woman of epic proportions. She was not alone; this narrative of women overcoming the odds on the way to success has continued to frame the stories of famous women performers throughout the twentieth century and into the present.[3]

Several mid-century films likewise reiterate the theme of the poor woman from the peripheries, rising to fame in the city through a combination of self-determination, chutzpah, and talent. One of the most prominent actresses who starred in such roles was Naʿima ʿAkef, the granddaughter of Miriam al-Musriyya. Her works recurrently took up variations on this narrative of rural women surmounting the odds in the city, suggesting its continued salience for both Naʿima and her audiences.[4] These mid-century films are rerun frequently on TV, although some of the racier parts appear to have been deleted in these more conservative times.

My friend ʿAziza arrived in Cairo with twenty-two years worth of mass-mediated notions and glamorous images of Cairene life from such films and TV night dramas. One of the primary figures in her imagined life was the same Naʿima ʿAkef, whom ʿAziza felt she resembled. I first saw a TV rerun of the film Tamar Hinna (Henna Flower), starring Naʿima ʿAkef in perhaps her most famous role, one hot afternoon with ʿAziza and her sister in the family compound, a walled-off farmyard wedged between buildings in the middle of Luxor. ʿAziza asked me if I didn't think she looked like Naʿima ʿAkef. To this, her sister retorted that she didn't know henna flowers came in black, as ʿAziza had dark skin, unlike Naʿima ʿAkef. Nevertheless, ʿAziza did resemble the star, both in looks and in her sparkling mischievousness, which was also one of Naʿima ʿAkef's hallmarks.

Through her mass-mediated understandings, perhaps enhanced by her identification with the famed Cairene star of the more liberal past, ᶜAziza had often told me how she "knew" Cairo and successful Cairene women's ways, although she had never been to the city. For ᶜAziza, the city seemed to represent uncompromised freedoms. And while I was not Egyptian, her observations of my own apparent freedom in traveling to and from Cairo made me approximate living proof of the possibilities offered to Cairene women. Her own impulse to travel to Cairo was linked to tasting such freedom, which she initially seemed to interpret through the idioms of heterosexual desire (via Ahmad) and unfettered movement. Both kinds of freedoms directly opposed her father's exhortations and the patriarchal anxieties that underlie the southern tale of *Shafiqa and Mitwalli*, a tale which she knew well. However, she soon jettisoned these initial preoccupations and became interested in exercising her freedom in new ways that more closely reflected the autonomy that she observed in Cairene women. But before I discuss what ᶜAziza did, note that while the southern folktale suggests that the cities (but also women) are inherently problematic, debauched, and in need of control, the Cairene myth suggests that the rural south is culturally backward and harmful *to* women. Thus, from the southern view, such traveling women should be condemned, while from the Cairene view, these same women are valorized. What are we to make of the gap created between these two narratives? What other narratives might intercede to make a way for women's experiences? I first explore these questions by recalling how a Cairene government-supported production tried to bridge this narrative gap in the south. I then examine how this relates to gendered difference in craft- and working-class conceptualizations of honor.

MODERNIST REINTERPRETATIONS

I first heard of *Shafiqa and Mitwalli* when I was conducting research in Luxor and a government-sponsored troupe from Cairo came to perform a new rendition of the old southern tale. I went with a group of middle-class Coptic Christian men, who were always trying to instruct me about "culture that counted." This meant government-promoted events for these Copts whose rights and security, as members of a religious minority, depended upon support from the relatively secular government.[5] I'd initially met this group of men when I stayed in their small hotel during my first trips to the south. They had witnessed some of my *mizmar* (southern Egyptian oboe) lessons, held in their parlor with my teacher. They were patronizingly amused at my attempts to learn about folkloric music, which they considered old-fashioned and backwards, despite my teacher's world-beat fame.

I hadn't heard of *Shafiqa and Mitwalli* before, so at the musicians' café I asked my teacher and some of his elderly village friends about the story. The

café owner's fourteen-year-old son, who was working in the café, sponta-
neously began telling a versified clapping chant of the story. He could not
remember all the verses, but he and several others there ended up narrating
the story of the honor killing to me.

My Coptic friends had told me that the play was to be based on a folk-
loric story from long ago. In part, this was true, but they had implied that the
story was no longer in circulation. However, as I had noticed before, Egyp-
tians I knew who counted themselves as modern tended to historicize those
things that they perceived as "traditional," as if their modernity was all-per-
vasive, despite its sporadic, often unconvincing, and puffed-up appearance to
those outside its fold. The social gulf between these modernist middle-class
Coptic men and the apparently premodern, unlettered café crowd of the
peasant *zumarin* (*mizmar* players) was easily maintained. No one from the
café would have considered going to a theater production put on by the gov-
ernment. To them, such activities were as irrelevant as their own village gen-
res and performances were to Luxor's Coptic middle class. To a certain extent,
the relationship between middle-class Luxorites and the peripheral peasant
villagers resembled the oppositionally formed stereotypes that were
exchanged between Cairo and its southern peripheries. Thus, as I will elabo-
rate presently, the play's modernizing aspirations were in vain, since no one
from the "nonmodern" camp would go to its Luxor production.

Suffice it to say that in this modern version, the plot was turned around,
showing that the sister Shafiqa was not a prostitute, but worked an honest job
in order to increase the honor of her impoverished family. Thus, when her
brother Mitwalli, bearer of the old ways, comes to reap justice, he is the one
who dies in a struggle between these two conceptualizations of honor.

Here I wish to briefly spell out the dynamics of the play and then I will
return to its social context. This play, in its new form, was at once redemp-
tive and quintessentially tragic in the Aristotelian sense, wherein the discov-
ery of unexpected information was causally linked to what Aristotle called
peripetea, a sudden change of fate, at several levels. First, within the play, in
the climax's rapid sequence of events, Shafiqa discovers that the would-be
assailant is her brother Mitwalli, just as her clients are murdering him. Sec-
ondly, the truth of Shafiqa's honor is revealed to Mitwalli even as he lies
dying in her arms, representing the dying of the old ways. Third, audience
members familiar with the old folkloric version discover that the old moral
about the fate of uncontrolled women has been displaced with an entirely dif-
ferent, modernist view of women, who are redeemed as productive, indepen-
dent, and honorable actors in the world. But to enjoy this modernist discov-
ery, the audience must agree, at least in the moment, that it is possible for
some women to gain independence and freedom without dishonor. And pre-
vious to any of this, they must agree to participate as audiences to this spec-
tacle. In part, the thrill of discovery for this audience might well have been

the recognition of an anticipated denouement that affirmed the pro-government modernist vision because even if the precise narrative twist was not known in advance, no modernist agenda would leave Shafiqa to her previous folkloric fate.

Although the turn of events at the end of the play was new, the revisionist impulses were not entirely without precedent, as the story had previously been "entextualized" (Bauman and Briggs 1990:72–78), that is, excerpted and reset in a 1978 film, in order to signify new meanings. In this anticolonialist version, set in the late nineteenth century, both the Ottoman rulers and their European overlords are vilified. Here Shafiqa's fall from grace is precipitated by the Ottoman government's forcible enlistment of her brother Mitwalli—a common practice at the time—into the army in order to help in the building of the Suez Canal. Like in the original, Shafiqa, unprotected by her brother, falls into prostitution, working her way "up," in parallel to Mitwalli's own rise in the army, until she is prostituting primarily to foreign elite—thus symbolizing Egypt's own compromised position in the nineteenth century. As in the older folkloric version, she dies at the end.[6]

The film version did the job of shaping a particular anti-imperialist national history at a time in 1978 when nationalist sentiment was flagging. However, while that version placed ultimate blame on evil foreign colonialists, the gendered moral of the original folkloric story did not fundamentally change. The idea that, unprotected, Shafiqa would be inexorably drawn to dissolute living and exhibit no independent moral agency of her own remained unquestioned.

Returning to the new government-sponsored production in Luxor, this interpretation with its modernist agenda challenged two deeply held conservative beliefs concerning women, which Cairenes tend to associate with the south. The first is that women, unguided or far from home, will come to dishonor; and, secondly, that women are rarely able to move productively in the world on their own. Here it is important to distinguish the difference between Cairene and southern portrayals of each other—which is understandably in opposition to their idealized selves—and between the stances northeners and southerners actually take on issues. Amongst both my northern and southern Egyptian acquaintances, I found that concerns about women's autonomy varied more by class and gender than by region. However, even for those who aspired to middle-class modernity, the idea of a woman leaving home and traveling to live alone in a distant city, unprotected by family, remained a dubious notion. Thus, women who go away to college live under strict supervision in women's dormitories.

The government-sponsored production in Luxor attempted to open up a narrative space for reinterpreting women's honor. Notably, the chosen topic of honor killings is stereotypically associated with rural southern ignorance. This focus on southern honor and "oppressed women" as a point of difference

between premodern and modern likewise locates the play's goals not far from previous scholarly and orientalizing discourses, which recurrently elaborated stereotypes and "central zones of theorizing" about the Middle East and North Africa (Abu-Lughod 1989:279–80). The difference is that here the discourse about oppressed women is taken up by Cairene modernists and transposed onto a geographical and cultural margin within Egypt. Likewise, true to orientalist form, entextualized now within the frame of national agenda, the Luxor production appeared to represent another of the government's long-standing attempts to colonize and pacify what has historically been framed as the unendingly primitive, premodern south, through the south's own cultural material. This multiply articulated differentiation between Cairo and the south manifests right up into present-day policies and discourses about the southern-based Islamic nationalists, who were framed in Cairene discourses as irrational throwbacks.

While, to my knowledge, the play didn't reach the southern villages where honor killings still are occasionally perpetrated, even my pro-government middle-class Coptic male friends, who aptly interpreted and approved of the play, viewed actual women who traveled with suspicion. It seemed that while these men could accept the idea of women's autonomy and travel under the imagined auspices of a government-sponsored play, such notions were not fully applicable or defensible for the women in their community. Thus, while they lauded the play's revisionist message, the practical consequences could only apply to a mythically modern "other"—Cairene women. Among these men, while women in their community might be modern in the sense of education and employment outside the home, only men could honorably maintain a truly modern identity in the sense of unfettered movement and autonomous living. It was in contrast to such distantly imagined "other" Cairene women, however, that southern men could describe the more honorable, if limited, modernity of their own women.

It is no surprise when purported ideology and practices fail to match up, but what is interesting is the differences of interpretative practice between north and south, men and women. I now return to my friend ʿAziza. She operated within the gaps created by these gendered and regional discrepancies, making use of the contrasting narratives surrounding southern views of family honor and opposing ideas, which she imagined Cairo to embody.

SHAFIQA IN THE CITY

ʿAziza spent almost a week in Cairo, incessantly exploring markets and neighborhoods.[7] Every night we stayed up late talking about what she had seen. She found it exhilarating to be in the city she had heard about all of her life. She was amazed at what she perceived to be unbridled freedoms that Cairene women exercised in their daily lives. However, within the week, she came to

speak about Cairene women and gender relations differently. ʿAziza effectively reinterpreted the Cairene and southern narratives, arriving at a newly merged and more workable understanding both of home and of how women may successfully move in the world.

ʿAziza was fascinated with the used clothing market not too far from Hilmiyya, where I was living at the time. She had previously worked in Luxor's market for inexpensive and used clothing, where she delivered shirts from her uncle's shop and was allowed to keep the difference between her uncle's cost and whatever price she could get from retailers. Now she ventured that she could make a profit buying in Cairo and selling in Luxor. She enjoyed haggling with dealers and came away, day after day, with armloads of wrinkled clothes. She seemed to be on a spree. Along the way, she came to a new understanding of how Cairene women operated in public space. By participating herself, she came to see their freedom in public as simply necessary to city life. Moreover, she found that many of these secondhand clothing dealers, which included both men and women, were either from the south or claimed southern roots. Their values and sense of humor were familiar to her. Thus ʿAziza concluded that Cairo had been taken over by southerners who only *appeared* to become Cairenes, whilst actually holding true to their southern ways of high morality, hospitality, and homosocial friendships. So, even as her chosen activities reflected a shift from the southern Shafiqa to the Cairene success-story narrative, ʿAziza was busy simultaneously reconstructing a sense of the familiar, and broadening her definition of home and southern identity.

But still the question remains—how could ʿAziza dismiss so quickly the promises that she made to her father about upholding family honor all within that short twenty-four-hour span? ʿAziza's ensuing actions and gradual redefinition of honorable behavior calls for a reexamination of what home and honor mean to young southern women.

By the end of the week, ʿAziza claimed homesickness for Luxor, her mother, and her sisters, and she took the train back to Luxor. She brought with her two burlap sacks stuffed full of bargains from the used clothing market. When she returned home, ʿAziza told all the women in the family, including her mother and aunt, of her adventures (she brought them blue souvenir good-luck beads from the famed Cairene mosque of Hussayn). The women were very envious of her daring and collaborated in not letting the men in the family know. While ʿAziza was unusually audacious, her actions and her female relatives' collusion were consistent with other subterfuges and strategies concerning honor that I had witnessed before among craft- and working-class women in both Luxor and Cairo, especially surrounding the freedom to move outside the home and to pursue courtship. Such covert activities, and the collusions and narratives that surreptitiously supported them, suggested a striking gender difference in the understanding of women's honor. This first came to my attention in taking part in one of ʿAziza's earlier schemes.

UMM JABR APPROPRIATING THE *HILALIYYA* EPIC

ᶜAziza's grandfather was an epic poet (this performance link was how I origi-
nally came to know her family) and her aunt Umm Jabr would occasionally
burst out with epic fragments to make her points. One evening in Luxor,
while returning home far after ᶜAziza's curfew, ᶜAziza and I were pestered by
some young men on the street. When ᶜAziza returned home, in order to draw
attention away from her lateness, she exaggerated the incident, saying the
boys had made me cry. The decoy seemed to work: when I visited the next
morning, I found her whole family suddenly concerned for me, much to my
bewilderment, and there were no signs of ᶜAziza being grounded by her father
for her late return. It was a bit later that morning when Umm Jabr took it
upon herself to sing to me from the quintessentially masculine *Hilaliyya* epic,
ostensibly to cheer me up from the incident of the night before. She sang
about an abducted princess and how the epic's heroes managed to rescue her
from her captors and return her to her father.

As Umm Jabr told the epic tale, she shifted between narratively explain-
ing the story and singing parts of it. She danced with her old but mobile body,
framed by her open black, torn shawl, flashing me wild grins, a conspiratorial
wink here, a little jab there, as she told the story. The art of the epic poet is
to insert social or political commentary about their audiences, through word-
play such as allusions and puns. While the epic told of restoring family honor
by reasserting the king's authority over his daughter, Umm Jabr, throughout
her spirited telling, seemed to suggest that the princess was not altogether
happy about returning to the safety of her father's castle. Umm Jabr thus
obliquely teased ᶜAziza, whom she appeared to associate with the princess,
suggesting that she, for one, had not fully bought ᶜAziza's story from the
evening before.[8]

I must note here that one of Umm Jabr and ᶜAziza's mother's favorite
pastimes was fantasizing about running off with the children—but not the
men—to Cairo and Port Said, on the north coast, to see the sights. ᶜAziza
must have heard such plans perhaps hundreds of times, although neither
her aunt nor her mother actually traveled much further than the market,
two blocks from the family compound. However, these imagined travels,
supplemented by narratives and vistas provided by TV, filled their days of
chores in the compound with a continuing sense of adventure. Umm Jabr's
playful epic rendering was consistent with her support of the family daugh-
ters' efforts at obtaining more freedom than she herself had. She prodded
them to pursue legitimated goals, including higher education, yet she also
relished the relatively innocent subterfuges by which everyday freedoms
were wrested secretly from under the nose of the unwitting family men,
such as slipping off to celebrations or visiting friends. In this context, Umm
Jabr's subversion of the epic may be read as her own liberatory commentary.

So if she didn't believe ʿAziza's story from the night before, her double-valenced epic singing functioned both to cheer me up and, to a degree, cheer on our shenanigans.

COURTSHIP PRACTICES

The gendered difference in narratives and practices concerning honor arises again in courtship. While many working- and craft-class couples whom I knew in both Luxor and Cairo first met through family or neighborhood connections, thus had legitimate reasons for at least minimal interactions, many such young people in both Luxor and Cairo commonly contemplate and share fantasies about prospective spouses from outside these networks, based on relatively scant personal interaction.[9] There is no honorable equivalent to dating and both men and women assert publicly that Egyptians do not have heterosexual friendships. However, in practice, prospective fiancés often expect to meet with women secretly at least a few times in advance of any formal negotiations. While women say such meetings make them apprehensive, as it constitutes a transgression of honor for them (but not for men), a promising marriage can mean the road to greater happiness or at least opportunities, so they feel that they must avail themselves to such meetings, and they usually bring a sister or woman friend as a self-designated chaperone. Most of the married couples I knew well had managed to meet secretly to talk, make decisions about marriage, and even go on short outings together, usually with the collaboration of a confidante or two, well before the man and his family went to inquire about a woman's hand. Such women assured me that if their fathers or brothers knew, they would never be let out of the house again, or worse, might be married off quickly to an elderly uncle (although the latter option seemed more of a rhetorical trope for the worst imaginable, but most unlikely, case). However, often a woman's sisters were aware, to a degree, of such interests. This is not to say that sisters and friends were fully willing in their collaborations. Facilitating or even knowing about such adventures invoked litanies of admonishments from friends and sisters, even as they helped. Nevertheless, in almost all the cases I knew of (seven directly, several more indirectly), women and their suitors, with the help of friends or sisters, secretly overstepped both their father's prerogative of control and family honor through such outings before becoming engaged.

The gender ideology emerging from these courtship practices forms around a basic contradiction whereby women often must transgress the hegemonic notions of honor and their father's authority in order to leave their natal home for what they view as better prospects. Note that the same men who participate in, but are not held accountable for, such secret rendezvous, tend to maintain an absolute notion of honor in relation to women in their family. In contrast, for women, it tends to be the *image* rather than

the practices of respectability, in public and for the male members of their family, that must remain unassailable.

In 1984, Uni Wikan (1984:637–38) pointed out that contrary to previous circa-Mediterranean scholarship, pairing honor with shame is not necessarily an accurate way to think about these two terms. She notes that among those she calls "the poor" in Cairo, there are no common terms for honor, but plenty for shame in local working-class Cairene discourse. This remains true, yet over the last two decades' intensification of the religious conservative movement, it appears that the idiom of piety has come more and more to stand in as a kind of approximation of honor. While this movement is concerned not just with participation, but with individual internalization of religiosity, it has ironically found its greatest social influence on the external image and behaviors of women in public. Many women feel they gain freedom by donning veils and pious clothing, but at the same time, perhaps in recognition of the difference between participation and internalization, the idea that public displays of piety may mask dishonorable thoughts and activities often serves to intensify the surveillance of women.[10]

The resulting tensions may likewise inform many men and women's ongoing interpretations of each others' behaviors, whereby men become wardens to be circumvented, and women are rendered suspect in the eyes of their husbands. This may ultimately limit women's freedom and reinforce the precedent for male control because as long as men are seen as the protectors of honor and the degree to which they thereby hold sway over the sexuality and labor of women in their family, women's strategies to secretly subvert the restrictions on their freedom can only push so far.

Significantly, these beliefs once again emerge in the pejorative gendering of stereotypes traded between north and south, whereby especially southern men feminize Cairo and what they view as Cairene dissolute and duplicitious living, while Cairenes imagine southerners as primitive, hot-headed men. The latter stereotype has contributed to the government's historical neglect and political exclusion of the south and of southerners as inconsequential. In turn, southerners' marginalization, paired with their moral distrust of Cairene culture and the government, has fueled southern support for Islamists. Drawing on this long-standing north-south dialectic, the government has tended to depict most Islamists as hotheaded, male terrorists whose understanding is limited, disregarding the modernist messages as well as the roles that women play in this movement. To ignore the north-south dialectic and its gendered nuancing is to misapprehend a central historical and cultural dynamic that has contributed to Egypt's current ideological and political conflict.

RETURNING SHAFIQA

Madan Sarup (1994:98) has noted, in discussing migrants, that "identity is changed by the journey; our subjectivity is recomposed." ⁽Aziza seemed to

undergo such a transformation. She initially articulated this most clearly in her understanding of how her prospects were gendered when she returned home after Cairo, the Mecca of enterprising, or in other stories, debauched, women. First off, she cut her hair short, similar to quasi-mythical Miriam al-Musriyya from the 1880s. It was a highly symbolic act. While ʿAziza and her sisters veiled, Egyptians tend to view long hair as a symbol of femininity. ʿAziza explained this act by saying that her hair took too much time to manage and she didn't care about her hair or getting married anymore—and it was clear that the two were somehow linked in her mind—to which her sisters jeered that she was more like a boy anyway.

At home, while still under the scrutiny of the men in her family, she seemed empowered by her adventure, of which her father continued to know nothing.[11] Having secretly consorted with city life, she seemed to find pleasure in knowing that the actual and cultural distance between Luxor and Cairo could be traversed without necessarily reaping negative consequences. Meanwhile, in discussions between ʿAziza, her sisters, and myself, the narratives about ʿAziza's travels were remembered, imagined, and embroidered into new plans. Small freedoms continued to be snatched in stealth as they had been in the past, usually on pretexts of trumped-up errands. However, while she still found excuses to escape the family compound and socialize with friends, she began spending more of her time actively trading in the used clothing market in Luxor. ʿAziza told me that her travels made her realize that she could never live anywhere else but Luxor because she was ultimately too emotionally attached to it to leave permanently. She felt that her travels made her family and Luxor all the sweeter—and conditional—for her, knowing that, if she wanted (and found the opportunity to get there), she could plausibly make her way in the city.[12] And she did. When ʿAziza returned to Assiut for her short course, she became bolder and took several whirlwind trips up to Cairo, apparently becoming more discriminating in her used clothes bargaining and turning an occasional profit.

IN CONCLUSION

In this paper, I have suggested how ʿAziza's understanding of women's personal freedom and honor drew on the two public, if contrary, narratives about women from the south who leave home and travel north to urban centers. Together, these contrary narratives provide a view into how the south and the north construct each other, whereby the south sees Cairo as a feminized spectacle of debauchery and uncontrolled power, while the north views the south through the idiom of harmful premodern masculinity—hence the attempted modernist mediation through the revisionist production of Shafiqa and Mitwalli. Such regional understandings, in turn, provide a gendered cultural lens by which we might better understand the historical and cultural context for the current political debates over Egypt's future as they circulate

between the north and the south. Thus, while many southerners regard any Cairene intervention in the south as an attempt to further attenuate their freedoms, the Cairene-based government continues to view all things southern as terminally premodern, and thus do not recognize any modern, progressive or democratizing impulses that emerge from the south. This makes it easy to discredit any modernist or democratic elements within the southern-based Islamist movement.

ʿAziza's ability to move between these two narrative and geographical loci in her own gambit for travel and freedom was facilitated by the interpretive gap in acceptable practices concerning honor and freedom, which I found varied far more uniformly between men and women from craft- and working-class backgrounds than it did between regions, contrary to interregional characterizations. Thus, while men espouse the importance of women's actual, practiced honor, women tend to focus more on maintaining an honorable image, even as they may regularly and covertly transgress hegemonic notions of honor, always under threat of repercussion from the men in their family, in order to gain personal freedom and enhance their opportunities.

So can there be honor and freedom? ʿAziza's story invites a view into the juxtapositions of narratives and practices by which southern Egyptian working- and craft-class women understand freedom, honor, home, and travel. Unlike the reified folkloric stories of women who travel or the archetypal narratives of progress and emancipation—all of which have definite destinations—in the real lives of such women, honor and freedom unfold in a dialectic process between home and travel, covert narratives and practices, and valorized male-dominated ideologies. And it is in the gaps between these apparent incommensurates, and through the narratives that bridge them, that women find emergent possibilities.

NOTES

This chapter has benefited from the help of the following people, to whom I am most grateful. Walter Armbrust first alerted me to the recurrent Cairene narrative of successful women performers. Fatma ʿAkef, a successful performer in her own right, kindly shared with me family stories about her legendary grandmother, Miriam al-Musriyya, and her equally famous sister, Naʿima ʿAkef. Deborah Jackson, Jane Goodman, and Rosario Montoya each generously provided me with commentary at critical junctures of successive drafts. Finally, both Bilinda Straight and Robert Shapiro provided me with unstinting encouragement and helpful criticisms througout the development of this chapter. The initial field work for this chapter was conducted from 1994 to 1995, with financial support from a Fulbright-Hayes Doctoral Dissertation fellowship and a Hewlitt Foundation International Dissertation Award.'

1. Fedwa Malti-Douglas (1991:15, 110) speaks to the phenomenon of homosociality paired with heterosexuality. She is concerned with men and literature, but this

applies equally to women. Most women I knew had one very close woman friend and tended to become very jealous if their best friend had any other close women friends.

2. To some extent, the distance gained by the passing years immunizes such past women and old films from political and moral scrutiny in the context of Egypt's present-day increasing moral conservatism.

3. In addition to Mariam al-Musriyya, whom I discuss below, others whose biographies follow this narrative include Taha Karioka, perhaps Egypt's most famous dancer in the past, singers Soheir Sukariyya, Umm Kalthum (who used her rural upbringing much to her advantage), and more recently, Egypt's number-one dancer Fifi Abdou, along with dozens of lesser-known women performers.

4. The 1958 film Ahibbak ya Hasan (I love you, Hasan), in which Naʿima starred, is emblematic of this genre, as it follows the rise of one such woman in a kind of "star is born" narrative. I am indebted to Walter Armbrust for having first alerted me to this film.

5. I would not normally go anywhere with a group of men precisely because of issues of honor. However, ʿAziza was not allowed out of her family's compound that late in the evening, and my other women friends had children and husbands to attend to. So, since the play was a very public, government-sponsored event, in the end I decided I would go with the Coptic men. Coptic men are somewhat emasculated because of their religious minority status, but also, in the case of these particular men, because they identify with nationalist Cairene middle-class culture. In the eyes of many Luxorites, especially those from the craft and working class, whom I knew best, these men would stand in just slightly better light than Cairene men, whom southerners viewed as effeminate.

6. Southerners who are old enough to remember that film remember it as government propaganda. The Suez Canal stood as a site of capitulation to, but eventual triumph over, colonial and foreign powers within Egyptian history, by the time this film was made. Setting the film in that earlier period provided a number of rich allegorical motifs concerning the integrity of Egypt as a people, unmercilessly battered by Ottoman and Western powers alike. The film could likewise be read to show how families were destroyed and siblings set one against another under foreign colonial servitude.

7. This began a week in which I got a taste of my own medicine, as my entire Cairene life was put under ʿAziza's ethnographic-like scrutiny. My Cairene friends were very sympathetic to my plight, doubtless having been subjected to a superficially more sophisticated version of the same curiosity by me in the years before. Meanwhile, paralleling my ethnographic assertions of scholarly and ethical integrity in my community studies, ʿAziza was busy vaguely assuring me that what she was doing in Cairo was morally acceptable because it was somehow going to help her family eventually.

8. Susan Sylmovics (1987:55 and throughout) reviews in great detail the story of Dawaba, the daughter of the Iraqi King, who was captured by the King's enemies and rescued by Abu-Zayd and his nephews. The story Umm Jabr recited was similar, but not quite the same as this tale and I do not know if it was her version of the same

episode. In any case, while the finer points that I might have gleaned if I had been able to record this spontaneous telling were lost on me, the meaning that Umm Jabr crafted into the piece for us found its mark. In fact, because of the usual fragmentary nature of her songs and her sister's feeling that it was inappropriate for a woman to be singing the epic, it was only in the case I am about to describe that I found out from ʿAziza that it was the epic from which she was always excerpting bits.

9. According to official understandings, men are supposed to look for women who have superior domestic skills, but I never heard of much of this from men. These seemed more the concerns of the fiancé's mother. Men whom I knew well enough to ask said that they had been most concerned about a woman's personality, looks, and family reputation in choosing their mate. The most important features that the women I knew looked for in a man were his prospects for making a living, that he had no other wives, was not *too* much older than she, and was at least reasonably good-looking.

10. This brings up the point that behaving shamefully does not necessarily involve an internalized element of shame. While women said that such activities such as meeting up with prospective spouses in advance of formal negotiations was shameful, it seemed that the feeling of shame only occurred in the context of such activities being revealed to family or community. For an extensive treatment of the gendered politics of veiling in Cairo, see A. E. MacLeod (1991). MacLeod's work primarily analyzes the experiences and perspectives of lower middle-class working women, yet many of her findings resonate with my findings concerning craft- and working-class women.

11. Unlike local subterfuges that were always in danger of being found out, her trips to Cairo were unlikely to be traced. She had covered her tracks by calling her parents (through the neighbors, since the family had no phone) the day that she arrived in Assiut.

12. Karen Fog Olwig (1998:235) has noted that "home" can be understood in (at least) two interdependent ways: first, as a conceptual space of identification and, secondly, as a concrete space of social relations. Although there are numerous class and ethnic differences within Luxor, for ʿAziza, it was only after her travels outside of Luxor that her Luxor and southern identity became a central issue in relation to home.

BIBLIOGRAPHY

Abu-Lughod, Lila. 1989. Zones of Theory in the Anthropology of the Arab World. *Annual Review of Anthropology* 18:267–306.

Aristotle. 1947 [?335–323 BC]. Poetics. Trans. Ingram Bywater. In Richard McKeon (ed.), *The Basic Works of Aristotle*. New York: Random House.

Bauman, Richard, and Charles Briggs. 1990. Poetics and Performance. *Annual Review of Anthropology* 1990: 59–88.

Clifford, James. 1997. *Routes: Travel and Translation in the Late Twentieth Century.* Cambridge: Harvard University Press.

MacLeod, A. E. 1991. *Accommodating Protest: The New Veiling in Cairo*. New York: Columbia University Press.

Malti-Douglas, Fedwa. 1991. *Woman's Body, Woman's Word: Gender and Discourse in Arabo-Islamic Writing*. Princeton: Princeton University Press.

Olwig, Karen Fog. 1998. Contested Homes: Home-Making and the Making of Anthropology. In Nigel Rapport and Andrew Dawson (eds.), *Migrants of Identity: Perceptions of Home in a World of Movement*. Oxford: Berg.

Sarup, Madan. 1994. Home and Identity. Chapter 5 in George Roberson, Melinda Mash, Lisa Tickner, Jon Bird, Barry Curtis, and Tim Putnam (eds.), *Travellers' Tales: Narratives of Home and Displacement*. London: Routledge.

Sylmovics, Susan. 1987. The Merchant of Art: An Egyptian Hilali Oral Epic Poet in Performance. *Modern Philology* 120. Berkeley: University of California Press.

Wikan, Uni. 1984. Shame and Honor: A Contestable Pair. *Man* (N.S.) 19:635–52.

Zirbel, Katherine E. 2000. Playing It Both Ways: Local Egyptian Musicians between Local and Global Markets. In Walter Armbrust (ed.), *Mass Mediations: New Approaches to Popular Cultural in the Middle East and Beyond*. Berkeley: University of California Press.

FIVE

Cold Hearths

The Losses of Home in an
Appalachian Woman's Life History

BILINDA STRAIGHT

Once we jettison fundamentalist versions of identity politics,
once we accept that the belonging ascribed to us is structurally
both exorbitant and unsatisfying, then we can begin to ask how
the narratives and claims of ethnos actually impinge on individual
subjectivity and agency. How, in other words, do we live in the
symbolic space of home or exile?
 —Carter, Donald, and Squires, 1993

No wonder she had pneumonia, my grandma Barton—somebody
sent for her. And she come, and grandma said what she thought.
Said, "It's a wonder you ain't ALL dead in here." (Mmm.) Livin
in that cold place. And I started awhile ago bout gettin up in the
mornings to build a fire. (Yeah.) Had to take a broom and sweep
the snow off the stove! The cracks in the wall was so wide that the
snow, snow blowin in at night, would blow the snow in there.
(Yeah.) Couldn't hardly get the fire started. I'd cuss and get so
mad, I stayed so mad
 —Marie Miller, October 1989

IN THIS ESSAY, I tell the story of a failure, a failure to keep a marriage
together, a failure to make a "home," a failure to make sense of the death of

a child. It is the story of Marie Miller,[1] a white Appalachian woman[2] who was born in West Virginia in 1911, married there in 1928, and left her husband and sons in the 1940s to migrate north. In re-narrating fragments of Marie's life story, I attempt to make sense of her own making sense of her life through an analysis of the narratives about Appalachia and the modern home enfolded in her stories. Working on another analytic level, I will also "make sense of her making sense" of things by examining the significance of her storytelling efforts for some of her most important interlocutors: her self, her daughter, and me—her granddaughter. While both levels of my analysis assume the intertextuality of my grandmother's (Marie's) stories, there is for me a clear difference between, on the one hand, describing the narratives embedded within hers as a way to access the emergence of culture out of dialogues between actors and texts, and, on the other hand, seeing within those narratives the poignancy of a life. Marie's life is one tale of North American culture on the margins of modernity. At the same time, Marie's narrative tells the story of what *she* meant by her life and it is the singularity of her experience that edges into the troubled understandings of those around her.

In attending to the discourses and narratives upon which Marie draws in fashioning her own narrative, as well as in my self-conscious interpretation of what the telling of her story meant to Marie as well as to me, I draw upon a concept of narrative that crosses disciplinary boundaries. Psychologist Marilyn Wesley, for example, has recently stated that

> Like a growing number of cognitive psychologists, I assume that narrative is a basic mental process through which people plot dynamic relationships with the exigencies of human experience. Telling or hearing a story, writing or reading a narrative, is an active practice of evaluation that connects experience to the schemes of interpretation that form the substance of culture. Through narrative, people align personal events with social meaning. (Wesley 1999:130–31)

Similarly, a number of anthropologists and folklorists—particularly Bruce Mannheim and Dennis Tedlock (1995)—have argued that culture emerges out of dialogic interactions between individuals, interactions that include the ethnographic encounter itself. Here, I am interested in the materials that individuals draw upon to actually produce the stories they tell to one another in everyday encounters as well as in the more structured encounters that fieldwork represents.[3] If "people align personal events with social meaning," if culture emerges out of encounters between people, the narratives produced in this process become collective property that both draws upon and leads to other narratives. Appalachia, as a region constructed as ethnically other, is excellent ground for examining this process because of the supposed gap between it and the mainstream United States. This gap is revealed in public discourses—social service documents, public policy statements, media

accounts, and novels for public consumption—that draw upon, and are themselves drawn upon by, individuals in everyday encounters.

These narratives at the level of individuals and everyday interaction have, then, a clear and often direct relationship to the larger discourses about, in this case, Appalachia as an "other" identity and the white middle class as a normative one. Indeed, as I have suggested elsewhere (Straight 2000), not only do inhabitants of the region contribute to and even recreate myths about "hillbilliness"; in doing so, they simultaneously expose the ways in which U.S. hegemonic discourses and discourses about Appalachia are at once mutually contradictory and constituted. Finally, in performing personal narratives that creatively draw upon and/or juxtapose these various discourses about Appalachia, hillbilliness, and (ideal American) home, individuals like Marie use their positions as relative insiders or outsiders to those discourses to make sense of critical life events—for themselves and their interlocutors. This is the process of making sense of things through which individuals create themselves anew and position their worth in networks of kin, neighbors, and friends, and through which their own lives become a part of the public, collective fabric that weaves together persons, precious meanings, and social institutions.

MARIE

Born in a small West Virginia town in 1911, Marie lost her father and only sister to the flu epidemic in 1919. Although critically ill, her mother and a newborn brother survived. According to the local newspaper, the funerals of husband and daughter were delayed so that the wife and newborn son could recover. According to Marie, however, the funerals were delayed so that husband and wife, sister and brother could be buried together, and it was only upon her grandmother's arrival and prophetic naming of the newborn infant, that it became clear that Marie's mother and brother would indeed live. With this story, Marie affectionately introduces her maternal grandmother as a strong woman with healing skills. Simultaneously, it marks a transition in her childhood from being the daughter of an artisan who supported his family "well" in the glass factories of Huntington, West Virginia, to a life spent on the move between family members of varying means, whose houses would later form the counterpoint to the material and social conditions of her married life.

From Marie's account, it appears that she only entered the life of a "hilligan" (her word) through her marriage to her first husband, Frank, in 1928 when she was seventeen. This period of her life is the predominant focus of her narrative, a period that culminated in her decision to leave him, their three sons, and the West Virginia hollers around 1941. In this essay, I suggest that she used her life narration as a vehicle for attempting to justify this most

controversial of her life decisions through a process of interpretation that reflects the multitude of texts available to her (Mannheim and Tedlock 1995; Bakhtin 1981).[4] These texts include the discourse about Appalachia as portrayed in contemporaneous novels, a local West Virginia discourse about proper motherhood (see Campbell 1996; Batteau 1990) that paralleled the one then prevailing and transforming within the United States as a whole (e.g., Lewis 1997; Simonds 1997; Thurer 1994; Van Buren 1989; Rich 1976), and other more personal texts—texts created over the years as Marie continued to recreate her story and justify her life decisions to herself, her children, and others in her social field—including me (see Behar 1995; DeBernardi 1995). The questions I pose here, then, are very troubling ones hinging on why she left and how both she and her husband failed in their respective marital roles.

Michael Jackson has referred to the importance of stories in fashioning one's sense of home, particularly in a place where "house" is not synonymous with "home" (Jackson 1995). Here, I attempt to make sense of leaving home where house and home *should* be synonymous but are not because the house itself *fails* in the task of making home. However, rather than Marie being like the immigrant whose travels are marked and explained by the simplicity of material comfort—a reading of "immigrant" that Caren Kaplan has critiqued (Kaplan 1996)—I wish to suggest instead how material comforts become metonymic for—among other possibilities—a home within which a mother can *be* a mother—in antithesis to a cold house that can only create the conditions for a mother's loss. Thus, in Marie's self-narration, heat, cold, and the hearth itself become metanarrative motifs that refer, for example, to loss, otherness, and an idealized American motherhood and fatherhood. If, as I suggest, Marie used her interpretation of Appalachian otherness and poverty to justify leaving her husband and sons, she simultaneously perceived the tenuousness of that explanation when juxtaposed with her status as an American mother. In her need to make sense of her life decisions, Marie created a narrative that exposes Appalachian otherness as a fiction precisely because the homogenizing narratives of the American home linked most of the nation in a failure to realize that home. Of course, the sameness of this failure was experienced differently across race, gender, class, and perhaps regional lines.[5] If Marie failed to attain (middle-class) American ideal motherhood, the dominant culture could create her as an other to be pitied and therefore excused. *She,* however, could not otherize herself enough. I will now discuss some of the texts and discourses I contend informed Marie's life narrative before proceeding further.

APPALACHIA AND THE AMERICAN IMAGINATION

As Henry Shapiro (1978) ably demonstrated over two decades ago, local color fiction writers (most notably, Mary Noailles Murfree) had created

Appalachia as an "other" place by the 1870s, while, perhaps more significantly, William Goodell Frost (president of Berea College in Berea, Kentucky, in the 1890s) coined the term "Appalachian America" and invented Appalachia as a discrete (white) cultural region.[6] Characteristics of being proud, hard-working, and stoic in the face of harship came with the territory. Building on Shapiro's seminal work, Allen Batteau (1990) has added a gendered analysis to the process of invention. Batteau argues that the region as a whole was constructed as feminine in Victorian, separate spheres fashion. In this view, the coal industry must be maintained as an external infringement on this unsullied domestic preserve. The Appalachian home, then, is, like the region as a whole, the site of conservative values, thrift, hard work, and cleanliness—and feuding and moonshine are its antithesis (Batteau 1990). In stereotypical fashion ideal Appalachian femininity is seen as strong, hard-working, and able to make the best of difficult circumstances. A good man and a good father becomes one who, above all, is employed in any way he can be, while a good woman and a good mother becomes the one who makes a home out of the tools he provides.

In contrast, the assumption that mountain life was harsh—formed both by novelists who were insiders as well as those who were outsiders to the southern mountains—translated into a novel genre about Appalachian migration, in which women bravely fled these circumstances. In his analysis of this literary genre and its role in constructing "Appalachia," Danny L. Miller (1996) tells us that fiction about individuals leaving the mountains was contemporaneous with the earliest local color fiction about Appalachia (which, as I have pointed out, dates to the 1870s). It would seem that if Appalachia was an isolated "other" place, a place in which its inhabitants lived apart from modernity, this otherness was constructed in dialectical tension not only against the mainstream United States but against itself as well. That is, I would argue that in the migration genre, Appalachia was written as other to itself—for the gaze and consumption of (an equally fictional) dominant society.

These are precisely the sorts of tensions that Marie negotiated in telling her own life story. On one hand, there is a local color literature that frequently depicts women as wishing to escape the harsh living conditions of the mountains. Thus, as Miller tells us in describing Elizabeth Haven Appleton's short story "A Half-Life and Half a Life," the protagonist Janet "courageously leaves the hills and goes alone to Cincinnati . . . where she becomes a school teacher" (Miller 1996). Similarly, Miller describes the character Dusk in Frances Hodgson Burnett's "Lodusky" as always wishing to leave the mountains: "'I've allers wanted to go away,' she said. 'I—I've allers said I would. I want to go to a city somewhar . . .'" (Burnett quoted in Miller 1996). As Miller describes, this genre oscillates between a noble, pristine Appalachia and a harsh, degraded one. In either case, Appalachia is other to, and constructed against, mainstream U.S. society.

On the other hand, there are insiders' self-constructions (which mutu-
ally shape and resonate with dominant discursive constructions) that seem to
valorize Appalachian otherness, as evidenced in this excerpt from a West Vir-
ginian woman's conversation with Roberta Marilyn Campbell, her ethnogra-
pher/interlocutor: "I think West Virginians and Appalachian people in gen-
eral glory in being thought of as somehow more primitive, more uneducated
and self-reliant than others" (Campbell 1996). Here, Appalachia's inhabi-
tants become other to themselves—either valorizing their identity in coun-
terpoint to a homogenized U.S. mainstream or deprecating it (as Marie some-
times does in narrating her life story).

Motherhood (although fatherhood is often notably absent) figures
prominently in all of these discursive possibilities. In Campbell's nuanced
analysis of the interplay of gender, race, and class in Appalachian women's
experiences, motherhood is frequently a common denominator women use to
justify life decisions (or lack of them). For example, in discussing
Appalachian rural and urban low-income mothers, she asserts that "they
wanted to assure me that they recognized their duties as mothers despite the
economic limitations. They emphasized the values of thrift, hard work, clean-
liness, and for setting an example to their children" (Campbell 1996). Camp-
bell attributes a "belief in the sanctity of motherhood" to these women's
attempts to combat deprecating mainstream stereotypes associated with mul-
tiple oppressions (gender, class, region, and, for some, race).

I would suggest, though, that the positioning of motherhood as the site
for these defensive postures is also linked to a continuing and complex pre-
occupation with motherhood both inside and outside of Appalachia. Thus,
mainstream U.S. myths about motherhood, even as they have changed
with historical and political context,[7] have partly informed and been
informed by constructions of "other" motherhood—of which Appalachian
motherhood is one example. If Appalachian mothers earlier in this century,
for example, were strong women capable of making a home out of the
roughest materials, such idealized images have become increasingly compli-
cated by equally homogenous but negative images placing hillbilly mothers
among uneducated welfare mothers—all of whom are presumed to be "bad"
mothers. If to be a "good" mother in mainstream U.S. society is synony-
mous with being white, middle- or upper middle-class, an Appalachian
mother can be a good "other" mother as long as she remains in the moun-
tains, stays off of welfare, and works just as hard as a century of fiction and
discourse have constructed her.

The traveling mother's position is particularly precarious. Indeed, she is
absent from discursive constructions of women "needing" to escape the
harshness of the mountains. Those migrating women have tended to do so as
nubile young maidens or as dutiful daughters. When mothers have traveled,
it is with their husbands and children in austere circumstances. Idyllic moun-

tain motherhood is left behind in these stories, and in its place is a mother-
hood under seige, degraded or possibly salvaged if the mother can successfully
recreate Appalachian industry and resourcefulness in an urban context (see
Williams 1976; Miller 1996). The lone woman traveler as morally suspect is
a recurring, cross-cultural theme (see, for example, Reed-Danahay and Zirbel
in this volume; Tsing 1993).[8] For Appalachia as elsewhere, however, while a
woman traveler is debased from within her community, her purity may be
recovered if she is constructed from without—as a member of a
marginal(ized) place who therefore is in need of rescue. Such narratives
undoubtedly help to strengthen dominant self-constructions to various
politico-cultural ends. Marie, however, navigated gingerly within and against
them—having to place herself uneasily as a lone traveling mother (a near dis-
cursive impossibilty), as a woman from Appalachia, as a woman whose trav-
els left children and home behind.

THEM HILLIGANS

Marie left her maternal home in 1928 at the age of seventeen to marry a per-
son she refers to as a "wood hick." Moving back and forth between her child-
hood and married life, Marie contrasts the houses and comforts of her child-
hood with the "shanties" she lived in with her husband, focusing particularly
on the hearth. Thus, her Aunt Mamie, with whom she lived for two years fol-
lowing the death of her father and sister, had a beautiful home and provided
her with fine clothing and sweets. Her grandmother, with whom she lived off
and on throughout her childhood, had a large fireplace that served well the
role of family hearth and warm gathering place for stories. Then, when her
mother remarried—this time to a coal miner named Creed—Marie enjoyed
the comfort of the "company house," a house she describes in positive terms
in direct contrast to her married houses:

> I was more, I was more unhappy alivin after I got married to him. After I got
> married to Frank. (Mmm.) Where I had to LIVE. Now Creed didn't have
> that bad a house. He put mom in a better house, a company house, to them
> coal mines. We had pretty nice little houses, painted walls and pretty yards,
> put a swing on the porch, had a porch to 'em.

As Marie sees it, she had been raised in a poor home for the most part,
but a *home* nevertheless, managed by women—her mother, aunt, and grand-
mother—who were strong and knowledgeable about matters of childrearing
and medicine, who, in short, fit the models of both the Appalachian and the
modern American mother.
Marie both prefaces and immediately follows her description of her
childhood home, however, with her feelings of anger about living with Frank,
saying that she was "mad and unhappy" all the time and could have died.

Moreover, Marie fashions the coldness of her married houses into a telling motif, pivoting around their sources of heat that she describes in great detail, focusing on their lack of efficiency and the great deal of labor they required:

> You know these big oil drums? (Yeah.) When they get the oil out of 'em? (Yeah.) You believe that we had one of them for a heatin stove? (Yeah.) One time? (Yeah.) He took and cut a DOOR on it, on the front of it, they put it roll ways you know, up against the wall. He cut a little door, square door, put hinges on it. They burnt wood I think, they burned wood in 'em. It ain't good, ain't as hot a fire. [Slight pause.] And there we had to put up with that, in the house. And boy, I had the awfullest time that ever you saw in your life. I was just cussin mad.

Here, the material conditions of Marie's childhood and married homes converge in competing, opposing, and sometimes ironic discourses about Appalachia. Her childhood home, particularly the one she experienced on her grandmother's successful farm, was a "civilized" mountain home, evoking the pristine home of timeless American values and cherished female domesticity depicted on the noble side of the myth of Appalachia (Shapiro 1978; Batteau 1990; Pudup et al. 1995). Ironically though—in opposition to a hegemonic and homogenous discourse of coal camp squalor that continues to have resonance in the American imagination—in Marie's mind, even the portions of her childhood spent as the daughter of a glass factory worker and then as a coal miner's stepdaughter were likewise superior to her married experiences: Her father's salary allowed her to have ribbons for her hair, and in the coal camps, her mother had a "better house."[9] Thus, in counterpoint, Marie's married home fit yet another Appalachian literary genre, the rough mountain life of feuds, moonshine, and drunkenness—the antithesis of domesticity (Batteau 1990; Waller 1995). In class terms, Marie's marriage to a man who worked in timber and tenant farming represented her first entry into "the hills." As she says, contrasting her childhood homes to her married one, "We didn't live in no hills. . . . We always lived in a house. This wasn't no house."

While Marie probably did not read the novels, books, and articles informing the discourses her narrative evokes, these opposing visions of life in the southern mountains had, as I have already discussed, coalesced not merely into a literary genre, but into the American imagination. As Marie's own stories of moonshine and feuds demonstrate, the subjects of these discourses about Appalachia were not only well aware of prevailing stereotypes about Appalachia; they were active participants in the process of shaping those stories. Whether the resulting (mythical) construction of the region was beneficial to its inhabitants is, of course, another matter (see Whisnant 1983; Batteau 1990).

As far as Marie was concerned, her childhood life admittedly had its tragedies and failures—as in the deaths of her father and sister and in her

acute awareness that she would have been "better off" had she remained with her mother's sister (whose husband was a barber) after her father's death. Yet Marie's admission on this point makes the contrast between her childhood and married homes all the more striking, as she compared the home of her landowning grandmother to those provided by men of varying occupations and found that all of these husbands except her own—her grandfather, uncle, father, and stepfather—provided a house superior to those of her marriage, a house that (as I will elaborate later) could be fashioned into a home. What constituted a home cannot, however, be reduced to the provision of a "better house." Marie's narrative evokes the darkest discursive features of a mythical Appalachia, suggesting that for her, moonshine and feuds, cold houses, and ill health mutually reflected and constructed a certain (antithetical) meaning of home. That home was wholly "other," both to the idealized mountain home of her childhood and to the ideal American home to which she aspired. Moreover, her husband and his family were likewise "other" to what we can only surmise is the mainstream white American self she would later perceive herself to be.

So although in her words, Marie's husband was a "good man" who did "the best he could," "all he knowed to do," he was simultaneously a "wood hick" in a family who lived like "brutes." This is exemplified in one story within Marie's narrative in which two of her husband's brothers came into the house one by one in the middle of the night with the apparent intention of killing her husband. In the ensuing fight with the first to arrive, her husband grabbed a poker and "laid 'im out," nearly killing him and leaving puddles of blood that Marie was later left to clean. Before the second brother arrived, the first one escaped: "Finally, he run and got away and got to the woods. . . . And he's used to hiding out in the woods away from the police. (For moonshine?) Oh YEAH! He's done good at that, at hiding from the police. Aunt Dude said she took 'im most of his meals in his life to the woods for 'im [laughter]." In another story, her husband had a toothache that his brother cured:

> Well he couldn't afford to go to the dentist and Sam said, "All I know is to pull your teeth." . . . Frank got 'im a fifth of whiskey. [I'm laughing.] And he got so drunk [more laughter] that he didn't know where he was. But then he couldn't feel it you know. [I'm laughing and there's laughter in her voice.] (Yeah). Sam made him, Sam got him to lay, Sam got him to lay down, on the floor. And he got a straddle a him to hold him, and he pulled that tooth out with them pliers. With nothin to numb them gums! [I'm laughing.] Nothin. . . . Don't you know that he coulda died? Now it's like brutes wasn't it?

In asking me to confirm that her husband's family indeed lived like "brutes," Marie's narrative both points to a discourse about Appalachian

savagery and simultaneously signals the contentiousness of her decision to leave. Thus, in otherizing her husband and affines as "hilligans" and "brutes," she prefigures her strongly perceived need to leave *and* implies that her decision was morally suspect. Indeed, while Marie's maternal family assert that she was so close to death that her mother had to remove her from the marital home, Marie's sons and affines variously report that Marie merely believed herself to be sick, that she was lazy, and that she was a whore. For her part, Marie neither accepts nor rejects her affines' interpretation of her leaving. Instead, she acknowledges that she had a number of boyfriends, but she paints her single life in a bemused and casual tone, saving her deepest, most troubled reflections for the fact of her leaving rather than for whatever wrongs she might have done in the midst of her travels. Thus, while she tells laughingly that men in Baltimore bars wanted her body even as her belly heaved with six months of pregnancy, she painfully rationalized the effect of her leaving on her young sons:

> Yeah, oh, yeah, Chris, but, Chris was the worst, hurt me the worst. I left him once, I left him and went down there like I said, go down there and take em, get their hair cut. Their hair was all shaggly and long. And I'd take em, I'd have a little money with me. And I'd get em some fruits and stuff they wanted to eat, candy and cookies they didn't hardly get and everything. . . . He wasn't over maybe four or five years old. And he'd walk with me down to catch a bus. Course I had Jack and Gerald. Course I done lost little Louise, she was the second one. And I, he was walkin with me. He was standin there with me. And how pitiful this was Bilinda. He said "Come on mom, let's go back home." [She's talking softly.] That was hard. And I said, I said, "Chris, your mother can't live this way no more. I can't live. I love ya, and everything. But I can't live like this." (Mmmm.) You don't know, kids mighta understood, they was little you know. (Yeah.) They mighta been too little to understand. He was the baby one.

If Marie danced in Baltimore bars or had boyfriends, in her pragmatic self-portrayal, it was not these facts by themselves that caused her painful introspection. Instead, it was the fact of leaving her children that she had to justify to herself and her interlocutors, and here her location on the noble or savage side of discourses about Appalachia was largely beside the point. *Here, her departure subverted conventional claims about Appalachia's otherness. That is, whatever differences Appalachian identity might have entailed at the level of the local, the modernist discourse of American motherhood was more powerful than those differences.* Marie was not a "bad mother" because she was a "whore." In traveling, in leaving her children in order to travel, Marie became simultaneously both bad mother and whore.[10] This is not merely a convenient rhetorical statement. The force of Marie's failure can be summed up in the painful dialogue between her children—in the statement of one of

the sons she left *behind* to the youngest child whom she *kept*—"You're going to be a whore just like your mother."[11]

As her granddaughter and interlocutor, I read Marie's life narrative as an attempt to make sense of her decision to leave—for herself, for me, and for her daughter or anyone else who might listen to the tape we were making together. In listening to the tape, moving through a labyrinth of public, private, and inner texts, I surmise a story of personal failure and tragedy embedded within—and partly caused by—a story, or master narrative, of American Family and American Home.

It is in this narrative space that Marie's focus on cold stoves and drafty houses opens onto a different and tragic terrain. Baldly stated, Marie left her husband because he did not provide her with the material comforts—especially the warm house—she had expected she would enjoy when she married. Less directly (and strategically), Marie positions herself as a "civilized" prisoner in an "uncivilized" male domain she feels incapable of taming—answering this conundrum, like so many women depicted in Appalachian migration stories (Miller 1996), by escaping to the "modern" lowlands where she might acquire the house and material comforts that could be fashioned into a home. What exactly, though, was the ideal home Marie had in mind? Why did she need to position herself on the noble side of these competing discourses about Appalachia? What, in short, led Marie to a rage she iterates throughout her narrative, a rage that led her in turn to migrate north, away from her husband and sons? The beginning of an answer comes early in Marie's narrative, when she first introduces the death of her daughter, Louise:

> No wonder she had pneumonia, my grandma Barton—somebody sent for her. And she come, and grandma said what she thought. Said, "It's a wonder you ain't ALL dead in here." (Mmm.) Livin in that cold place. And I started awhile ago bout gettin up in the mornings to build a fire. (Yeah.) Had to take a broom and sweep the snow off the stove! The cracks in the wall was so wide that the snow, snow blowin in at night, would blow the snow in there. (Yeah.) Couldn't hardly get the fire started. I'd cuss and get so mad, I stayed so mad.

Beside her refrain of staying "mad" all the time, Marie places another in the form of a question: "What would make a man KEEP a woman in a place like that?" Yet, apparently it was not a question that she could ask her husband. Instead, she traveled, leaving her husband and children each time she became pregnant because the pregnancies reminded her that she would not have the material items she believed she needed to care for the child:

> I was all the time leavin him. Everytime I got pregnant I'd get mad and leave. I had to have the baby anyway, what good'd that do? I just KNOWED how I'd have to do. I'd just get so blame mad. (You didn't want to be pregnant?)

No! I'd get MAD! I knowed I wouldn't have nothin! I was lucky to get a
dozen Bird's Eye baby diapers, and a box of powder, Johnson powder, and a
little outfit of clothes. I couldn't have much for 'em or nothin. I knowed how
I'd have to DO.

Rightly or wrongly, for Marie, the death of her daughter, Louise—unlike
that of her sister, Nettie Lucille, over a decade earlier—was preventable. It
was as preventable as cold houses and inadequate diaper supplies. "What
would make a man KEEP a woman in a place like that?" For Marie, her mar-
ital houses failed to make a home because her husband failed at his task of
ideal breadwinner. As Robert Griswold (1993) and Ralph LaRossa (1997)
have recently argued, transformations in American fatherhood have not
erased the single most consistent and significant charge given to American
husbands: that they be good providers. LaRossa writes specifically about the
period of the 1920s and 30s, arguing that these decades were crucial in shap-
ing the modern father as an involved parent, as more than the breadwinner.
Yet LaRossa writes, "As significant as masculine domesticity and domestic
masculinity were during the Machine Age, at no point did these two scripts
ever supplant the father as economic provider as the principal precept for
men to follow" (LaRossa 1997:40). In Marie's perception, Frank failed at this
quintessentially masculine task, and she was baffled by it. On the one hand,
she quotes other men she knew at the time to support her contention that
Frank failed to provide her with a house:

> Andy Farmer moved us, in his truck, and while we was goin along that day
> Frank went on to work and I had never SEEN THE PLACE yet! He was
> goin to move me in the house that I had never SEEN. (Mmm.) And he said
> [pause]. And I'd get up there go out in the mornin now 'cause we didn't have
> much to move, I think one truckload took it, we didn't have nothin. And I
> rode in the cab with him and he said, "When you see the place he's movin
> you to, you're goin to take a fit!"

On the other hand, she earnestly and repeatedly questions why he did not
provide her with a house, lamenting that he could not be reasoned with on
this issue: "I reasoned every way there is to reason, with a MAN."
 Frank died in 1956, making his response to Marie's questioning unre-
coverable. Something of his position can be gathered, however, from the
memories of Frank's and Marie's children.[12] Marie contrasts shanties to
"proper" houses, a life of feuds and moonshine to a childhood home in which
she contends her father did not drink and no one fought. Marie's surviving
son tells the same stories of fighting and moonshine to very different effect
though. He describes his role in making moonshine and even the violence
within his childhood home with a twinkle in his eye. While his mother like-
wise told stories for their entertaining effect, her son does not follow his sto-

ries with queries like "It was like brutes, ain't it?" Moreover, Marie's son does not remember living in a "shanty," but rather in a house that his father improved over the years, and that his father's second wife (whom he did not marry until the boys were grown) was capable of making into a nice home. It is in this opposition between Marie's and her son's perceptions of a house that Marie's own failures begin to be legible.

In response to Marie's question, "What would make a man KEEP a woman in a place like that?" we might put on Frank's lips, "What would make a woman LEAVE a man to care for the children?" If Frank failed to provide Marie with a house she felt she could make into a home, she, for her part, failed to make the house he did in fact provide into a home. As I discussed in an earlier section of this paper, the myth of Appalachian motherhood drew its force from the larger myth of Appalachian strength of body and character. Appalachian mothers might, as Marie's mother-in-law was reputed to do, smoke a corncob pipe and cut down their own trees for firewood. As Marie says, "And all them women there was STRONG, but they didn't LIVE as long (mmm), people didn't live as long then."

At the same time, however, in consonance with the myth, these mothers strictly maintained the boundary between the home's civility and the harshness of the woods and masculine brawls beyond it. A shanty could become both a house and a home when a strong mountain woman moved into it. Marie's son clearly alluded to this when he related to me, on the one hand, the strict rules governing the use of linens in the home of his father's sister (with whom he sometimes stayed) and the wonderful—as he relates it—lack of such feminine interference after his mother left. Beneath his entertaining exultation in the exploits he and his brothers were free to indulge in, though, is the absolute negation of home. Marie did not perceive herself to belong to the class of strong mountain women who might care for cows and pigs, haul water and wood, and help in the strenuous labor of repairing fences. Indeed, there were subtle differences of class here that point sharply to the fiction of a homogenous white Appalachia as well as to the very real fact that she had not been prepared for that married life. However, in leaving altogether, Marie left behind a shanty that could only become a home when her husband remarried many years later. Frank could and did raise their sons without Marie's help, but the entailments of modern, separate spheres masculinity and femininity were unassailable. To Marie's bewilderment, Frank taught the children to call their parents by their first names, and he did little to circumvent the stereotypically masculine texture of their home.[13] As Marie's son relates, cleaning was done if someone did it, a fire was built if someone built it. If not, dirt and cold were the consequences, but above that, no one complained. Moreover, just as Marie relates for the period when she lived there, moonshine was made—with their sons' assistance—and brawls were fought. To the extent that feminine domesticity, through the

agencies of paternal grandmother and aunt, intervened, its influence is minimized to the double-edged effect that all survived without Marie in a masculine version of home. Whatever the actual truth of Marie's, her children's, or her other kin's stories, the narrative effect is clear: Either Frank failed in his masculine role of provider or Marie failed to make a home. Both possibilities left Marie, Frank, and their sons "homeless."

DEATH IN A COLD HOUSE:
DESIRE AND THE FAILURE OF HOME

Marie's narrative clearly reveals the opposing forces and contradictions that made her married life an impossibility for her. For her, childhood houses with their peaceful, sober domesticity were experienced in jarring contrast to the shanties, fighting, and drunkenness she experienced with Frank. Marie used the performance of her life history, then, to reaffirm and transform her own identity, an identity filled with unfulfilled desires as well as conflicting roles and failures—her own and her husband's. Her reason for leaving is deceiving in its simplicity. She expected an easier life and a little version of the modern American Home: "And I uh, I begged Frank to get a little house, I didn't want no mansion, I just wanted a little decent house I could enjoy keepin'. I'd come back." Yet leaving was a decision she struggled with in raw emotion: "I even wrote letters to him. I laid and CRIED! . . . If he just WOULD get me a house." Marie was chronically anemic and severely ill the last time she left her husband. To me, as her granddaughter, the most transforming moment—the moment that undid her attempts to be a mother and make a home in what I perceive to have been bitterly adverse conditions—was the death of her daughter, Louise. However, at the same time that this death—occurring amidst her own ill health—strengthened her resolve to leave, her anguished reflection of it leads me to suspect that it was epiphanic: In telling the story to me, Marie heard *in her own voice* the tragedy of loving a good man literally in the wrong place, at the wrong time of her life. This is perhaps nowhere more clearly or more poignantly visible than in the detailed description of her daughter's death that she offered late in our conversation:

> And so uh, uh, she was in between us, and she got so uh, she DIED is what made 'er, I thought she was gettin BETTER. And I happened to wake up, we had to get up, I had to get Frank off to work. And uh, he, I, I WOKE up! I, I somehow, it was just so to be, I WOKE up. And she wasn't gettin her BREATH like 'at! And I, I put my, she was still warm, I don't think she'd been dead very long. But she wasn't carrying on! I said, "Frank!" I shook Frank. And he was on the other side there and got him awake. I said, "You KNOW, I think Louise is BETTER, she's not a carryin ON like she was! Tryin to breathe." [Low voice.] She's dead. (Yeah.) LORD, have mercy!

Frank jumped outa there, he jumped across me and got out of that bed, over the other side, and grabbed her, and we hollered to Omer, and Omer said, "Put your hand over, under what's she's sleepin in, over her HEART. If her heart ain't beatin, she's GONE." Like she'd been in a coma or somethin. Frank run through the house with her, SHAKIN HER, UP AND DOWN shakin her. [Low voice.] And she was GONE. And boy, we just took a fit, fit, fit. [Pause.] And uh, Frank just CRIED. You know, if I'd a kept my PATIENCE, I was young, we mighta, he mighta finally got a house. But I just quit having any patience that he'd EVER do nothin. (Yeah.) But MAN couldn't do no better!

In this single story fragment, Marie alludes to a metanarrative of coldness and loss, travel and home, and to the possibilities that continue to trouble her of what might have happened had she remained. Without the slightest pause, she moves from her voiced recollection that her husband cried at the loss of his daughter, to considering that he might have given her the tools to create a domestic space, a "proper" home, if she had waited: "And uh, Frank just CRIED. You know, if I'd a kept my PATIENCE, I was young, we mighta, he mighta finally got a house." In the plenitude of this passage, Marie refers to the multiple discourses that she negotiated in making and later justifying her decisions. Simultaneously, however, in that slender space between performing grief and reflection, she refers to the fact of her travel as a decision that haunts her so much that it catches in my own throat, leaving me to ponder whether the grief of losing her daughter has become—like the absence of domestic heat—a powerful metonym for living children lost to travel, for lost possibilities, and even for grief itself.

NOTES

1. All quotes from Marie appearing in this paper are taken from her life history, recorded in her Springfield, Ohio, home in October 1989. My transcription style follows Dennis Tedlock (1983) and is meant to reconstruct, as much as possible, the rhythms of her language, particularly the stress she placed on certain words as she spoke. I run the risk of exoticizing Marie here, but I have accepted the risk in order to convey, as much as possible, the emotional force of Marie's narrative performance. That emotional force has been formative in the direction this analysis took.

2. Marie identified herself as part Cherokee.

3. On the creation of meaning through performance, see also, for example, Darnell 1974; Tedlock 1983; Bauman and Briggs 1990; Fabian 1990.

4. I have also drawn upon Colin Campbell's illuminating discussion of individual motivations, particularly his notion of individual conversations and narratives as justificatory accounts—framed in the context of individuals' needs to justify their actions to the interlocutors (including themselves) who comprise their community. In

his view, rather than deciphering such accounts as truth or lies, it is more fruitful to examine them as "'dynamically' related to the contexts of their production" (Campbell 1994).

5. Even if Appalachia as a separate region is a fiction, as I will discuss in the next section, a sense of belonging to that fiction undoubtedly structures individual experience.

6. The invention of Appalachia is the invention of a region as homogenous in race as in character. Local color authors of the 1870s "discovered" the mountaineers and planted them firmly in the American imagination. In the 1880s, however, Protestant Home Missions availed themselves of Appalachia's purported whiteness to garner support for their work in the south, when work with African American freedmen became problematic for complex reasons, including the hostility of whites in the south towards these northern churches' commitment to work with both blacks and whites. In the 1890s, Frost at Berea College focused on the mountain inhabitants for similar reasons: Berea College's unique commitment to racial coeducation was facing the dilemma of white underenrollment (see Shapiro 1978).

7. The literature on motherhood in the United States is enormous. See, for example, those already cited in the second ("Marie") section of this paper, as well as Gimenez 1983; Bassin, Honey, and Kaplan 1994; Lichtenstein 1994; Hays 1996).

8. On place and immobility as productive of "woman," see Massey 1994. On gender and travel, particularly travel as masculine trope, see Kaplan 1996. On women's travels as "secret journeys"—contradicting if not subverting the dominant (masculine) trope of travel—see Wesley 1999.

9. Crandall A. Shifflett (1991) has also opposed this discourse of "squalid coal camps," offering a carefully detailed portrait of coal towns that demonstrates their social, economic, and political complexity. Life in coal camps varied a great deal, but as experienced by the workers and their families, it frequently presented a superior alternative to tenant farming and other possibilities—even as it represented exploitation of those same workers and the region as a whole.

10. I would place this at the interstices between Victorian-generated dichotomies of mother vs whore and bell hooks' (1981) brilliant discernment of the devaluation of motherhood as women become cast simultaneously as mother and whore.

11. This was related to me by my mother, who was the child she kept. In a story told both in laughter and amid voiced frustration at her stupidity, Marie contends that she and Frank conceived my mother on one of her visits to her sons, when she and Frank were separated but not yet divorced. It is interesting that she related in another story that she and Frank argued about child custody when she first broached the subject of leaving. The era of women being awarded custody had dawned by the close of the nineteenth century, but she acquiesced. While she did not intend to conceive my mother, in doing so in a context that threw open the question of paternity, she got to keep her child without argument but she also guaranteed enmity between her daughter and the sons she left behind. She as well as her children and grandchildren have subsequently and painfully debated the overarching question I discuss here: Why did she leave? To suggest resistance in this instance, or the construction of desire (for

home), or to place her departure in the context of various discourses about Appalachia are all inadequate. My intention is to attempt to unite all of these possibilities because (as is usually the case) there is no single (or easy) truth here.

12. Marie's children are the oldest surviving members of the family. Every one of Marie's affines—elders and contemporaries—are dead, which would seem to lend some support to her contention that hilligans (women especially) were strong but they did not live long. Her own family in contrast—which she depicts as civilized—lived longer. Her mother's sister is still alive at 103. There is little doubt that conditions in the hollers were harsh.

13. While the fact that he did not allow speaking at the dinner table points to a flaw in the apparent seamlessness of this narrative, he undoubtedly contributed to the creation of this—his and his sons' story(ies) about home.

BIBLIOGRAPHY

Bakhtin, Mikail. 1981. *The Dialogic Imagination*. Trans. C. Emerson and M. Holquist. Austin: University of Texas Press.

Bassin, Donna, Margaret Honey, and Meryle Mahrer Kaplan. 1994. Introduction. Pp. 1–25 in Donna Bassin, Margaret Honey, and Meryle Mahrer Kaplan (eds.), *Representations of Motherhood*. New Haven: Yale University Press.

Batteau, Allen W. 1990. *The Invention of Appalachia*. Tucson: University of Arizona Press.

Bauman, Richard, and Charles L. Briggs. 1990. Poetics and Performance as Critical Perspectives on Language and Social Life. *Annual Review of Anthropology*:19:59–88.

Behar, Ruth. 1995. Rage and Redemption: Reading the Life Story of a Mexican Marketing Woman. Pp. 148–78 in Dennis Tedlock and Bruce Mannheim (eds.), *The Dialogic Emergence of Culture*. Chicago: University of Illinois Press.

Billings, Dwight B., Mary Beth Pudup, and Altina L. Waller. 1995. Taking Exception with Exceptionalism: The Emergence and Transformation of Historical Studies of Appalachia. Pp. 1–24 in Mary Beth Pudup, Dwight B. Billings, and Altina L. Waller (eds.), *Appalachia in the Making: The Mountain South in the Nineteenth Century*. Chapel Hill: University of North Carolina Press.

Campbell, Colin. 1994. Capitalism, Consumption, and the Problem of Motives: Some Issues in the Understanding of Conduct as Illustrated by an Examination of the Treatment of Motive and Meaning in the Works of Weber and Veblen. Pp. 23–46 in Jonathan Friedman (ed.), *Consumption and Identity*. Chur, Switzerland: Harwood Academic Publishers.

Campbell, Roberta Marilyn. 1996. Images and Identities of Appalachian Women: Sorting Out the Impact of Class, Gender, and Cultural Heritage. Pp. 29–45 in Phillip J. Obermiller (ed.), *Down Home, Downtown: Urban Appalachians Today*. Dubuque: Kendall/Hunt.

Carter, Erica, James Donald, and Judith Squires. 1993. Introduction. Pp. vii–xv in
 Erica Carter, James Donald, and Judith Squires (eds.), *Space and Place: Theories
 of Identity and Location*. London: Lawrence and Wishart.

Darnell, Regna. 1974. Correlates of Cree Narrative Performance. Pp. 315–36 in
 Richard Bauman and Joel Sherzer (eds.), *Exploration in the Ethnography of Speak-
 ing*. Cambridge: Cambridge University Press.

DeBernardi, Jean. 1995. Tasting the Water. Pp. 179–97 in Dennis Tedlock and Bruce
 Mannheim (eds.), *The Dialogic Emergence of Culture*. Chicago: University of Illi-
 nois Press.

Fabian, Johannes. 1990. *Power and Performance: Ethnographic Explorations through
 Proverbial Wisdom and Theater in Shaba, Zaire*. Madison: University of Wisconsin
 Press.

Gimenez, Martha E. 1983. Feminism, Pronatalism, and Motherhood. Pp. 287–314 in
 Joyce Trebilcot (ed.), *Mothering: Essays in Feminist Theory*. Totowa, N.J.: Row-
 man and Allanheld.

Griswold, Robert L. 1993. *Fatherhood in America: A History*. New York: Basic Books.

Hays, Sharon. 1996. *The Cultural Contradictions of Motherhood*. New Haven: Yale Uni-
 versity Press.

hooks, bell. 1981. *Ain't I a Woman? Black Women and Feminism*. Boston: South End
 Press.

Jackson, Michael. 1995. *At Home in the World*. Durham: Duke University Press.

Kaplan, Caren. 1996. *Questions of Travel: Postmodern Discourses of Displacement*.
 Durham: Duke University Press.

LaRossa, Ralph. 1997. *The Modernization of Fatherhood: A Social and Political History*.
 Chicago: University of Chicago Press.

Lewis, Jan. 1997. Mother's Love: The Construction of an Emotion in Nineteenth-
 Century America. Pp. 52–71 in Rima D. Apple and Janet Golden (eds.), *Moth-
 ers and Motherhood: Readings in American History*. Columbus: Ohio University
 Press.

Lichtenstein, Therese. 1994. Images of the Maternal: An Interview with Barbara
 Kruger. Pp. 198–203 in Donna Bassin, Margaret Honey, and Meryle Mahrer
 Kaplan (eds.), *Representations of Motherhood*. New Haven: Yale University Press.

Mannheim, Bruce, and Dennis Tedlock. 1995. Introduction. Pp. 1–32 in Tedlock,
 Dennis and Bruce Mannheim (eds.), *The Dialogic Emergence of Culture*. Chicago:
 University of Illinois Press.

Massey, Doreen. 1994. *Space, Place, and Gender*. Minneapolis: University of Min-
 nesota Press.

Miller, Danny L. 1996. The Appalachian Migratory Experience in Literature. Pp.
 143–56 in Phillip J. Obermiller (ed.), *Down Home, Downtown: Urban Appalachi-
 ans Today*. Dubuque: Kendall/Hunt.

Pudup, Mary Beth, Dwight B. Billings, and Altina L. Waller, eds. 1995. *Appalachia in the Making: The Mountain South in the Nineteenth Century*. Chapel Hill: The University of North Carolina Press.

Rich, Adrienne. 1976. *Of Woman Born: Motherhood as Experience and Institution*. New York: Norton.

Shapiro, Henry D. 1978. *Appalachia On Our Mind: The Southern Mountains and Mountaineers in the American Consciousness, 1870–1920*. Chapel Hill: University of North Carolina Press.

Shifflett, Crandall A. 1991. *Coal Towns: Life, Work, and Culture in Company Towns of Southern Appalachia, 1880–1960*. Knoxville: University of Tennessee Press.

Simonds, Wendy. 1997. Confessions of Loss: Maternal Grief in True Story, 1920–1985. Pp. 111–30 in Rima D. Apple and Janet Golden (eds.), *Mothers and Motherhood: Readings in American History*. Columbus: Ohio University Press.

Straight, Bilinda. 2000. Throw 'em in the Fire: Becoming a Mother in Depression-Era Appalachia. Paper presented at "Piecing it Together: Ethnicity and Gender in Appalachia," 3–5 March, at Center for the Study of Gender and Ethnicity in Appalachia Conference, Marshall University, Huntington, West Virginia.

Tedlock, Dennis. 1983. *The Spoken Word and the Work of Interpretation*. Philadelphia: University of Pennsylvania Press.

Thurer, Shari L. 1994. *The Myths of Motherhood: How Culture Reinvents The Good Mother*. Boston: Houghton-Mifflin.

Tsing, Anna Lowenhaupt. 1993. *In the Realm of the Diamond Queen: Marginality in an Out-of-the-Way Place*. Princeton: Princeton University Press.

Van Buren, Jane Silverman. 1989. *The Modernist Madonna: Semiotics of a Maternal Metaphor*. Bloomington: Indiana University Press.

Waller, Altina L. 1995. Feuding in Appalachia: Evolution of a Cultural Stereotype. Pp. 347–76 in Mary Beth Pudup, Dwight B. Billings, and Altina L. Waller (eds.), *Appalachia in the Making: The Mountain South in the Nineteenth Century*. Chapel Hill: The University of North Carolina Press.

Wesley, Marilyn C. 1999. *Secret Journeys: The Trope of Women's Travel in American Literature*. Albany: State University of New York Press.

Whisnant, David E. 1983. *All That is Native and Fine: The Politics of Culture in an American Region*. Chapel Hill: University of North Carolina Press.

Williams, Cratis. 1976. The Southern Mountaineer in Fact and Fiction, Part IV. *Appalachian Journal* 3:334–92.

SIX

Liminal Space and Liminal Time

A Woman's Narrative of a Year Abroad, 1938–1939

CAROLINE B. BRETTELL

My heart is warm with the friends I make,
And better friends I'll not be knowing;
Yet there isn't a train I wouldn't take
No matter where it's going
 —Edna St. Vincent Millay

ALTHOUGH WESTERN WOMEN have been producing written accounts of their travels since the fourteenth century (Mills 1991), only recently has the female travel experience become a real focus of attention (Andrews et al. 1990; Mills 1991; Melman 1992; Frederick and McLeod 1993; Fawley 1994; Blunt 1995; Wesley 1998).[1] Women's travel accounts, whether as diaries, journals, letters, essays, or published books, are now recognized as a literary genre, a mode of expression for those to whom other modes of written expression have been denied. They help us to understand women's ways of seeing, experiencing, and recording.

Women's travel narratives are sources for both history and biography because they situate a particular woman in a particular place at a particular time. One learns as much about the traveler as about the travels (Fussell 1980), but this learning is more than an objective experience for the reader; it is also a subjective process for the writer. Andrews et al. (1990:5) suggest that the travel narrative is a window on the way women writers negotiate

"competing priorities of self and social identification" while Porter (1991:5) observes that women travelers who submit themselves "to the challenge of travel . . . manage if not always to make themselves over, then at least to know themselves differently." Similarly, Trinh Minh-ha (1994:9) argues that if a voyage is about displacement from here to there, it is also about a self negotiating ideas about home and abroad and, by extension, ideas of the self defined in relation to the Other or Others encountered while traveling.[2] Ochs and Capps (1996:20–21) have in fact defined the self as "an unfolding reflective awareness of being-in-the-world, including a sense of one's past and future. We come to know ourselves as we use narrative to apprehend experiences and navigate relationships with others."

In this chapter, I explore these concepts of home, self, social identity and otherness as they are revealed in the travel narratives (a journal and letters home) of a twenty-three-year-old Canadian woman named Zoë Browne-Clayton who, in September of 1938, left the west of Canada to journey to England and Ireland in search of her roots.[3] This voyage was her pilgrimage back, back to the homes and families of her father and mother who had emigrated to Canada in 1909 and 1912 respectively. Scholars of pilgrimage as a process have sometimes referred to it as a sentimental journey, arguing that it is not solely confined to religiously motivated behavior (Bhardwag and Rinshede 1990).[4] Sentimental journeys can be equally marked by the phases of pilgrimage outlined by Turner and Turner (1978). Of specific importance is the liminal phase. Zoë Browne-Clayton's year abroad was a period of liminality or passage not only in space but also in time. In May of 1937 she graduated from the University of British Columbia in Vancouver with degrees in English and Agriculture and with experience as the editor of the university newspaper (The Ubyssey), one of the major training grounds for Canadian journalists in those days. But, unlike her male cohorts, she, as a woman, could find no job in journalism, especially during a time of severe economic depression.[5] And at university she had not yet found a husband. She was caught "betwixt and between," with her childhood, adolescence, and rural provincial past behind her but her future still undefined.

If her journey to Europe marked a liminal period in personal time, it was also a liminal period in global time. Zoë moved through an uncertain and unpredictable world that was both obsessed by and attempted to ignore the latest moves of Adolf Hitler. The impending war is a theme that pervades her travel journal and the journal ends as war becomes reality. Zoë undertook a risk in going to Europe that year, but risk is itself often characteristic of the pilgrimage quest (Osterrieth 1997).

SEPARATION: THE VOYAGE OUT

Zoë Browne-Clayton's travel journal begins where many women's travel memoirs begin, at home, dealing with the process of separation. Since Janu-

ary of 1938 she had been living with her parents on the farm where she grew up in the Okanagan Mission in the apple-farming region of the province of British Columbia.[6] She had returned home from Vancouver to nurse her mother Winifred who died from cancer on June 9. After her death, Zoë opened an envelope that her mother had left for her. The envelope contained a savings bond and a note.

> This bond which I bought for you years ago is a little parting present for you from me, with my dearest love. Don't ever grieve for me my dear—when you read this you will know that I am well again and very happy—I hope you will have a lovely time in England—Good bye and God bless you. Your loving Mother.

With these words and this gift Winifred, who had great ambitions for her daughter, sending her to university when few from this farming community and certainly few girls pursued education beyond high school, gently encouraged Zoë to find a life and a home for herself elsewhere than in the Okanagan Mission. For years, Zoë had traveled to far-off places in her mind, transported by the books she read, books that were readily available in a household of well-educated although not well-off parents. Mind travel could now be transformed into real travel, giving satisfaction to the wanderlust she had written about in her diary at age sixteen: "The idea of spending a life in aimless traveling appeals immensely."

Zoë's departure on August 26 was wistful; she struggled with the conflicting emotions of daughterly duty on the one hand and a yearning for freedom and adventure on the other. As is common in any pilgrimage experience, home and a sense of place were pitted against the unknown:

> It was quite upsetting leaving Bob [her brother] and Dad but as usual we kept emotionally firm and reserved. I am going to miss home terribly. Maybe I've made a mistake by not staying there where I had a definite place. But there is no assured future and I think I should have grown discontented at being stuck there. Must see part of the world first. But I do hope I can go back sometime. Dad is a peach of a father.

This passage reveals both desire and transgression, two elements that Porter (1991) identifies as significant themes in women's travel writing. Zoë knew that she still lived in a world where "definite place" for a woman was defined by her roles as daughter, sister, or wife. And yet the independence of her college years had taught her that there might be an alternative worth exploring and, with the money left to her by her mother, she had the freedom to choose that alternative. Her "peach" of a father did not stand in the way of her decision to voyage out and go beyond—something that perhaps made the departure easier because it left open the door to return. Throughout her year abroad, Zoë kept this familiar and stable

"home" in the Okanagan Mission as a place to which she could go back and the weekly letters she wrote were the lifeline of connection.

On Thursday, September 1st her ship, the Swedish freighter *San Francisco*, set sail from Everett, Washington. Zoë also expressed sadness at leaving her university friends for they too gave her grounding:

> Sure hope I see John, Norman and Nancy again[7] in the next few years, but probably we will all drift apart rapidly now and in a few years won't even be writing. Of course, if the war breaks I may be back in a month or so. . . . I'm not looking forward to making the acquaintance of English men so I've got my fingers crossed hoping Norm does come to England next spring. I may need cheering up by then. Not that Norman is ever very cheerful, but I like him and in a long acquaintance he has never bored me and he is one of the few men that I feel always has in nearly every way a better brain than I have. That sounds a conceited statement, but so many men seem unbalanced, either so practical they have no vision or not practical enough and sometimes intolerant.

Here Zoë expresses a set of assumptions about men in general and English men in particular. Her trepidation was in meeting men who might challenge her need for autonomy and independence of thought. She had a sense that she was moving toward a world that was potentially more conservative in its attitude toward women than the one she was leaving. Holding on to the idea that someone from home, in the person of her friend Norman, might join her abroad gave her a sense of security in the face of an unknown future.

In the close quarters of a freight ship that carried few passengers, Zoë's seven traveling companions, most of whom boarded in San Francisco and five of whom were other women at various stages of life, became like characters in a novel or play as she described them, sometimes scathingly, in her journal and to her father in her letters:

> The passenger list is funny, so ill assorted—[a] quiet middle aged widow; [a] talkative dull, old foreign lady who can't speak English; [a] typical English old maid determinedly gay and jolly; [an] attractive young wife and child; [an] aging bohemian; [a] young businessman; and me, I suppose the ingenue type, eyes wide-open, etc.

She rather liked her cabin mate, the "quiet, unfussy" widow who was returning to Sweden to see her mother, but was less favorably disposed to the English old maid, Miss Breeds,

> the kind of maiden lady that only England breeds. She is going back to England to get on the quota so she can come back to the States. . . . She is . . . cheerful even when seasick and talks in bright bromides and reduces every conversation down to the nearest platitude. She calls everyone dear

already. . . . Like so many old maids she has passionate friendships with other women. She talks all the time of "my friend," writes to her daily, worries over her and practically lives for her. . . . I don't think she is lesbian because she probably doesn't know the word and it is just accidental she wasn't married. The situation is due to enforced circumstances rather than inborn inclination I should say. The rotten English system of training girls to be inferior to men and at the same time "jolly good sports" is to blame for the amazing English old maids.

In contrast to Miss Breeds, Zoë found the "aging bohemian" Miss Campbell, who was a Hollywood scenario writer, eccentric and entertaining. She wore vivid Chinese coats in the daytime, had a dragon tattooed on her hand, and talked incessantly about her travels around the world. Miss Campbell had wide interests and could start provocative discussions. Yet despite her cosmopolitan lifestyle, she was returning to England out of a sense of duty and patriotism. Zoë's only criticism of Miss Campbell was that she gave too much of herself away in conversation to be a very penetrating observer:

> She is so busy making an impression on people that she does not give them time to make an impression on her. I imagine her career as a writer suffers from this.

By the end of the trip Zoë had changed her opinion of Miss Campbell as her stories became wilder and wilder. "Miss Breeds and I decided that she was probably a mental case."

As archetypes, of course, Miss Breeds and Miss Campbell stood at opposite ends of a continuum and as distinct and gendered models for living—one in the world of convention and the other at the unconventional edge. These archetypes reappeared in Zoë's characterizations of London as opposed to Paris—the family with whom she interacted and the class-based society to which she was exposed in England as opposed to the university friends with whom she was reunited and with whom she "played" in France during the summer of 1939. Her considerations of these differences reflect a young woman trying to decide for herself what path to take and what self to construct. How transgressive was her own journey in life going to be?

As the ship headed south toward the Panama Canal, the days became hotter. On board, Zoë passed the time knitting, reading, writing letters to friends and family, swimming in the saltwater pool, playing shuffleboard and bridge, eating, and conversing. The European situation was at the forefront of everyone's mind. In an argument one night the passengers, agreeing about the inevitability of war, debated as to whether or not it would be a long one. Miss Breeds thought it would be short and Zoë disagreed:

> I of course don't think the next war will last more than four years. Read heaps of articles to back up that opinion but unfortunately couldn't remember

names of authors. Anyway Miss Breeds has no background of facts to argue against so it isn't much use trying. I don't think she reads very much or widely. Not that I was much good yesterday forgetting all my authorities.

Zoë was well aware of the implications of the growing crisis in Europe for her own future, evaluating her options in the following way in her journal on September 24:

> If the war becomes fact I don't know what I'll do. Return at Panama. To what? Vegetate at home or vague chance of job in Vancouver? Might be able to wangle New York but war could impair family finances. Or I could go on. England during the first months of war might be an instructive experience. I could perhaps stay 6 months then return. Might be able to write articles etc. on return. Also if Canada enters I'd rather stay over in England; if Canada doesn't then I'd go back there. Only danger is I might not be able to get back, money difficulties as well as boat.

By the time the *San Francisco* reached Panama the international situation had calmed down but the air of uncertainty remained. The world was in limbo as well: "The deadlock may suddenly burst into war or may lapse into a new quiet until the next crisis bubbles up." Zoë's physical passage through the Panama Canal, which the ship entered on October 5, represented a mental passage as well. The Pacific Ocean was familiar; the Atlantic was unfamiliar. She wrote with fascination about the trip through the locks—of the engineering, the scenery, and the people. At Cristobel/Colon she and her shipmates went ashore for some bargain shopping. When the ship entered the Atlantic, the days became monotonous, one a replica of the other:

> I find myself deliberately following a routine in spite of a professed hatred of routine. . . . Conversation is the only thing that is varied.

The war, religion, the relationships between the races, and their personal life stories were all fair game for these interchanges among people who several weeks earlier had been total strangers to one another. Zoë used these encounters as a foil to think about her own past and future. As a young woman who had not found her mate in university, and therefore not made the transition into marriage, she reflected on marriage itself:

> The only advantage of not marrying is to be able to retain a single individuality dependent on no one else. It is pathetic to see people unable to do that, desperately clinging to chance contacts and friends of the same sex because they feel out of it otherwise. If I don't marry I want to remain utterly alone, dependent on no one.

In one conversation Miss Campbell spoke of procreation as the highest function:

Her whole life was wasted because she had no son and she envied her sister who did "own" a son of twenty-two. From the sound of her sister, she has spoilt her son terribly and her owning him hasn't been altogether a success.

This conversation led Zoë to think about her parents in a way that yields insight into her own personality and forming values:

Thank heavens Mother and Dad were so perfect and well-balanced. Never talked of owning their children and never put we children above each other—with Dad it was Mother first and with Mother him, then us, and that is the sanest way. Maybe Miss Campbell is right and having children is the highest achievement, but surely bringing them up properly is equally important. To have a son and spoil him badly is no better than having none at all. The emotional trend of the whole conversation disgusted me a trifle—brought out my usual horror of scenes and cheap sentiment. I hate it when people try to bare their minds like that—besides I always suspect that it is not honest, just posed sentiment for effect.

Perhaps Zoë was reacting to growing up in the small world of the Okanagan Mission, a world that functioned on what people knew about one another. She had learned to be private. In a letter dated March 10, 1939, addressed to her brother Bob, she offered some sisterly counsel:

All the advice in the last letter wasn't a warning about "class" but against Mission gossip—the old hens there can "tie" you up very thoroughly and I don't suppose you want that yet. If I was you I would take out Kelowna girls and at least escape the gossip.

It is possible to speculate that all of these passages, which combine both objective and subjective reflections on marriage, motherhood, and social relations, might never have been written had Zoë herself not been in passage and had the world she was transgressing not itself been changing. The distance from the structured environment of her natal home, the unpredictability of what was to transpire, and the range of options presented to her by the people with whom she interacted and conversed during the two months at sea created a space for more radical thinking.

TRANSITION AND ENCOUNTER:
IN THE BOSOM OF FAMILY IN ENGLAND AND IRELAND

On October 28, Zoë finally arrived in London. Once ashore, she made her way by train to Haywards Heath in Sussex where she was expected by her Aunt Madeline, one of her father's nine sisters, and the first of a number of "old world" relatives she was to encounter during this year abroad.[8] These encounters with extended kin made her past tangible and thus offered

grounding to a developing sense of self. Of staying with her Aunt Madeline, she wrote: "I am very glad I came here first as the house is so simply run and it feels more like home—same sort of food, etc. and lovely open fire to sit by in the evenings." After a short stay with Aunt Madeline Zoë moved to Sloane Square where she lived for several months in the apartment of her aunt Florence, a widow who had lost her husband at Gallipoli in 1915. She was welcomed for a visit by her aunt Annette Harris, a widow who had married in Canada in 1913 but returned to England after her husband's death, also at Gallipoli. Aunt Annette told Zoë she had offered to go out to Canada to be with Lionel while Zoë was away. She thought it inappropriate that Zoë had abandoned her widowed father and brother. An unmarried daughter's place was with the men of her family not half way around the world. Although this criticism seemed to confirm Zoë's worst fears about English convention with regard to woman's roles, she did not let it bother her too much:

> I do not think it would be a very good idea [for Aunt Annette to go]. Dad
> is so capable around the house and I think he and Bob are fairly happy
> together. They have the housework down to a science.

In addition to Aunt Madeline and Aunt Florence, Zoë met two more of her father's sisters in England: Kathleen, a spinster like her sister Madeline, and Lucy Pease. When she traveled to Ireland in April of 1939, she was welcomed by three additional Browne-Clayton aunts: Julia Hely-Hutchison, Zoë Hall, and Mary Ruttledge, a widow. She also met the widow of her father's eldest brother Robert who had died suddenly just a few months before, leaving the family estate of Browne's Hill in County Carlow to his eldest son William:[9] "Dad's family really is wonderful, nearly all over 60 yet remain so independent and with quite young and interesting outlooks." Zoë felt more "at home" in Ireland than in England. She liked the informality, the relative lack of pretension, and what she considered to be a more modern worldview. There, no one challenged her about her decision to travel:

> I like Ireland much better than England; it is much prettier and everything
> much more amusing—people not so stuffy and the country is really country
> not just stiff pretend country like in England. David and Michael [Hely-
> Hutchison] hate England and say it is no place to live, and I must say I am
> inclined to agree with them. . . . I think Bob (her brother) and I have more
> in common with the Hely-Hutchinsons than with the English of our age.

On her mother's side, at the Gatehouse at Pyrton Hill, Oxfordshire, England, near where her mother grew up, Zoë met Aunt Lillian ("Lil") and Uncle Leonard ("Len") Bell whom she admired greatly:

> He seems to know a great deal and I think has an open mind. I find him
> exceedingly interesting and easy to talk to; also he will listen to other peo-

ple's ideas and if he doesn't agree explain why. His speech is very English and sounds at first odd to my Canadian ears. He has the family look, nose rather like mother's; often reminds me of Uncle Jack.[10]

She stayed with her aunt Constance Hooker and also visited with Aunt Dorothy ("Dodd") and Uncle Philip Stallard. She remarked to her father that neither Aunt Lil nor Aunt Dodd looked much like her mother; both were tall while her mother was small. Aunt Lil did not have Winifred's social gifts and Aunt Dodd was lacking her mother's "infectious cheeriness."

Her life during the English autumn was a round of sightseeing, lunching with her aunts at their ladies clubs, participating in literary gatherings and teas, reading, and attending plays, concerts, and films. Periodically she popped in to Canada House to read the Vancouver newspapers and occasionally she ran into old acquaintances:

> Found Canada House, Mountie at the door. [I] gave my address at the desk; asked for Margaret Palmer who is in Italy and John Bartholemew who had gone home. Man at desk knew about them without having to look it up in a book. They have a lounge and reading room there with all the Vancouver papers. . . . Saw that Muriel Goode is engaged to Bob Leeson and Peggy Thomson is married to Bill Randall.

Canada House became a home away from home and in the comfort of the sitting room she wrote letters home, with great regularity, to family and friends. In these letters, as in her journal, she recorded observations of English customs, some of which she felt were a bit unreal. Characteristic was her account of her visit with her Aunt Lucy and Uncle Claude at Selaby, not far from the Lake District:

> They all just do what work they want—picnic when they like, dress for dinner, have elaborate meals, lovely gardens, etc.—all sort of a leftover from another age. Uncle Claude sketches, watches birds and finds their nests, fishes a bit, does business when he wants and putters around. Aunt Lucy gardens and has servant trouble like most other English houses of any size.

Amid all the activity of this year, the international crisis was always in the back of her mind. At one point Zoë remarked on how unprepared the British were and at another she recorded the horror with which people observed the Jewish persecution of which they seemed to be well aware. With irony she wrote to her father that she did not think "that Germany will ever really let the Jews out, especially if she finds she can squeeze more money out of them." The Italian invasion of Albania in April of 1939 led her to an observation about the different attitudes her English and Irish relatives expressed toward war and Canada's involvement in it:

> Mother's family think that Canada should join in at once because England has done so much for Canada. Personally I can't see exactly what she has

done and they don't know either. Dad's relatives don't see why she should come in at all when she is far enough away to stay out. They think she would be crazy to come in. Aunt Zoë thinks England is far too imperialistic anyway and is always thrusting her nose in where it is not wanted. I don't know whether she does or not but any way I think she is going to find herself propelled into war by 1940.

During this stage of her journey, Zoë constructed home as a place peopled largely by kin and where she most felt like herself (her self). She constantly drew comparisons among the various places presented to her, preferring the ease of her Irish family to the formality of her English family. Yet despite her life in the bosom of family abroad who offered these homes to her, including giving her extra funds when she ran out of money, her unsettled state and sense of displacement, aggravated by the uncertainties of the European world around her, emerged in dreams:

> I'm feeling very tired all the time, dreaming at night, ever so vividly remember most of them; once dreamt I was home awake in my room and remember thinking in dream that I had dreamt I was in England.

TRANSITION AND REENCOUNTER:
IN THE COMPANY OF FRIENDS

After Christmas Zoë began courses in advertising and shorthand. By March of 1939, with letters coming from her friends and family at home, Zoë was feeling somewhat homesick. She was looking forward with anticipation to the arrival of her friend Norman Hacking. "I guess you know that Norman is coming to England," Zoë wrote to her brother Bob on March 10, 1939:

> He is the most surprising person—I never can get used to the fact that he does what he says he is going to do—so few people mean what they say. I never believed he would come up to the Okanagan last summer and he did; I never thought he'd really write a novel and he has; and I certainly never thought he was serious when he said he'd come to England in the spring and now apparently he is.

Zoë's friend Jim Beveridge also wrote to say he was coming to England. Zoë expressed concern to her father for both Jim and Norman and, by extension, her brother Bob:

> I am worried about them being caught over here. Of course I would rather they didn't fight—it does seem so futile when all it results in is another war in twenty years. However if they had to it would be a great mistake to join the British Army. Class consciousness over here is still too strong for them to find any companionship among English privates. Much better in the

Canadian army. Personally I still think Canada can do more by sending boat loads of grain, food, minerals etc. than boat loads of men. Bob would really do far more good cultivating our land intensively than by trying to shoot a few more Germans and possibly getting shot himself.[11]

Norman arrived in mid-May and after several weeks of seeing the sights in London together, he and Zoë headed off to France, enticed by her UBC friend Lloyd Hobden who was spending a year at the Sorbonne on a scholarship. Zoë recorded that Lloyd was staying "in a very nice hotel, a whole colony of Canadians there and it costs only 40 cents per night." The unnatural calm in Paris during the summer months of 1939 was noted by Janet Flanner (1972:220) in her *New Yorker* column. The city was full of foreign tourists and was experiencing "a fit of prosperity, gaiety, and hospitality. . . . People are enjoying the first good time since the bad time started in Munich last summer."

In Paris, Zoë and Norman were reunited with a small group of UBC graduates who knew each other well during their years on the campus at Point Grey, Vancouver. To this group were added a Canadian-Russian studying medicine, two Americans, an English journalist, a French girl dating one of Zoë's UBC friends, and two French girls studying medicine. Many of them took rooms at the same hotel. Reflecting on this experience in an article she wrote for the alumni magazine of UBC in 1940, Zoë wrote:

> We lived in a semi-domestic atmosphere . . . conditioned by the feeding times of Alan and Francis Walsh's baby Marie. . . . As a group we were not good tourists. Only one of us climbed the Eiffel tower; but that he did by sheer accident. Every day for lunch we met at the same cafe, just off the Boul' Mich and reveled in French biftecks, strawberries and creme fraîche; from there we moved to the bistro across the street for coffee and liqueurs. Gems of conversation flew to and fro and profound conclusions were reached; such as the one "if there is any object or thing in France which is puzzling it almost inevitably has something to do with sex." (Browne-Clayton 1940)

Zoë was immediately attracted to Parisian life:

> The French have the art of living down to a fine science, and most of them look so happy—quite different from the English. In the Latin Quarter nearly everyone seems to know everyone else, full of students. Lloyd knows masses of people and when he goes into a cafe he has to make a procession shaking hands; that is a French custom. . . . In the cafe everyone talks to everyone else, so different from the silent English meals. . . . Life here is very much like that at Varsity or that at home—friendly and easy—people talk instead of grunt like they do in England.

Zoë's reaction to Paris was similar to that of many other "stateless wander-ers" (Minh-ha 1994:13) to whom this city offered a second home. At one point, Zoë turned to her friend Norman and asked him, "Where are all the Bohemians?" to which he replied, "We are the Bohemians." And indeed they were to some extent. They went to nightclubs and stayed out until the early hours of the morning. A good deal of alcohol was consumed and the conversation frequently turned to discussions of war, their generation, repression, homosexuality, and bisexuality. Fred Backhouse, with whom Zoë entered into what she termed an "amorous" relationship, admitted to her one evening that his father was bisexual. They argued about whether homosexuality was instinctive (Fred's position) or due to environment (Zoë's position) and Fred offered the opinion that homosexuals were geniuses because they combined the two sexes in one. "Look at Tchaikovsky or Wilde," he suggested. It was in the aftermath of this con-versation that Zoë speculated in her journal about the sexuality of some of her close friends.

The UBC literati, living on the edge, soaked up a city that was "always awake." Zoë initially thrived on it. It was a change from the life she had been leading for more than a year:

> I feel wonderfully happy, like being back at college again only almost better because as far as fun of this kind goes my life has been rather empty the last few years. Paris sure does things to you. One loses all one's repressions, talks of anything, embraces in public, walks in forbidden parks. . . . Paris makes one feel in one's teens again. Norman hasn't broken loose, but I have almost completely. . . . I don't understand him at all. He just won't unbend and play. But I enjoy being foolish, crazy and young again.

By early July, Paris life began to get Zoë down—"all the drinking and ambling without much direction." She became impatient with her old and new friends, their adolescent life style, and their dirty stories. The "semi-domes-tic" life among fellow Canadian expatriates was not a place she could call home. She and Norman headed off on a bicycling trip in Normandy. Zoë knew she was leaving something she might never experience again, but the practical and rational side of her knew that such living was only an interlude and could not endure. This personal limbo reflected the international limbo of the summer before World War II broke out. From Normandy she and Nor-man returned to England and, joined by Jim Beveridge, they continued their bicycle tour in Devon and Cornwall.

REINTEGRATION: RETURNING HOME

By late August Zoë, Norman, and Jim were back in their "digs" in Kensing-ton and the crisis was upon Europe:

The general feeling of tension loosened English reserve; strangers spoke to each other in busses and theatres. And in our apartment block all the tenants became most friendly and talkative. There was an air of false gaiety about; the restaurants around Picadilly and Soho were crowded each evening and the theatres were packed. We all got fitted with gas masks and after reading the warnings in the papers decided that it would be a good idea to combine together war supplies. The expectation was that in the event of war a general food shortage would result. So with pooled resources we bought a giant box of rye-vita, seven shilling bars of chocolate, three pounds of tomatoes, a bottle of rum and one of sherry. In addition we had an immense Dutch cheese, which Jim had brought back from a weekend excursion in Holland, and we filled the decanters with water. (Browne-Clayton 1940)

Zoë was clearly quite undecided as to what to do. Her aunt Madeline was adamant that she should leave England immediately but she hesitated. She volunteered for canteen work and was told to wait until the air raids began. She made some attempt to look for work in advertising, but no one was hiring. Time had almost stopped. On August 31 she wrote in her journal:

Yesterday I sat around all morning. One is so unsure of what is going to happen tomorrow one makes no plans. Life becomes very pointless. Although everyone is calm there is an underneath strain and tension so one almost wishes war would come to relieve uncertainty and waiting. The weeks seem so endless and yet one has done nothing in it and make no dates ahead.

From Paris, a friend wrote predicting that war would be averted and inviting the UBC crowd back. It sounded appealing and plans were made for a mid-September departure. Then Germany marched into Poland and everyone woke up. It was no longer a lark and a game:

The sky became filled with the silver blimps of the balloon barrage. The landlord of the flatlets where I lived was an Italian who up to this point had been firm in the belief that there would be no war. Now he turned the place into a flurry of activity. Black paper was pasted over every window, hall lights became dim blue bulbs and other lights were shaded in black. . . . Some of the tenants volunteered to help to dig an air raid shelter and they succeeded in creating one deep enough to hide two regiments standing upright. . . . Finally a truck from the Department of National Defense arrived and decided the hole was too big—the country couldn't afford the corrugated iron necessary to cover it up. So they filled up about seven-eighths and turned the remainder into a small kennel-like shelter which would hold two comfortably and four uncomfortably. (Browne-Clayton 1940)

London was in a blackout. "The only lights allowed were the pin prick red and green stop signs." Zoë and her friends each acquired gas masks. Returning to her lodgings with Jim and her cousin Loys from an exhilarating evening watching John Gielgud, Edith Evans, and Peggy Ashcroft perform in a production of *The Importance of Being Earnest*, Zoë described the

> flashes of lightning [that] lit up the towers of Westminster for brief seconds before casting them into inky blackness again. Dim ghostly busses moved slowly down the streets with the conductors shouting out the numbers above the noise of the rain. As we rolled home past Hyde Park the lightning grew wilder, illuminating the gardens and trees in a weird glow, like some make-believe and magnificent ballet set. An appropriate setting for a declaration of war. . . . Depressing all of it, one felt like an odd character in a nightmare; soon one must wake up.

Having firmly decided to leave for Canada in mid September, Zoë made a farewell visit to her family in Ireland. The train she rode was filled with young Irishmen who were returning to their homeland to avoid conscription. Back in England a few days later, Zoë found that all the children had vanished from the city, sent to the country to stay with relatives or friends. All of a sudden ship passage was available on the *Duchess of York*. Jim and Zoë were able to purchase two of the final third-class tickets. Norman decided to remain. Zoë begged her cousin Loys to return with them, predicting that war would change England forever and that it was the beginning of the end of the empire.[12] How right she was! Zoë and Jim set sail on September 15. Just off the coast of England a tanker exploded nearby. The ship was full of people escaping Europe. The seas were rough and only Jim and a Czech man made every meal at Zoë's table. Many people on the ship never entered their cabins or the dining room. Fearful of submarine attack, they remained in the lounge with their lifebelts on throughout the trip. Zoë was not worried but she kept her papers and a flashlight with her at all times.

After eight days at sea, they saw the lights of Quebec City. Zoë was safely delivered to Canadian soil. In Montreal, a city she had never seen before but liked, she found it a relief to talk literature instead of war. She said goodbye to Jim who caught a bus for Ottawa: "I felt like hell. I had gotten used to having him around." After visiting with a few friends, she boarded a train for British Columbia. On the train she made the final entry, dated September 28, 1939, in her European journal:

> The Okanagan train is now rapidly approaching Kelowna where I hope I'll find Dad. The next move for me is most uncertain. I get more and more sure that a winter is all I'll be able to stand.

Zoë's concerns are a reflection of what Carol Stack (1996:ii) has observed in her analysis of the "Call to Home" of African Americans who returned to the South from their lives in the North: "For all of us, in good times and bad, the image of home is multilayered and the notion of return is unsettling."

CONCLUSION

In his work, Victor Turner (1967, 1969, 1978) compares a range of liminal situations including those characteristic of rites of passage and pilgrimage. Zoë's journey has characteristics of both—a journey that separated her temporarily from home and eventually concluded when she returned home and that left her, in between, trying to decide where home was going to be. Home, Robertson et al. suggest (1994:3, 5) "is that from which we are constantly displaced but we try to replace," and if we return home, it is "never the home we left." At the close of her journal Zoë wonders what she will encounter. Her mother was no longer at home and her father, as it turned out, had developed the self-sufficiency she predicted as she responded in her thoughts to the criticism of her journey opined by her aunt Annette.

Osterrieth (1997:36) has noted that by deciding to go on a pilgrimage, an individual takes her/his own destiny in hand. The result, therefore, is a sense of self that comes out "renewed and reinforced." Pilgrimage, she argues, enlarges consciousness of self and of the world stemming from the mundane experience. The same could be said for travel in general because it removes a person from the familiarity of home. The period of liminality or "time-out" while on a voyage allows an individual to gain or regain control of the future. Zoë had a sense as she closed her travel narrative that the childhood home to which she was returning could and would only be a stopping place. Early in 1940 she left to look for a job in Vancouver, eventually finding employment in public relations at the Hudson's Bay Company. Did her year abroad facilitate this final home-leaving? Probably, since it confirmed the ability and possibility of making a life elsewhere. But so too did the fact that she was a woman with advanced education. Most of the other girls who were her classmates in high school spent their entire lives in the Okanagan Mission or moved away only after marriage.

In the winter of 1941 Zoë headed to eastern Canada, eventually taking a position in the capital city of Ottawa (where Jim Beveridge, her friend and partner on the ship back from Europe, had settled) at the Wartime Prices and Trade Bureau. It was in that city and through Jim that she met her future husband and by the fall of 1942 she was married and had started her career in journalism, working first as a reporter for the *Montreal Standard*. Throughout her life, initially in opposition to larger cultural and social trends in the post-World War II period and then increasingly in harmony with them, she balanced work and motherhood roles (Brettell 1999). Much of her writing as a journalist dealt with women's issues and these were sometimes inspired by what went on in her own home. This was one way in which she "expanded home into the public sphere" (Kaplan 1994:137) in a form of writing that was always for others rather than, as in her travel narratives, for those at home or for herself.

In her contribution to a book about narratives of home and displacement Trinh Minh-ha (1994:21) divides voyages into segments: "Every voyage is the

unfolding of a poetic. The departure, the cross-over, the fall, the wandering, the discovery, the return, the transformation." Although this is a somewhat more complex partitioning than that used by Victor Turner, the analytical aims are similar. Furthermore, several scholars of pilgrimage have emphasized its touristic dimensions (Cohen 1992), focusing, as Bell (1997:248) has noticed, on tourism as a "secular substitute for traditional religious experience or the structural similarities in terms of a ritual pattern of transformation by means of spatial, temporal and psychological transition." As I thought about Zoë's voyage/pilgrimage, the tradition of the Grand Tour came to mind. The Grand Tour was a journey undertaken primarily by the sons of the European elite at a specific time in life as part of their education (Hibbert 1969; Black 1992). Their tour included the major historical and artistic sites of the continent, the mountains of Switzerland, and, as a culmination the monuments of ancient Rome. Clearly this was not Zoë's experience although her trip was undertaken at roughly the same time of life. Neither her journey nor her narratives of it were focused on sites, but rather on the people she encountered. She wrote, during this liminal phase of her life, of experiencing and sharing, of otherness and human conversation, of difference, and, between the lines, of self. Hers was, in many ways, a "safe" voyage in that she was always "at home" with family or friends and even her testing of the waters of a bohemian expatriate lifestyle in the cafés of Paris verged, at least initially, on the semi-domestic. But as a white woman of middle-class background she could choose to take this journey in search of home. None of the homes she lived in, neither the one she left nor the ones she temporarily constructed and occupied during her year abroad, were sites of violence or repression like those of other women written about in this volume. Rather they were sites of kinship, fellowship, and hospitality and thus could remain as havens throughout her life—places to which she was welcome to return.

AFTERWORD: A ROOM OF ONE'S OWN

In the month before Zoë, my mother, died, I overheard a telephone conversation she was having with her brother Bob, who married a Kelowna girl and was still living in the family home. At one point she told her brother that what she really wanted to do was return to the Okanagan and to her old room, a room where you can still see her name etched into the wooden window sill. Her life had taken her on a journey from one end of Canada to the other, and she had lived in her home in Montreal for many more years than she had in her parent's (now her brother's) home in the west. In Montreal, in a house built on the side of Mount Royal, she treasured her bedroom with a view of the city and of the St. Lawrence River. And yet in this final phase of life the home and room of her childhood was very much present in her mind as a place of safety, security, and rootedness. Perhaps the memory of this

room, and the resilience of home,[13] is what provided the foundation for the kind of financial, emotional, and geographical independence that Virginia Woolf called for with the metaphor of "a room of one's own" and that Zoë went in search of during the voyage out that she had taken more than fifty years prior to her death.

NOTES

1. Kaplan (1996:54) observes that Paul Fussell, in his highly respected book *Abroad*, omits Euro-American women writers from his analysis thereby suggesting that "real travel books are the creation of an elite group of British, male writers between the two World Wars." Fussell, of course, limited his work to published accounts of travel and living abroad.

2. See also Sarap 1994. It is this encounter with the Other that leads some scholars to classify women's travel accounts as a form of colonial discourse because they often involve written descriptions by Western women of the peoples of Africa or India or Asia (Middleton 1965; Birkett 1989; Kingsley 1991; Mills 1991).

3. Some of the material in this chapter also appears in my book *Writing Against the Wind: A Mother's Life History* (Scholarly Resources Inc. 1999). I am grateful to Scholarly Resources for allowing me to delve further into the material in the context of this chapter.

4. Clifford (1997) evaluates several terms that cover the different displacements and interactions of the late twentieth century and includes pilgrimage among them.

5. For a discussion of the course of the Great Depression in Canada, see Berton (1990).

6. The Okanagan Mission was a settlement of primarily English and Irish immigrants, many of them well-born, near Kelowna, British Columbia, about two hundred miles inland from Vancouver. Zoë's father, Lionel Browne-Clayton, had arrived there from Ireland in 1909 and eventually purchased land to start an apple orchard. Her mother, Winifred Bell, came out three years later from England to keep house for her brother Jack. Lionel and Winifred met and were married in 1914.

7. John, Norman, and Nancy were friends of Zoë's at the University of British Columbia. They all worked together on the university newspaper, *The Ubyssey*. Zoë did lose track of John over the years but Norman remained a lifelong friend as did Nancy, who became godmother to Zoë's daughter.

8. Encounter is one of the stages of pilgrimage identified by some scholars (Osterrieth 1997:32).

9. The Browne-Clayton family of Ireland is included in *Burke's Book of Irish Gentry* and the house, Browne's Hill, is a published Georgian House. See de Breffny and Ffolliott (1975). There were twelve children in Lionel's generation, three sons and nine daughters. The eldest son inherited the estate and the daughters were dowered. Lionel, as the third son, had to fend for himself.

10. Jack Bell was the brother for whom her mother traveled to Canada in 1912 to keep house.

11. Bob did enlist and saw action in Italy where he was wounded (his ear was shot off) and spent time in a military hospital before being sent home.

12. Loys was a daughter of her mother's brother Jack Bell (see note 10). She and Zoë were close throughout their girlhood in the Okanagan Mission (Brettell 1999). Loys went to England after graduating from high school. She studied nursing, spent time in India during the war, and married a doctor. She never returned to Canada except to visit.

13. Rapport and Dawson (1998:32) refer to this resilience of home among migrants who lead their lives in and through movement, both cognitive and physical.

BIBLIOGRAPHY

Andrews, William L., Sargent Bush Jr., Annette Kolodny, Amy Schrager Lang, and Daniel B. Shea, eds.

———. 1990. *Journeys in New Worlds: Early American Women's Narratives*. Madison: University of Wisconsin Press.

Bell, Catherine. 1997. *Ritual: Perspectives and Dimensions*. New York: Oxford University Press.

Berton, Pierre. 1990. *The Great Depression 1929–1939*. Toronto: McClelland and Stewart.

Bhardwag, Surinder M., and Gisbert Rinschede. 1990. Pilgrimage in America: An Anachronism or a Beginning? *Geographia Religionum* 5:9–14.

Birkett, Dea. 1989. *Spinsters Abroad: Victorian Lady Explorers*. Oxford: Blackwell.

Black, Jeremy. 1992. *The British Abroad: The Grand Tour in the Eighteenth Century*. New York: St. Martin's Press.

Blunt, Alison. 1995. *Travel, Gender and Imperialism: Mary Kingsley and West Africa*. New York: Guilford Press.

Brettell, Caroline B. 1999. *Writing Against the Wind: A Mother's Life History*. Wilmington, Del.: Scholarly Resources.

Browne-Clayton, Zoë. 1940. *Lights Out in Europe. The Graduate Chronicle*, May 7. Alumni Association of the University of British Columbia.

Clifford, James. 1997. *Routes: Travel and Translation in the Late Twentieth Century*. Cambridge: Harvard University Press

Cohen, Erik. 1992. Pilgrimage and Tourism: Convergence and Divergence. Pp. 47–61 in Alan Morinis (ed.), *Sacred Journeys: The Anthropology of Pilgrimage*. Westport, Conn.: Greenwood Press.

De Breffny, Brian, and Rosemarry Ffolliott. 1975. *The Houses of Ireland: Domestic Architecture from the Medieval Castle to the Edwardian Villa*. London: Thames and Hudson.

El Moudden, Abderrahamne. 1990. The Ambivalence of Rihla: Community Integration and Self-definition in Moroccan Travel Accounts, 1300–1800. Pp. 69–84 in

Dale Fr. Eickelman and James Piscatori (eds.), *Muslim Travelers: Pilgrimage, Migration, and the Religious Imagination*. Berkeley: University of California Press.

Fawley, M. 1994. *A Wider Range: Travel Writing by Women in Victorian England*. Oxford: Oxford University Press.

Frederick, Bonnie, and Susan H. McLeod, eds. 1993. *Women and the Journey: The Female Travel Experience*. Pullman: Washington State University Press.

Fussell, Paul. 1980. *Abroad: British Literary Traveling Between the Wars*. Oxford: Oxford University Press.

Hibbert, Christopher. 1969. *The Grand Tour*. London: Spring Books.

Kaplan, Caren. 1994. The Politics of Location as Transnational Feminist Critical Practice. Pp. 137–52 in Inderpal Grewal and Caren Kaplan (eds.), *Scattered Hegemonies: Postmodernity and Transnational Feminist Practices*. Minneapolis: University of Minnesota Press.

———. 1996. *Questions of Travel: Postmodern Discourses of Displacement*. Durham: Duke University Press.

Kingsley, Mary. 1991. *Travels in West Africa*. C. E. Tuttle.

Massey, Doreen. 1994. *Space, Place and Gender*. Minneapolis: University of Minnesota Press.

Melman, Billie. 1992. *Women's Orients. English Women and the Middle East 1718–1918*. London: Macmillan.

Middleton, Dorothy. 1965. *Victorian Lady Traveler*. New York: E. P. Dutton.

Mills, Sara. 1991. *Discourses of Difference: An Analysis of Women's Travel Writing and Colonialism*. London: Routledge.

Minh-ha, Trinh T. 1994. Other than Myself/My Other Self. Pp. 9–26 in George Robertson, Melinda Mash, Lisa Tickner, Jon Bird, Barry Curtis, and Tim Putnam (eds.), *Travellers' Tales: Narratives of Home and Displacement*. London: Routledge.

Moore, Henrietta L. 1994. *A Passion for Difference: Essays in Anthropology and Gender*. Bloomington: Indiana University Press.

Nelson, Dana. 1995. Diaries and Journals. Pp. 244–47 in Cathy N. Davidson and Linda Wagner-Martin (eds.), *The Oxford Companion to Women's Writing in the United States*. New York: Oxford University Press.

Ochs, Elinor, and Lisa Capps. 1996. Narrating the Self. *Annual Review of Anthropology* 25:19–43.

Okely, Judith, and Helen Callaway. 1992. *Anthropology and Autobiography*. London: Routledge.

Osterrieth, Anne. 1995. Pilgrimage, Travel, and Existential Quest. Pp. 25–40 in Cathy N. Davidson and Linda Wagner-Martin (eds.), *Sacred Places, Sacred Spaces: The Geography of Pilgrimages*. Baton Rouge: Louisiana State University.

Personal Narratives Group. 1989. *Interpreting Women's Lives*. Bloomington: Indiana University Press.

Porter, Dennis. 1991. *Haunted Journeys: Desire and Transgression in European Travel Writing*. Princeton: Princeton University Press.

Rapport, Nigel, and Andrew Dawson. 1995. Home and Movement: A Polemic. Pp. 19–38 in Nigel Rapport and Andrew Dawson (eds.), *Migrants of Identity: Perceptions of Home in a World of Movement*. Oxford: Berg Publishers.

Robertson, George, Mellinda Mash, Lisa Tickner, Jon Bird, Barry Curtis, and Tim Putnam, eds. 1994. As the World Turns: Introduction. Pp. 1–6 in George Robertson, Mellinda Mash, Lisa Tickner, Jon Bird, Barry Curtis, and Tim Putnam (eds.), *Travellers' Tales: Narratives of Home and Displacement*. London: Routledge.

Sarap, Madan. 1994. Home and Identity. Pp. 93–104 in George Robertson, Mellinda Mash, Lisa Tickner, Jon Bird, Barry Curtis, and Tim Putnam (eds.), *Travellers' Tales: Narratives of Home and Displacement*. London: Routledge.

Somers, Margaret R., and Gloria D. Gibson. 1994. Reclaiming the Epistemological "Other": Narrative and the Social Constitution of Identity. Pp. 37–99 in Craig Calhoun (ed.), *Social Theory and the Politics of Identity*. Cambridge, Mass.: Blackwells.

Stack, Carol. 1996. *Call to Home*. New York: Basic Books.

Turner, Victor. 1967. Betwixt and Between: The Liminal Period in Rites of Passage. Pp. 93–111 in Victor Turner (ed.), *Forest of Symbols*. New York: Cornell University Press.

———. 1969. *The Ritual Process: Studies in Anti-Structure*. Chicago: Aldine.

Turner, Victor, and Edith Turner. 1978. *Image and Pilgrimage in Christian Culture*. New York: Columbia University Press.

Wesley, Marilyn C. 1995. *Secret Journeys: The Trope of Women's Travel in American Literature*. Albany: State University of New York Press.

Wollstonecraft, Mary. 1995 [1792]. *A Vindication of the Rights of Woman*. Cambridge Texts in the History of Political Thought. Cambridge: Cambridge University Press.

SEVEN

Desire, Migration, and Attachment to Place

Narratives of Rural French Women

DEBORAH REED-DANAHAY

There is, then, an issue of whose identity we are referring to when we talk of a place called home and of the supports it may provide of stability, oneness and security.
—Doreen Massey, 1994:167

RECENT DISCUSSIONS OF geographies of identity (Bammer 1994; Kaplan 1998; Keith and Pile 1993; Lavie and Swedenburg 1996; Rapport and Dawson 1998) focus primarily on transnational migration, and on populations facing various forms of dislocation and/or displacement. Colonial and postcolonial politics of exclusion and control in the margins, emanating from Europe as the "center," provide the dominant focus in this literature. This is primarily a view from the urban centers of the metropole in which the migrants have landed. In response to this literature, Creed and Ching (1997:3) rightly point out that "it is remarkable that the explosion of scholarly interest in identity politics has generally failed to address the rural/urban axis." (See also Sommestad 1995 on the neglect of rural women's experience.) They argue for an opening up of the postmodern emphasis on the city to include, as Raymond Williams (1973) elucidated over two decades ago, the ways in which the rural and the urban define each other. The countryside

is perceived through notions of national identity, gender roles, and moralities of modernity. The pristine view of rural life, as untainted by change or outside influence, as somehow "out of time" (Thomas 1989) is part of this complex of ideas. Geographer Doreen Massey suggests that the boundedness associated with local places is a construct and that "a large component of the identity of that place called home derived precisely from the fact that it had always in one way or another been open . . . in one sense or another most places have been 'meeting places'" (1994:171).

Rural women, and their relationship to home have been subject to a range of representations. As Carolyn Sachs (1996) points out, understandings of rural women are obscured by cultural constructions that oppose urban and rural and that view women in terms of ideal types. She writes that "portrayals and perceptions of rural women's lives range widely from romanticized harmonious images of women working with nature in bucolic settings . . . to representations of overworked, strong women grinding out their daily existence" (1996:1). Concepts of tradition and modernity are both, as Jane Fishburne Collier (1997) suggests, aspects of the "modern." Following Foucault and others, Collier writes that "tradition remains vibrant because modern discourses of nationalism require people to have traditions" (1997:213). Discourses about what is rural and traditional are gendered, so that "women are more often cast as the bearers and enactors of tradition than men" (1997:210). In her study of discourses of home and "modern" among Andalusian informants, Collier found a shift over a period of thirty years spanning changes toward democracy in Spain, from a view of home as a site of "duty and constraint" to a space of "freedom and desire." Women continue to be associated with home as a private space in which traditions are upheld. In more recent times, however, tradition has increasingly come to be seen by Collier's informants as a matter of "choice."

Rural women are tied to nationalist rhetorics of tradition *vs* modernity, particularly because of the central role that they play in households and private family life as dutiful wives, mothers, and daughters. This construction, which pits traditional duty against modern desire as a way of defining the modern, permits no neutral ground in moral evaluations of women's roles. Rural women can be transgressive for being too linked to duty and patriarchal family forms or they can be viewed as transgressive for seeking pleasure either through marriage or outside of the family. Susan Carol Rogers (1987) has drawn attention to the changeable position of the "peasant" in French national discourse, without specifying gendered variations on the theme. In her analysis, she found that the peasant sometimes represents a romantic ideal and at other times represents all that is backward and uncivilized. She links the concept of the peasant to French national identity, explaining that

The quintessence of Frenchness derives (both literally and figuratively) either from its dominant center (Paris) or from its authentic many-shaped roots (assemblages of provinces). The process of change in France can be read as one in which cultural diversity is alternatively managed, coordinated, masked or highlighted. The peasant persona serves this process, sometimes as the antithesis of modern France and sometimes as its authentic essence. (1987:56)

I would suggest that this can be read in gendered terms as well. Female peasants, depending upon the values projected onto them, can be viewed as symbols of an outmoded past or associated with what are considered to be the most basic values underlying the nation—particularly family values.

In this essay, I examine the life stories of three women in rural France in order to interrogate the possibilities for and constraints on female experience that they portray.[1] These stories are part of French popular culture—they are published and available for purchase at book stores. They thereby inform and are informed by ambivalences in French cultural attitudes towards women's roles. As social historian Mary Jo Maynes (1989:105) reminds us, autobiographical narratives "impose order, form, and meaning on the facts of existence" and are "informed by available [cultural] models as well as by the details of their [authors'] experiences." The three narratives I discuss here each deal with issues of gender identity, migration, and sense of place. There are significant differences, however, in the ways in which the stories narrate the possibilities for travel, transgressive or not, in these women's lives. Connections to family and home are major cultural values expressed by the women in their stories. These life narratives, even when portraying "modern" and seemingly transgressive behavior on the part of the women, reinforce the conventional value of woman's duty to family.

READING LIFE STORIES AND AUTOETHNOGRAPHY

There has been a steady production in France of published rural memoirs or life histories throughout the twentieth century. The publication of such texts has, however, increased dramatically since the 1980s. There are many such texts available, published by large Parisian firms as well as by small regional presses or even self-published in some cases. Some of these tend to be more autobiographical, while others are more ethnographic—focusing on the way of life of the region more than on an individual life. Most of these tell the life stories of men and are either directly penned by the narrator or are written with the intervention of a male interlocutor. I have written elsewhere (Reed-Danahay, ed. 1997) of the genre of autoethnography into which many of these texts fall. The appearance well into the late twentieth century of stories written or narrated by older people who grew up in French villages occurs

at a time when, not surprisingly, France has the smallest farming population in its history—at about 4%. However, it is also a period in which Paris and its nearby region are losing population while rural regions are gaining—due primarily to the resettlement of urbanites to the countryside that has been enhanced by new technologies and modes of transportation that permit telecommuting and easy weekend access to second homes. The loss of rural population through out-migration has, however, stabilized in many parts of the country in recent years. This reflects population movements of "neo-ruralism," a return to rural villages and towns, and not a resurgence of farm-ing, which continues to decline. The life stories of those mythically linked to some notion of a previous authentic rural lifestyle associated with agriculture have become increasingly visible in popular culture at this historical moment. Late twentieth-century, and early twenty-first-century France also represent a time of high unemployment, anxiety about national identity asso-ciated with the growing influence of the European Union and globalization pressures, a growing divorce rate, an increase in cohabitation among couples who are not married, and a surge in feminism that has come much later than in the United States. A romantic longing for a rural past that represents key cultural values and a simpler life is shared by people across the political spec-trum in contemporary France.

A focus on individual lives in ways that represent wider social trends is common in European biographical approaches (Bertaux and Kohli 1984). The continued demand for rural memoir in France today reflects all of the above social tendencies. For the purposes of this essay, I want to draw atten-tion to the ways in which this memoir production is a gendered activity that constructs female experience (especially of travel and rural migration) in par-ticular, culturally meaningful ways.

The first of the three texts under consideration here was published in 1977. The life story of Emilie Carles, it is entitled *Une Soupe Aux Herbes Sauvages* (literally, "a soup of wild herbs") and has since been translated into English with the title *A Life of Her Own* (Carles 1991).[2] The second book, *Au Pays d'Yvonne: Memoires d'une paysanne leonarde* ("In the Land of Yvonne: Memoirs of a Leonard Peasant") was published in 1991. The most recent is the story of Antoinette, *Une Vie de Femme in 1900: Antoinette. Souvenirs* ("A Woman's Life in 1900: Antoinette. Memories") published in 1995. It is through my own experiences of travel to France that I located and purchased these texts. I first read Emilie Carles' story while doing fieldwork in rural France during the early 1980s, having accidentally come across it through a mail-order book club to which I subscribed in France. I found Yvonne's story in Paris in 1996 during a trip specifically aimed at locating autobiographic narratives of rural lives; I purchased it in a well-known Parisian bookstore. I found the book on Antoinette in 1998 during a research trip to the Auvergne region and purchased it in a regional bookstore in Clermont-Ferrand. All

three texts are readily available to the French reading public, which is why I have chosen to focus on them here. They are, however, just a few of the one hundred rural French memoirs and life histories (most of which are more obscure and less in the public eye) that I am in the midst of analyzing.

One way to approach these texts would be to examine the individual strategies of their protagonists in order to gain insight on women as social actors in rural France—to help flesh out the demographic record with experiential accounts and to debunk various myths of rural women through counternarratives by women in their own voices. Although I am in sympathy with this approach and might adopt it were I dealing with oral history material that I had collected myself, I do not view it as the best approach to the texts I will discuss here. I read these texts, rather, as a way of understanding images of rural women and ideologies of family and gender in French popular culture during the late twentieth century. All three books have been recently published in paperback editions readily available to the general reader. Each was published by a major French publishing firm and selected, one assumes, because of their marketability and broad appeal. The experiences of women earlier in the century are, therefore, being rewritten onto the present through such texts as they subtly engage with contemporary attitudes of readers toward women and their life choices.

An important feature of the stories of Antoinette, Emilie, and Yvonne bears mentioning as a cautionary note. All are "as told to" life histories molded into coherent first-person narratives by their interlocutors, who, in each case, are male. The vast majority of first-person narratives of rural life that have been published and that treat the lives of average people rather than those who went on to become famous writers or public figures have been composed in the "as told to" genre.[3] Emilie's collaborator was a French journalist who at first downplayed his role in the creation of the text and subsequently became more up-front about it in later editions. Yvonne's story was told through an ethnographer and folklorist who used oral history methods. Antoinette's voice was interpreted by her grandson from memories of her stories, although this must be inferred from the text. These stories cannot, therefore, to be read as "authentic" female voices about lived experience. I follow Joan Scott (1991) in taking a critical perspective on notions of "authentic experience" and focus on the ways in which these narratives construct female experience rather than reflect it directly. It is impossible to know how much of the text reflects directly the words and experiences of these women and how much is based on material inserted or interpreted in various ways by the compilers, who were male. While I will argue here that these books are basically conservative in their messages about women's roles, the introduction to the English translation to Emilie Carles' book was written by a female scholar, and it works hard to cast Carles as a feminist, even though she never espouses that position in her own remarks. The title of that translation, "A

Life of Her Own," must certainly also be seen as deliberately echoing Woolf's "A Room of One's Own." While not intending to diminish the accomplishments of Emilie Carles, my own reading of this and the other two texts is that they underscore aspects of female experience that are constraining—in some ways, keeping women in their conventional place. Whether or not this is a result of their interlocutors having been males is not a straightforward issue, but certainly one that needs acknowledgement. My interest in these texts lies in the images that they portray of rural women, of the possibilities and limitations of their lives, and in their responses to their conditions of existence.

The women in question here represent three successive generations of rural women, born twenty years apart beginning in the late nineteenth century. They lived in three different regions of France under different historical and material circumstances. Each woman's narrative is constructed from the perspective of old age and reflects upon the choices and constraints that her life presented. In reading these texts, I explore the ways in which each woman either embraces or resists forms of geographical dislocation or relocation. In order to understand the ways in which the women engaged in or even contemplated transgressive travel, it is important to consider the various discourses of expected female behavior in her milieu. Each of these women played a pivotal role in her family as dutiful daughter, wife, and mother, and worked to keep families together. I will suggest here that the stories in these three books place a higher value on a woman's duty to her family than on her geographical locations, conveying the message that she can pursue her desires as long as these do not conflict with her duty to family. Each of these women respond to this value system differently, however.

ANTOINETTE, EMILIE AND YVONNE

The three women are Antoinette Blachon, born in 1880 in the region of Ardèche in south-central France; Emilie Carles, born in 1900 in the Alpes region of southeastern France; and Yvonne Riou, born in 1919 in the region of Brittany. I will begin with the story of Yvonne, and then move to those of Emily and Antoinette.

YVONNE

Yvonne Riou is a farm woman born in 1919 in a region of Brittany well known for its conservative Catholicism. Her story begins with her birth and ends with her marriage in 1945. Yvonne presents herself as the model of a "good girl" who is decidedly not transgressive in her behavior and who actively and consciously resists temptations to engage in such behavior. In this way, she actively privileges what she constructs as "traditional" over the "modern." She is devoutly religious, remains chaste until marriage, values

hard work, shuns urban attractions, and eventually marries the boy next door—despite her girlhood dreams of a romantic marriage. Yvonne stresses the strong role played by women in this region and portrays men as weak. Her own father, an alcoholic, was often absent from the household. It is Yvonne's mother who played the central role in her life, teaching her the virtues of the good farm wife by example and through a strict surveillance of Yvonne's upbringing.

Yvonne portrays herself as understanding the value of farming from a very young age. Manual labor, she was taught by her devout mother, was a form of prayer. When her parents finally purchased their own farm, and she was just nine years old, she already knew, she writes, "how much this means to peasants . . . to die on their land. This is the condition of happiness" (54). Here she is celebrating the connection of farmers to land, especially when they are proprietors and have an economic stake. Uninterested in school or in books, Yvonne felt liberated when she finally returned home after Catholic boarding school. Although the nuns tried to interest her in a religious vocation, she resisted and chose to stay with her parents. In her words, "What greater pleasure for a human being than to stay at home for ever? The life on the farm represented for me perfect happiness, despite the unceasing work" (204).

Yvonne was well aware of the possibility of migration to the city—either Brest or Paris. Some young women did leave, including her sister, to marry urban men. Yvonne says:

> It happened from time to time that I envied the lot of those girls who didn't have to work, the young ladies of the city. We, the girls of the fields, railed against this injustice at the same time that we worked ourselves to death. But we adjusted bit by bit to the work, even those whose hearts were not in it at the beginning. In any case, we had no choice. My sister Mimi did not share my taste for agricultural labor. She didn't stay on the farm, moreover, and married a worker. (175)

By contrasting her own virtues with the faults of her urban cousins, Yvonne expresses the ideal values associated with rural life. She does this in a chapter entitled "Girls of the Cities and Girls of the Fields." Here, Yvonne expresses her rejection of urban life through a contrast between herself and her female cousins from the city who often came to visit. She begins the chapter "We . . . felt no jealousy for the girls of the city. We envied neither their clothing nor their affectations . . . we scorned them" (211). The virtues of the country girl are thereby championed through the criticisms of the city girl. Yvonne tells us that girls in the city didn't know how to work hard, they were vain, they didn't respect their elders, they didn't practice their religion, and they lived in a hierarchical and class-stratified society. All of these ills, her story suggests, were absent from the rural idyll in which she grew up.

When discussing her own community, Yvonne denies class differences or social problems and portrays the village as a face-to-face community where all were accepted despite the economic differences among them. Social class differences are, thus, downplayed in her privileging of the urban/rural dichotomy as the key social division.

Yvonne highlights her resistance to transgressive travel by relating a pivotal incident involving her fiancé in a chapter called "The Good Reputation." Taken as a war prisoner by the Germans, Yvonne's fiancé, who was the son of neighboring farmers, gained a short leave during their five-year separation and sent word for her to meet him in Paris. When Yvonne showed her mother the letter, her mother cried out, "My God, a young girl like you chasing after a man! What will the world say? Our neighbors will soon spread this throughout the village. It would be better for you to meet your fiancé [closer to home] rather than in Paris, where you would have to stay together under the same roof. What a scandal!" (217). Having internalized the morality of the priests, nuns, and her mother, Yvonne remained chaste and stayed home rather than meet her fiancé.

The image of the rural woman presented in Yvonne's story is that of the virtuous girl and, later, wife who represses her desires, rejects education, and resists temptations to travel or migrate. At the same time, however, it is a story that celebrates the strength of women who, like Yvonne's mother, hold the family and farm together despite weak husbands and the lures of urban life. Devotion to family, to the church, and to regional identity as preserved in rural life are the central themes of Yvonne's life. The influence of religious values, and of an agrarian ideology associated with tradition that was prevalent during mid-century France, especially heightened during the Vichy regime, and is clearly seen in the messages conveyed by Yvonne's narrative.

EMILIE

Yvonne's self-portrait of the ideal traditional wife and mother in contemporary France is an effective foil to the stories of Emilie Carles and Antoinette Blachon. An alternative image of rural women is portrayed in the life story of Emilie Carles, who was born almost twenty years earlier than Yvonne, in 1900. Emilie grew up in the region of Briançon, in the Alpes region of southeastern France. Despite some of her own statements, such as "all my life I have lived where I was born" (1991:2), Emilie embraced travel, and train trips are key symbols of the transitions in her life, as they are symbols of modernity in France. Emilie escaped what she perceived as the drudgery of women's agricultural labor through the most common avenue for her generation—that of becoming a schoolteacher. She is critical of patriarchy and of the limited roles for women in her milieu. Rather than accepting her fate piously, as did Yvonne (who writes,

"we had no choice"), Emilie parodies peasant marriage arrangements in which young girls become the pawns in their father's economic strategies. She tells the reader that "Usually the men arranged things without consulting anyone. . . . 'Say, you've got a girl at home, I've got a son—why don't we marry them off? I've got the farmhouse, you've got the land. So if it's all right with you, let's draw up the contract'" (1991:8).

Whereas Yvonne identified with her mother, and set up a distinction between herself and girls of the city, Emilie distanced herself from rural farm women like her mother. Orphaned at an early age due to her mother's death, Emilie was raised by her father in a household with several siblings. Lacking the strict surveillance of a devout mother, which was a guiding factor in Yvonne's life, Emilie portrays herself as more of an independent thinker than does Yvonne. She is critical of her father's peasant worldview. In what she experienced as the backward, stifling environment of her village, literacy and schooling became Emilie's haven. For Emilie, "home" was not the farm nor the land, but school. She says, "I loved school; I loved to study; I loved reading, writing and learning. I felt at home the moment I started school, and I blossomed" (1991:42).

After overcoming several obstacles concerning family obligations in her desire to become a schoolteacher, Emilie left on a train for Paris to continue her studies at age eighteen. In Paris, living with a cousin whose boyfriend was an anarchist, Emilie discovered, as she puts it, "a world unknown to me" (1991:79). She began to doubt her religious faith and was drawn to a way of thinking that she felt to be the opposite of that among the peasants back home. Still, after completing her training in Paris, she accepted a teaching post back in the region she was from. She explains that she wanted to be close to her father, who needed her. Various temporary posts in the region eventually resulted in Emilie's securing a job back in the village where she grew up.

In a far cry from Yvonne's experience in marrying the boy next door, Emilie met her future husband, Juan Carles, on a train trip back home from Lyon. Of their first meeting, she says, "Once I got started, I couldn't stop. I told him the story of my life, and he—a man I didn't even know—sat there listening to me, he inspired trust" (1991:147). In her old age, after Juan dies, Emilie became highly visible on a national level for her environmental activism in halting the construction of a highway through her native valley. Even though she used travel, albeit by train, to accomplish her own goals, she opposes this highway because it will destroy the natural environment. Her attachment to home, the rural, and the regional is, it becomes clear at the end of the narrative, based on nature and on the concept of regional identity as connected to the territory of the region—not on the "backward" peasants who live there nor on agriculture per se.

In her life story, Emilie confirms women's attachment to family and to place, even as she tell stories of her separation from local values and women's

roles. At various points, she altered the course of her life in order to accom-
modate her family—as when she moved back home to care for her aging
father. Her roles as dutiful wife and daughter are stressed in the narrative,
even as she pursues her goals of becoming educated and overcoming her
background. Emilie presents herself as a modern woman who has rejected the
traditional, backwards ways of her parents, but who nevertheless continues to
accept her duties to family and to the preservation of local identity. Her story
does not depend upon religion and agrarian values, as does that of Yvonne,
and Emilie portrays herself as an atheist, but the narrative nevertheless rein-
forces the basic attachment of a woman to family and place.

ANTOINETTE

The final example I will use here is that of the life of Antoinette Blachon,
born in 1880 (twenty years before Emilie Carles), who grew up in a village in
the Ardèche (south-central France). Antoinette's life story presents yet
another model of a woman who confronts the possibility of living the life of
her mother or seeking another destiny. Antoinette's father was a horse trader,
and her mother maintained the family farm. Antoinette's mother is portrayed
as a strong-willed woman who held the family together while her father, the
horse trader, earned little money and was often absent from the household as
he traveled for his trade. She refers to her father as a "papillon" (butterfly); in
contrast, she describes her mother as a "maîtresse femme" (woman-in-charge).

Antoinette was exposed to agricultural labor at an early age when she
assumed the common role for rural girls as a shepherdess. But this was trau-
matic for her, and she never managed to feel comfortable with the animals,
who seemed always to slip out of her control. Lacking enthusiasm for farm
labor, she also lacked interest in either religion or education as a young girl.
Raised in a Catholic community that was not particularly devout, Antoinette
was not exposed to the same conservative religious teachings as was Yvonne.
She eventually married a man from a region that is more devout, however,
and later in life came to adopt a more conservative Catholic worldview—
sending her own children, for example, to Catholic schools. Of her own early
public schooling, she says, "Since I was learning nothing at school, content
to repeat what I had learned the year before, my mother, who thought that a
girl had no need for a diploma, withdrew me during the year of the [primary
school] certificate" (29). Antoinette expresses no regrets about this, explain-
ing that she wanted to work in the silk industry, and she found work in the
nearby town. This begins a series of moves, including one to Paris during
early adolescence, where she was invited to spend time with a wealthy great-
aunt. She both rejected and was rejected by the self-centered aunt who
seemed to embody the negative qualities of the *arriviste*[4] in Paris. Antoinette
returned to the provinces, where she remained for the rest of her life.

While the stories of Yvonne and Emilie pose a traditional *vs* modern opposition, with each woman responding to it differently, Antoinette's narrative relies on concepts of social class and class mobility to a greater degree than the other two. Antoinette does not pit the country girl against the city girl; rather, she moves in and out of both roles throughout the course of her life. She met her future husband at the train depot near to the cafe where she was working at the time—in a context of commerce. The social milieu she describes was full of movement between villages and towns, with fluid, permeable boundaries. After their marriage, Antoinette and her husband embarked on a life in a provincial city—a life based on acquiring capital through business ventures and hotel ownership.

Antoinette explicitly expresses bourgeois values and states that she aspired to this class. Her mother encouraged social mobility. Antoinette says: "My mother was ambitious. She wanted her children to grow up, leave the condition of 'petit paysan' and rise to the bourgeoisie which she envied" (1995:40). Since her brother, as the male, would inherit the family property, Antoinette's mother saved money for her from her first jobs in a savings account and encouraged thrift. There were two ways to raise one's class position, Antoinette learned from her: through hard work and through savings. Her own region was poor, and Antoinette explains that it was the impossibility of making a living there that eventually drove her to seek her destiny elsewhere: "I congratulate myself for having left this poor region where one had to struggle without stop, not in order to elevate oneself in society, but simply to survive" (1995:94). The family prospered, largely due to Antoinette's business sense. In due course, Antoinette's path out of rural life led back to agriculture—when her husband decided late in life that he wanted to be a farmer. When they settled back on the land, however, they did so as proprietors of a small manor with two farms, as employers of agricultural laborers rather than as small family farmers. Antoinette describes herself as being, like her mother, the dominant partner in her marriage, managing the family estate and raising of the children despite her husband's relative lack of ambition.

The image of the rural woman portrayed in Antoinette's story is that of someone who took charge of her life, freely handled her own money and that of her husband, and made her own decisions in a universe in which there were few constraints. She did not reject her mother's role, as did Emilie; rather, she continued the social mobility envisioned by her mother and fulfilled her mother's ambitions and desire for wealth. Whereas Yvonne's mother constrained her, Antoinette's mother encouraged her to leave their village and seek a better life elsewhere. At the same time, however, Antoinette never strayed too far, and remained in the provinces, maintaining some continuity with the life of her parents. As with the other two women, duty to family was the paramount value conveyed in Antoinette's narrative.

WOMEN AND RURAL LIFE:
IDEOLOGIES OF DUTY AND DESIRE

Stories of rural women in France are posed against a backdrop of the recurrent theme of rural depopulation through out-migration in French history, and the role of women and their mothers in migration. For social conservatives in France, it is transgressive for a woman to leave village life, thereby abandoning a potential husband and refusing to support the reproduction of a farm family. Although the strongest waves of out-migration from French villages occurred in the early twentieth century and again after World War II, concerns about rural migrants leaving for towns and cities were being expressed by numerous commentators in France as early as the mid-nineteenth century. Historian Frederic Le Play wrote in 1865 that "the difficulty arises primarily among the youth and the women, who, not being able to find outside of the cities the satisfactions of their complicated desires, refuse to submit themselves to the simple habits of rural life" (1865:62; cited in Pitié 1967; my translation). As expressed in Le Play's rhetoric, much popular imagery in France has defined the act of leaving the land as a form of transgressive travel that violates important cultural values of attachment to place and region. There is something suspect or deviant, as Le Play suggests, about the person who is not satisfied with village life and who leaves home in search of fulfilling her desires.

The role of women in rural depopulation is a recurrent theme in France, but views of women's culpability in the abandonment of village life have changed over time. During the nineteenth century and early in the twentieth century, women were often portrayed as weak in both popular works and scholarly studies and as easily lured to the city, site of vice and degradation. During more recent times, this view has been transformed into one that sees women more as rational social actors, choosing to leave or being encouraged to do so by their mothers who want a better life for their daughters than they had.

The period following World War II in France was one of rural depopulation and internal migration. As Jean Pitié (1979) has noted, the term used to describe this trend, *l'exode rural* (rural exodus), is an emotionally laden phrase with highly negative connotations. The complex reasons for rural-urban migration, and the fact that decisions to migrate are individual (Moch 1989), are occluded by this term. The French population has been a mobile one throughout history. Dwyer reports that

> One of the most revealing discoveries was that in 1961 only four French people in 10 (38%) had lived in the same place all their lives. Of the remainder, 29% had moved once and 16% twice. A third had changed their place of residence on two or more occasions. Most French people were not, therefore, born, married, and perhaps buried all in the same spot, as has so often been assumed. (Dwyer 1978:199)

And yet French rural imagery places high value on place, on having roots in one's local *pays*, and in staying home. Most migrants were, significantly, not landowning farmers or peasants but most often wage laborers or petit bourgeoisie. And there have been important regional differences between rates of, as well as reasons for, migration among men and women.

Many detailed studies of internal migration in France over the past two centuries (Clout 1976; Dwyer 1978; Moch 1989; Ogden and White 1989; Courgeau 1990; Fuchs and Moch 1990) show that economic factors play a significant role in decisions to leave rural villages for urban centers. However, Courgeau (1990) indicates that family reasons (marriage or the desire to move closer to family members) are almost as important as economic reasons in French internal migration. Moreover, most such migrants were not landowning farmers or peasants, but more often wage laborers or petit bourgeoisie. Therefore, the imagery of "leaving the land" is not entirely accurate because many who left rural life for the city were not farmers. Despite the realities of migration, however, much cultural imagery in France attributes rural exodus to the desires of women, who either tempted farmers away from their farms or would not stay to marry them. Studies in historical demography (Courgeau 1990) do show that women have been more geographically mobile than men since 1890, but this might be due to marriage patterns of exogamy as much as to rural exodus. Fuchs and Moch (1990:1009) suggest that, for female migrants, there is a link between "migration to the city and sexual vulnerability—that is, a connection between leaving home and the loss of social protection." Their analysis of out-of-wedlock pregnancies among female migrants to Paris in the nineteenth century illustrates this social trend and indicates that its causes lay in poverty and lack of social support for the women.

An important source for and reflection of cultural attitudes toward internal migration comes from French agrarian fiction. In her study of agrarian values in French rural novels published during the 1950s and 1960s, Rosemarie LaGrave traces gender attitudes during the period associated with rural exodus after the war.[5] In these novels the land (*la terre*) takes on a feminine gender, but the primary bond in the countryside is between men and the land. Women are associated with nature more generally and are less rooted than men to the land itself. In the novels it is through their submission to their husbands that women become attached to the rural way of life. These gender myths are also found in early French thought. Jules Michelet, as LaGrave points out, described the land as both "wife and mistress." Le Play, quoted above, advocated the strongly patriarchal family for its role in keeping women in their place and maintaining social order in the countryside.

In contrast to the man-land dyad of the countryside, LaGrave writes, is the dyad of woman-city, through which women were portrayed as more prone than men to be swayed by the vices of the city. Rural fiction of this period

supported a view that it was natural for the male peasant to be attached to the land and for the rural woman to support him in his toils. This easily turns into an ethical and moral view, so that, as LaGrave writes, "the peasant didn't leave the village because he doesn't have to work . . . but because he is seized by vice and because he yields to it" (198). In other words, the city attracts him much more than the harshness of village life pushes him out. For women, the construction was different, so they were considered to be in danger of being "stolen" by the city that would then attract them away from their families. As LaGrave writes, "Both object and subject of debauchery, the woman is first of all the victim of the brutal desires of the city; then, once assimilated, she actively participates in the city's seductive and destructive power" (198).

Ethnographic observations in some parts of rural France echo this tendency to explain rural exodus through women's desires to leave the land. Pierre Bourdieu interviewed farmers in a southwestern French village on the subject of the high rate of male bachelors in the region. They were in agreement that the fault lay with the women. "The young girls no longer want to be in the countryside," one tells Bourdieu (1962:108). About two decades after Bourdieu's research, Susan Carol Rogers (1991) found a similar attitude among farmers in the Aveyron. In her discussion of rural migration from Ste. Foy during the 1960s and 1970s, Rogers notes that there were a high number of male bachelors among heirs to the family farms (ostals) during this period due to the out-migration of potential brides for these men. During this period of an expanding French economy, mothers encouraged their daughters to leave and thereby avoid the burdens of farm labor and constrictions of living with their mothers-in-law after marriage. Nevertheless, this behavior was condemned locally as selfish and destructive to family farms. After the French recession of the mid-1970s improved conditions on the farms, girls have been more apt to marry farmers in more recent years. Rogers makes the point that out-migration was the result of individual strategies.

Speaking of an earlier period in French history and of the influence of regional fairs and markets on the evolution of rural families, Martin Segalen has written:

> Although it was a specifically female market, where sellers had only to do with other women coming to make purchases, one must not overlook the effect on peasant women of finding themselves in regular contact with the customs of the town, and its language, and it is perhaps there that one should look for the underlying changes in the rural family observed towards the end of the nineteenth century, with the girls leaving for the towns, encouraged by mothers who knew of the existence of a different way of life from their own. (1983:152)

The role of mothers in their daughters' decisions about whether to stay in the village or to leave—whether to transgress expected gender roles or resist pres-

sures to undermine them—is a theme expressed in the autobiographies of Yvonne, Emilie, and Antoinette. Yvonne's mother pressured her to follow in her footsteps as a farm wife, while Antoinette's mother encouraged her to seek a better life. Emilie's mother died too soon to exert such explicit control over her daughter's destiny. Perhaps due to her regret that the tragedy of her mother's early death was in part a result of the drudgery of the farm woman's life, Emilie herself came to reject the type of life her mother led and turned to education as a way out. Rural migration is nuanced in these narratives by the element of individual choice, as we read the ways in which the desires of each woman affected her decisions.

CONCLUSIONS

The three narratives analyzed here are products of late-twentieth-century French society, even if they reflect upon lives lived earlier in the century. They are best viewed in dialogue with each other and with alternative narratives of identity as presenting different perspectives on the possibilities and constraints on women's lives during the past hundred years or so. They provide commentary upon the importance of family and place to women's sense of identity and of the role of women in maintaining regional identities and families. In postmodern discourses concepts of dislocation coexist with concepts of location (Rapport 1997; Kaplan 1998). Notions of being local, rooted, and attached to place thus become counternarratives in a time of attention to narratives of displacement, migration, and exile. Rapport writes that "being rootless, displaced between worlds, living between a lost past and a fluid present" are "fitting metaphors for the journeying, modern consciousness" (1997:69), yet this is not how Antoinette, Emilie, and Yvonne discuss their lives. Each woman locates herself clearly in space and time; she does not inhabit the "non-places" (Augé 1995) of supermodernity, but the places of tradition/modernity.

The focus on individual choice is quite explicit in each of the narratives. Antoinette, Emilie, and Yvonne speak in a first person voice that expresses emotions and attitudes as well as actions. Yvonne presents herself as the ideal farm woman, content with her lot and satisfied with the "simple habits of rural life" that the conservative historian LePlay celebrated. She resisted urban life to fulfill her duty as wife, mother, and preserver of regional identity. Her narrative is constructed through the dichotomy of traditional and modern, with Yvonne taking the traditional route. Emilie, on the other hand, presents herself as a modern woman, and the English title of her book ("A Life of Her Own") underscores the departure from traditional rural women's roles that she embodies in her life story. Social mobility through education was the route Emilie took out of the poverty and harshness of her parents' lives. Antoinette actively participated in a capitalist economy of consumption, commerce, and

the flow of ideas and goods throughout space. She was the most mobile of the three women; she was also, as she admits, the most bourgeois. She and her family built their fortune upon the labor of agricultural workers and poor farmers in a region, the Ardéche, that suffered more from rural exodus than other regions. Antoinette's story is one of social mobility through commerce, of a woman who, like Emilie, creates "a life of her own." Yvonne also, however, portrays herself as a woman who chose her life by actively resisting temptations to move to the city.

Yvonne, Emilie, and Antoinette all reached old age in the rural settings in which they were born. None of these women settled permanently in the city, even though Emilie and Antoinette lived in urban settings for parts of their lives. In this sense, none of them has been transgressive in her travels according to French cultural images of rural women. The cultural value of attachment to place and to region is affirmed by each story. Nevertheless, these life stories do provide counternarratives to the stories of transgressive rural women in the mid-century agrarian novels analyzed by Rosemarie LaGrave discussed above. None is distracted by the evils of the city. Each prefers, in the end, to live a provincial life and describes this as an active choice on her part. All three stories reflect traditional family values and reinforce the pivotal role that women have in family life. Each of these women is portrayed as strong-willed, practical, and down-to-earth—as embodying values associated with duty to family. Each woman supports marriage and the family as an institution, Yvonne in the most traditional way, but Emilie's story is also one of sacrifice for her family and of devotion to her husband. Antoinette supports her family through wages and the accumulation of capital; she is also a devoted mother and supportive wife.

Emilie Carles, reinforcing her rootedness to region despite her travels, states that "all my life I have lived where I was born, in the mountain country around Briançon" (1991:2). This statement contradicts the evidence in her narrative of those periods in which she lived outside of that region, yet it embodies a "fiction" of emotional attachment. Emilie's life story, as do those of Yvonne and Antoinette, serves the national project of France by invoking the seemingly timeless nature of provincial life and regional identity that is, as Collier (1997) and Rogers (1987) suggest (cited earlier in this essay), essential to modern nationalist discourse. These stories reinforce the importance of attachment to place for rural women, of remaining in one's local region and keeping the family together.

At a time in French history when few women live rural lives, this myth continues to influence urban women. In a recent study of educated professional women who live in the urban and suburban areas near Paris, Jeanne Fagnani (1993) reports that these women are very influenced by "cultural dictates linked to the image of the 'good mother'"(1993:172). Decisions about where to live and when to move for professional reasons are, she sug-

gests, influenced by the different gender roles and expectations of men and women in contemporary France. Women, who bear the brunt of the child care in these families even when their husbands help with domestic and educational responsibilities, choose living environments and locations that best help them handle their work and home duties. This is not so different from the values expressed in decisions made by the three rural women under consideration here, whose lives were also constrained by cultural dictates linked to women's roles in the home.

These books present representations of rural Frenchwomen from different regions and periods of history who are rooted in their regional, national, and gender identities. Complicated contradictions between duty to family and individual desire are not presented in these stories; rather family values and individual desires eventually complement each other in the lives of all three women. Their stories do not question fundamental values of their society; rather they tend to reinforce woman's place in the nation and family even as she becomes "modern." Even Emilie Carles' potentially transgressive travel and departure from peasant life are tempered by her devotion to family. Just as the agrarian novels of the 1950s and 1960s studied by LaGrave portrayed various cultural anxieties about the city and women's roles, these late twentieth-century life histories illustrate a continuing cultural dialogue about men and women, the traditional and the modern, and the urban and the rural in French society.

NOTES

1. A much earlier version of this paper, called "Becoming Educated, Desire, and Leaving the Land: Cultural Myths of Gender and Rural Exodus in France," was presented at the American Anthropological Association Annual Meetings, Philadelphia, 1998. I discuss these three narratives from a different perspective, related to issues of memory, in Reed-Danahay 2002.

2. I have discussed Carles' text at greater length, with a particular focus on schooling and in relationship to a masculine counterpart, elsewhere (Reed-Danahay 1997).

3. I have discussed the wider implications of this in my earlier chapter on Carles (Reed-Danahay 1997).

4. The French *arriviste* is a pejorative term that refers to an opportunist, someone with unscrupulous ambitions. The connotations of *arrival* as embodied in the word are intriguing in the context of discussions of travel and transgression. The implication of the criticism is that the aunt has gotten to her social position not through her own industry (a quality highly admired by Antoinette), but through dishonesty and trickery. Her travel, unlike that of Antoinette, is thereby constructed as transgressive in the narrative.

5. Similar constructions of gender in agrarian novels in Quebec are discussed by Guenther (1997). She writes that "cultural norms validate country life by restricting

gender (here in particular, women's) roles" (1997:173). Earlier versions of agrarian novels equated cultural identity, labor, and motherhood, and privileged rural over urban life. Guenther traces the development of newer ways of writing such novels that transgress those normative views.

BIBLIOGRAPHY

Augé, Marc. 1995. *Non-Places: Introduction to Anthropology of Supermodernity*. Trans. John Howe. London and New York: Verso.

Bammer, Angelika, ed. 1994. *Displacements: Cultural Identities in Question*. Bloomington: Indiana University Press.

Bertaux, Daniel, and Martin Kohli. 1984. The Life Story Approach: A Continental View. *Annual Review of Sociology* 10:215–37.

Bourdieu, Pierre. 1962. Celibat et condition paysanne. Etudes Rurales 5–6:32–135.

Carles, Emilie. 1977. *Une Soupe aux Herbes Sauvages. Propos Receuillis par Robert Destanque*. Paris: Simeon.

———. 1991. *A Life of Her Own: The Transformation of a Countrywoman in Twentieth-Century France*. Trans. A. Goldberger. New York: Penguin.

Clout, Hugh. 1976. Rural-Urban Migration in Western Europe. Pp. 30–51 in John Salt and Hugh Clout (eds.), *Migration in Post-War Europe: Geographical Essays*. Oxford: Oxford University Press.

Collier, Jane Fishburne. 1997. *From Duty to Desire: Remaking Families in a Spanish Village*. Princeton: Princeton University Press.

Courgeau, Daniel. 1990. France. Pp. 125–44 in William J. Serow and David F. Sly (eds.), *International Handbook of Internal Migration*. New York: Greenwood Press.

Creed, Gerald W., and Barbara Ching. 1997. Recognizing Rusticity: Identity and Power of Place. Pp. 1–38 in Barbara Ching and Gerald W. Creed (eds.), *Knowing Your Place: Rural Identity and Cultural Hierarchy*. New York and London: Routledge.

Dyer, Colin. 1978. *Population and Society in Twentieth Century France*. New York: Holmes and Meier.

Fagnani, Jeanne. 1993. Life Course and Space: Dual Careers and Residential Mobility Among Upper-Middle-Class Families in the Île-de-France Region. Pp. 171–87 in Cindi Katz and Janice Monk (eds.), *Full Circles: Geographies of Women over the Life Course*. London and New York: Routledge.

Fuchs, Rachel G., and Leslie Page Moch. 1990. Pregnant, Single, and Far from Home: Migrant Women in Nineteenth-Century Paris. *The American Historical Review* 95(4):1007–31.

Guenthier, Beatrice. 1997. The *Roman du Terroir au Féminin* in Quebec: Guèvremont's and Blais' Re-visioning of a Rural Tradition. Pp. 171–94 in Barbara Ching and Gerald W. Creed (eds.), *Knowing Your Place: Rural Identity and Cultural Hierarchy*. New York and London: Routledge.

Kaplan, Caren. 1996. *Questions of Travel: Postmodern Discourses of Displacement.* Durham and London: Duke University Press.

Katz, Cindi, and Janice Monk, eds. 1993. *Full Circles: Geographies of Women over the Life Course.* London and New York: Routledge.

Keith, Michael, and Steve Pile. 1993. *Place and the Politics of Identity.* New York: Routledge.

LaGrave, Rose-Marie. 1980. *Le Village Romanesque.* Le Paradou: Actes du Sud.

Lavie, Smadar, and Ted Swedenburg, eds. 1996. *Displacement, Diaspora, and Geographies of Identity.* Durham and London: Duke University Press.

Le Play, Frédéric. 1865. *Petite Bibliotèque Economique.* Paris: Guillaumin et Cie.

Massey, Doreen. 1994. *Space, Place and Gender.* Minneapolis: University of Minnesota Press.

Maynes, Mary Jo. 1989. Gender and Narrative Form in French and German Working-Class Autobiographies. Pp. 103–17 in The Personal Narratives Group (eds.), *Interpreting Women's Lives: Feminist Theory and Personal Narratives.* Bloomington and Indianapolis: Indiana University Press.

Moch, Leslie. 1989. The Importance of Mundane Movements: Small Towns, Nearby Places, and Individual Itineraries in the History of Migration. Pp. 97–117 in Philip E. Ogden and Paul E. White (eds.), *Migrants in Modern France: Population Mobility in the Later Nineteenth and Twentieth Centuries.* London and Boston: Unwin Hyman.

Ogden, Philip E., and Paul E. White. 1989. Migration in Later Nineteenth- and Twentieth-Century France: The Social and Economic Context. Pp. 1–33 in Philip E. Ogden and Paul E. White (eds.), *Migrants in Modern France: Population Mobility in the Later Nineteenth and Twentieth Centuries.* London and Boston: Unwin Hyman.

Pitié, Jean. 1979. *L'Exode rural. Que Sais-Je?* Paris: Presses Universitaires de France.

———. 1987. *L'Homme et son espace: L'exode rural en France du XVIᵉ siècle à nos jours.* Paris: Editions du Centre National de la Recherche Scientifique.

Proriol, René. 1995. *Une vie de femme en 1900: Antoinette. Souvenirs.* Paris: Editions de l'Harmattan.

Rapport, Nigel. 1997. *Transcendent Individual: Towards a Literary and Liberal Anthropology.* London and New York: Routledge.

Rapport, Nigel, and Andrew Dawson, eds. 1998. *Migrants of Identity: Perceptions of Home in a World of Movement.* Oxford and New York: Berg.

Reed-Danahay, Deborah. 1997. Leaving Home: Schooling Stories and the Ethnography of Autoethnography in Rural France. Pp. 123–44 in Deborah Reed-Danahay (ed.), *Auto/Ethnography: Rewriting the Self and the Social.* London and New York: Berg.

———, ed. 1997. *Auto/Ethnography: Rewriting the Self and the Social.* London and New York: Berg.

————. 2002. Sites of Memory: Women's Autoethnographies from Rural France. *Biography* 25(1):95–109.

Rogers, Susan Carol. 1987. Good to Think: The "Peasant" in Contemporary France. *Anthropological Quarterly* 60:56–63.

————. 1991. *Shaping Modern Times in Rural France*. Princeton: Princeton University Press.

Ropars, Jean. 1993 [1991]. *Au pays d'Yvonne: Mémoires d'une paysanne léonarde*. Paris: Editions Payot et Rivages.

Sachs, Carolyn E. 1996. *Gendered Fields: Rural Women, Agriculture, and Environment*. Boulder: Westview Press.

Segalen, Martine. 1983. *Love and Power in the Peasant Family*. Trans. Sarah Matthews. Chicago: University of Chicago Press.

Sommestad, Lena. 1995. Rethinking Gender and Work: Rural Women in The Western World: Thematic Review. *Gender and History* 7(1):101–05.

Thomas, Nicholas. 1989. *Out of Time: History and Evolution in Anthropological Discourse*. Cambridge: Cambridge University Press.

Williams, Raymond. 1973. *The Country and the City*. New York: Oxford University Press.

EIGHT

Foreign Spirits inside the Family

Vodu Home on the Ex-Slave Coast

JUDY ROSENTHAL

The vodus are slave spirits. Hundreds of years ago people of the north—Hausa, Mossi, Tchamba, and Kabye—passed through Eweland. Some of them suffered hardships and had to sell their children to our ancestors. These children did everything for us. They worked their whole lives and made their masters rich. When they grew old and died, the objects we had taken from them upon their arrival—cloths, bracelets, fetishes, sandals—these things became the vodu, and the slave spirits came and settled in them and became our gods. If we do not serve them, generation after generation, we become ill and die. It is beautiful when the vodu comes to possess you. It is good.

—Vodu priestess Kpodzen, in Rosenthal, 1998:73

THIS ESSAY IS ABOUT Vodu women in West Africa, especially Ewe and Mina spirit hosts who belong to the *atikevodu* or "medicine spirit" orders called Gorovodu and Mama Tchamba. These Vodu cultures and their ritual practices provide the sorts of home and "not-home" that are connected to a history of enslavement and north/south relations. In this case, unfortunate but never inferior northerners were torn away from their original homes up-country and sold in the coastal south—called the Slave Coast—at the time of the Atlantic Trade. Some of these captured people did not leave for the long ocean voyage but stayed behind, serving as "bought people" (*amefeflewo*)

149

in southern families. As the introductory quotation indicates, there was also
the phenomenon of northern families fleeing from slave traders, and some of
them left their children, especially their daughters, as bought people in south-
ern homes. These daughters of the north usually became wives in their south-
ern host lineages, and in most cases their own children were not enslaved.
Today Ewe and Mina spirit hosts, about eighty percent of them women, pro-
vide their own minds and bodies as "home" during trance for the northern—
thus foreign—spirits of erstwhile enslaved people. The differences between
trance and the unpossessed or not-in-trance consciousness of these spirit
hosts will be interpreted through the *heimlich/unheimlich* distinction as dis-
cussed in this volume's introduction.

This ethnographic material joins other writing on West Africa and
memories of the slave trade, such as Rosalind Shaw's haunting work on
Sierra Leone (2002).[1] It also is connected to monographs of different but
related Vodu cultures (variously Voodoo, Vodhun, etc.) in the Adja-Tado
ethnolinguistic area, including Nadia Lovell's work on Watchi Vodhun
(2002), as well as ethnographies on Vodu (Vodou or Vaudou) in the dias-
pora, such as Karen McCarthy Brown's *Mama Lola* (1991). It is informed
by historical scholarship on Ewe (Evhe, Eve, etc.), in particular Sandra
Greene's extensive publications on the Anlo Ewe (1996, 2002). The ref-
erences to Vodu subjectivity in the present essay are related to Kathryn
Linn Geurts' new and original ethnography (2002) about Ewe personhood
and "bodily ways of knowing." The Vodu women I write about are very like
and yet unlike spirit-possessed women in other parts of Africa, such as
those in Adeline Masquelier's beautiful book (2001) about certain Muslim
women in Niger. Lastly, this essay hints at other sorts of theory, links that
the present essay cannot leave room to develop, including Michael Taus-
sig's writings on mimesis (1993) and Judith Butler's well-known work on
power and identity.[2]

The poem that follows is my interpretation of how certain Gorovodu
women in Ghana and Togo think of a particular spirit who always appears
during possession ceremonies. It contains evocations I have collected
through the years, comments I have heard from spirit hosts as well as my own
impressions of what is happening during ritual and what people say about it.
The spirit evoked here is usually considered to be masculine, the one who
"marries" many women and thus the one that these same women "become"
while in trance. Their personalities are marked by his traits, and they are
associated with him even when not in trance. They are said to be like him.
He is a composite, made of the souls of northern enslaved people who died
violent deaths far from their own home. He is thus foreign to his southern
worshippers, probably Muslim, a fierce protector, a warrior, and a hunter; and
he is associated with the "hot bush," that is, the dangerous wilderness, a time
and space of transformation, of not-home.[3] He is called Banguele Ketetsi, and

also Kokosatsi, which means vulture. He is a stranger Vodu, made of up-country captives who were stolen from their homes during the time of the Atlantic slave trade.

Vodus are positions to take up, to inhabit
voices from the inside, from the past
from imagination, desire, Others
Banguele Ketetsi Kokosatsi, *me yowo* (I call you)
ne me dzagowo tsoekem (if I have offended you, forgive me)
protect us from hot death, from the violent end, grandfather with
 wings
Kpalime vulture soaring as the beauty of sudden truth
patterns in the red harmattan sky
dust in heaven's corridors
wind and dread at noon
Kokosatsi eats all yet is never eaten
that is the secret of the warrior
we nestle in the feathers of the vulture
ride a furtive dance to outwit early death
plunging
hovering over the earth
flying low, seeing everything that happens
heavy with sorrow leadening our wings
spreading frets higher and higher to other worlds
we revel in laughter and love swoons, voice leaping, bodied and
 bodied again
we know we are not omnipotent; we lack and lack
we are without, through and through
as for unspeakable misery, we can only heal this one and that one
against fear that exhausts we can only ravish the attendance
answering injustice, as it gallops on, we cry out revolution, we cry
 out galloping
lacking power to banish horror, we make magnificence and truth
we make them over and over again, copies unidentical
we dance them out, thrusting skyward arms and faces
imploring, offering
crouching fetal in circles, faces pressed to the ground
we sing tears, moaning, offering
burning incense from the bush
we have scarcely heard of God
we do the work of fetishes, small gods, made things
collage of seed and skin, of earth and ash
sculpture of desire and event

glued with blood and prayer
we take on necessary tasks, local jobs
we travel between north and south, husbandly and wifely
between narrative and action
between times and spaces
between the terrifying real and the ritual work of art
we are metonyms, stuff of language, stuff of flesh
no border impermeable, no frontier uncrossed, no line virginal,
 no forced entry
already between again and again, we are
between always and now

VODUS ARE POSITIONS TO TAKE UP, TO INHABIT

The experience of home/not-home (Other), or family/foreign, is a constant in Gorovodu and Mama Tchamba spirit possession communities today.[4] Both of these Vodu (or *etro*) orders can be traced to the colonial period and may have existed before the years of actual British and French occupation and administration. The spirit-possession communities themselves, often inhabitants of entire villages and city neighborhoods who know each other well, along the coast and across national borders, are a nexus of north/south, not-home/home, or the foreign come to stay in the heart of the "big family." They are sites and networks, places as well as groups of people, linked in sacred practice that unites for the time of trance and ceremony the two sides of this binary, along with others, such as husbandlike (north) and wifelike (south, home), death (north) and life (home), godly (north) and mortal (home), and, in many cases, Muslim (north) and Vodu (home).

What I am calling the home side of these pairs is home to the southern worshippers and not the original home of the northerners. The diaspora of northern people brought south during the period of the slave trade involved a traumatic unhoming for them. According to the idealizing discourse of the Vodu practitioners, they themselves, especially the ancestors of today's Gorovodu and Tchamba worshippers, were obliged to make these foreign enslaved people feel at home in the south, for the northerners were working for the southerners, producing wealth for them, and such contributions to the good life in the south could be carried out only by workers who were welcomed and loved and who eventually married into southern lineages. When these foreigners died, the southern homefolk, in grand gestures of reciprocity, of debt being paid and repaid generation after generation, invited the spirits of the northern dead to possess southern bodies and minds. These spirits thus became Gorovodu and Mama Tchamba deities, made to feel at home as gods in southern ritual spaces.

BETWEEN THE TERRIFYING REAL
AND THE RITUAL WORK OF ART

Because the phenomenon of trance is stunning and marvelous in these Vodu orders, because it is both desirable and disquieting, both sublimely beautiful and monstrous, and unspeakably powerful in its nature, it is said to be *sesento*, very, very (immeasurably) strong. I call it *unheimlich* in distinction to the less "strong" experiences of the workaday life—the *heimlich*—which are less disquieting, less magical, less thrilling and world-shaking. I have borrowed this handy and well-worn pair from philosophy, especially Nietzsche and Freud (and it is already explained in the introduction to the present collection), for it works in the Vodu context and carries its own tradition, reminding us of the unstable or multiple nature of the psychic at-homeness of human beings, that is, subjectivity itself (even capable of becoming the ultimate Other in trance!).[5] So while the *heimlich* refers to what is safer, more comfortable, more familiarly home in every sense, and Vodu worshippers must have such home, they also desire to live and relive the *unheimlich*, that decentering and uncanny experience of the Other in one's own self and in the collective memory and body. Among Gorovodu and Mama Tchamba worshippers there exists a need to visit again and again the recess of real history, often horrifying, as well as the thrilling and aesthetically awe inspiring recess of the religious and creative imagination seeking to redress the abject traumas of the past. Redemption is ritually obtained only through recalling the trauma of the loss of home, reliving the tearing away of self from family and normal life in the early stages of the phenomenon of trance, and then the uniting of home and not-home, self and Other, for the time of ceremony.

BETWEEN ALWAYS AND NOW

Daily life in the secular sense along the ex-Slave Coast is more or less good or bad, depending on the day, but it is not often stunning and earthshaking the way spirit possession is. (When unplanned earthshaking events do occur, they by definition are not part of the usual at-homeness of daily life, and they give rise to immediate and urgent ritual.) In fact, the everydayness of work in the family compound, on the road, and in the market (also home to village and town women), of childcare and spirit care, of words between friends and words to gods in song-prayers, also has its ritualized components. Vodu ritual in the form of prayer and sacrifice, as well as Afa divination, punctuate the more workaday activities of the week and so are not entirely separate from earning a living, caring for children, cooking, and washing clothing. In order to bring about the uncanny intensity of spirit possession, special three-day festivals are held. The drumming, singing, and dancing during these events must be splendidly powerful and artful (yet dionysian,

not entirely controlled) so that they seduce the northern spirits back to the south for the time of celebration. I have thus translated this qualitative difference between the workaday world and the time/space of high ceremony and spirit possession as a home/foreign or familiar/uncanny distinction similar to the *heimlich/unheimlich* in Freud's writings.

BETWEEN TIMES AND SPACES

The home/not-home distinction is also repeated inside the Gorovodu order and its pantheon in the form of "home Vodus" and "hot bush Vodus," although they are all said to have come from the north. While this pantheon varies greatly from place to place, we can say that in general a divine grandparent or parent couple and two or three of their "children" are called home (or village) Vodus (*afemevoduwo*), whereas a group of hunter/warrior Vodus, composite spirits of northerners who died violent deaths (*zogbeku*), are "hot bush Vodus" (*zogbevoduwo*). One way of indicating the north is to say "on the other side of the bush." In earlier generations when there actually was some forest surrounding villages or settled areas and real brush land between villages, certain rituals had to be carried out in this not-home place, full of danger because of wild animals, wandering spirits, and hunters, even hunters of human beings during certain periods (therefore called "hot," the dangerous or wild pole of the cool/hot opposition). People might die violent death—*zogbeku*—outside the village. "They did not see death coming," it is said. (Home death—*afemeku*—is called "good death.") Or they might be captured and enslaved, in many cases a fate worse than death.

BURNING INCENSE FROM THE BUSH

Today along the ex-Slave Coast most Gorovodu and Tchamba shrines in villages and neighborhood shrines in towns and cities have their own little wilderness or "outside" on the inside; that is, they have fashioned a hot bush (*zogbe*) inside or on the margin of the village or compound (although some groups still go to cemeteries or brush areas for important rituals). The uninitiated cannot enter zogbe. This stylized wild place inside or on the boundary of the village, fenced off from outsider eyes, is in fact usually very beautiful and calm, graced with lovely plants and special trees with healing properties (including *zogbeti* or byrophyllum pinnata, used to treat sickle cell crises). Zogbe inside the village or host compound (or on the edge of the neighborhood, as in Tema New Town in Ghana) is therefore quite a contradiction in terms, a logical impasse materialized, a liminal space. Zogbe inside or attached to the village presents a turning-inside-out of the home/not-home binary and thus of the cool/hot, protected/dangerous, and familiar/foreign distinctions. In this case the village in general becomes a place of relative

heat and danger, of a quotidian *unheimlich*, whereas the stylized zogbe or dangerous ritual place is the site people run to for protection in time of literal, emotional, or imagined danger. The very space of un-home has slipped into the *heimlich*. Or, we might say, the uncanny space of transformation has become a place of peace and comfort, while the workaday village life, the secular space of banal everyday activities, is by comparison full of hidden danger and anger, illness and folly, characterized by uncontrolled *n'bia* (jealousy, envy, rivalry, even death wish).

WE TRAVEL BETWEEN NORTH AND SOUTH, HUSBANDLY AND WIFELY

In the context of Ewe and Mina spirit possession, home is a multivalent sign. It is historical/geographic—the south (home) as distinct from the north (not-home) for Ewe and Mina Vodu people, with regard to the buying of northern captives by southern lineages for domestic work and marriage, during the period of the Atlantic trade and afterward. In this case home refers to the southern network of Vodu communities, or to the village, lineage, or family as distinct from foreign places and foreign people who do not speak Ewe or Mina (but some of whom might marry into the lineage).

SCULPTURE OF DESIRE AND EVENT

At the same time, home is a dense conceptual space, since the mind/body of the living southern worshipper who hosts northern spirits is also home to the foreign guest for the time of trance. Yet home in this reading is more than conceptual, more than historical and geographical: Home, in the experiences of Ewe and Mina Vodu people, defies material/spiritual substantial dualism. I have often been told that the material Vodus, those sculptural collages, fetishes made of so many ingredients—from plants, animals, cowries, *objets trouvés,* including some from the north—were the *homes* of all the spirits even as it is also said that the god-objects—while containers of a sort—*are* the divinity. And while a spirit host in trance is the landing place of the spirit, s/he is also called the *Vodu* or *tro* itself. So material fetishes and spirits, spirit hosts and Vodus, homes and occupants, husbands and wives, north and south, the "hot bush" and the village, the heimlich and unheimlich, sometimes fuse. We might say that they relate metonymically rather than metaphorically.

The Vodu (or *tro*) shrine is also called a home—*voduxome* or *troxome.* Not only the shrines and alcoves for each Vodu, but the Vodus themselves and the spirit hosts, are all in a sense receptacles. But receptacles are also spirit, also alive and in movement. We could say that it is "receptacle all the way down" in Vodu logic, just as it is "spirit all the way," given that each

movable piece of the Vodu universe, each actor or agent, is both spirit and receptacle in one way or another, both home and inhabitant.

The English translation of *axoe*, the Ewe and Mina word indicating a person's or a family's material abode, a "house" in the nearly universal sense, would also be home. Similar to home in English, axoe can mean the place or country where one was born, one's home country, as well as one's "emotional home." The word *afeme* is also employed to mean home in the sense of a house or material abode. And the word for family, extended family, sometimes lineage, is *fome*, including members who are already dead or not yet born. In greetings one often asks, *Afemetowo foa?* or *Fometowo foa?* Literally, these greetings ask whether the people of the house or the members of the lineage are awake.

FROM IMAGINATION . . . OTHERS

The Muslim nature of the north (in the eyes of southerners) is highly significant in Gorovodu and Mama Tchamba culture.[6] While Gorovodu spirits are always said to come from up-country populations that suffered slave raiding, not everyone speaks of these Vodus as "slave spirits." They are, however, always called "Awusa" (Hausa, which for these southerners is synonymous with Muslim), and there is always an effort to imitate a Muslim aesthetic during trance ceremonies.[7] On Friday morning *sala* ceremonies, for example, Gorovodu women and sometimes men, and "men-women" or feminine men,[8] dress all in white and wear white veils as they chant and dance in what they consider to be a Muslim style.

Mama Tchamba spirit possession practices, on the other hand, are named after the actual Tchamba people of northern Togo, a Muslim group. With its pantheon of Muslim spirits, this Vodu order speaks very explicitly of the enslaved condition of the northern diaspora that worked, loved, and died in southern lineages, later to become (after their death) deities who heal and bring happiness to the lineages of their erstwhile owners and their common descendents. During trance, Tchamba spirits, through their hosts, speak of their once enslaved, yet now powerful, condition. The indebtedness that the southern lineages carry with respect to these northern bought persons never ends.

WE DANCE . . . THRUSTING SKYWARD ARMS AND FACES

In both Gorovodu and Tchamba orders the ancient debt to the north is honored and ritually reinstated over and over again. As the spirits keep rendering services to the southerners, the debt keeps growing, and thus the need to keep giving back to the spirits through lavish drumming and dancing festivals and daily gifts of food, drink, and prayer, never goes away. Sacred debt is the

very name of the relationship between the former enslaved and the southern lineages, thus between not-home and home, north and south, the husbandly and the wifely, the foreign and the family, gods and humans, death and life. It is precisely this focus on giving back as well as receiving again in Gorovodu and Mama Tchamba practices that makes it necessary for the foreign and the familiar, the traveler from afar and the family, the husbandly and the wifely, to include each other in some profound way ritually, psychologically, socially, and politically. Obviously, this is true even of the reciprocation between the living and the dead (an element included in thousands of cultures throughout the world). It is therefore necessary at the level of personhood itself for each individual who partakes of this history and this interpretation of the sacred to somehow house or "home" the northern Other in her own personality. This nesting of the foreign in the family, of the Other in the self, is part and parcel of the register of the familiar, of home itself.

WE ARE METONYMS, STUFF OF LANGUAGE, STUFF OF FLESH

As we have seen, home (afeme) and family (fome) are overlapping concepts among Ewe and Mina Vodu people. Together they compose one pole of the family/foreigner opposition that we have just evoked, so significant in Vodu ceremonies and in concepts of the social itself and of exchange. This might also be expressed as a bought person/buying family binary. So home is a place, site, family, community, state of mind or state of things that one can come back to and go forward to again and again. Some people say that a mother and her home remain her children's own home throughout life. A mother's very presence is home. Home is also house, birth village, established personhood, and intimacy with a loved one. Home requires the relationships and the objects that one cannot do without, that contribute to one's personhood, including objects invested with ancestral history and those necessary for Vodu worship.

BETWEEN NARRATIVE AND ACTION

The Vodu subject herself, a crossroads of family and foreigner while in trance, is surely not quite the same as the subject in the cultures and religions of the book. Indeed, in Gorovodu and Mama Tchamba identities, home and family involve very distinct ways of establishing psychic and emotional relationships. As we have already seen, these orders involve ways of thinking and living one's own personhood within a network that practices a continual restatement of history and exchange between north and south, between the utterly foreign and the snugly familiar, between enslaved persons and buying lineages, a personhood unthinkable in Western cultures. Individual persons

are also composed of distinct agents from very different times and places, including an ancestral reincarnation soul *(dzoto)*; an Afa divination soul *(kpoli)* quite outside kinship that links the individual to various plants and animals, weather, and other ingredients of the natural world; mother and father souls; and the personalities of various Vodus who enabled the person to come into this life. So the psychic at-homeness of each individual is already plural, shot through with *unheimlich* components.

HOVERING OVER THE EARTH

Vodu women live an (un)enchanted life at every turn. The turnings of consciousness that mark the sudden entrance of the enchanted *(unheimlich)* or of the unenchanted *(heimlich*, not necessarily disenchanted) may happen so easily back and forth that the borders are all but erased. The most homely (in every sense of the word) and banal matters may command the presence of spirits; the commonest and seemingly least charged words may hang a mind in trance for a while. On the other hand, the falling out of trance and the ordinariness of home and work life are of a piece, just as bereft of magic (or adrift from trance) as any unenchanted life anywhere in the world. Yet there is always a trace in everyday conversation and thought of the ravishment that keeps happening. When a spirit host says that she is always troubled by her path through a certain area in order to arrive at the port market, for there "the Vodu is liable to come upon me even though there is no drumming"; or that "I am unhappy for my spirit has not come to me for a long time"; or that "I have put the Vodu's clothing into my bag for I think my 'husband' may seize me (or I may seize my husband) at the festival in Aflao," it is obvious that the expectation of trance has its place in a woman's everyday consciousness. There is a vague memory of the experience of what will come again, a thought-feeling that is always there, sometimes foreground, sometimes background, sometimes an ungrounding, a trans-homing, or an undomestication of home. The *heimlich* and *unheimlich* are radically alterior even as one slips easily, paradoxically, into the conceptual (languaged) and embodied or inspirited space of the Other. This, as I have understood it from what Vodu women have conveyed to me, characterizes a consciousness that is simultaneously home and not-home, uncanny in its lush homeliness, and at home within and through its own uncanny otherness.

NO BORDER IMPERMEABLE, NO FRONTIER UNCROSSED, NO LINE MARGINAL, NO FORCED ENTRY

I have spoken here in terms of subjectivity that is "there" or "coming," as though "it" had a life of its own, as though "it" were the home of consciousness itself, rather than speaking in terms of individuals who own their con-

sciousness. In order to understand the words of real Vodu women in all their individuality, we must listen to their voices. We might say that these pieces of narrative are words produced by the consciousness attached to or housed in particular subjects telling their stories, including the anthropologist's consciousness as she translates and narrates the stories of these women. Here it is important to highlight the connectedness of (and between) Vodu subjectivities, the in-betweenness of plural minds and bodies, and the transindividual nature of Vodu life. I am convinced that such interconnectedness of selves and such nonessential nature of individual subjectivity is true of all humans, but that Vodu people somehow know this more consciously, in a more intentionally practiced manner, than most Western or Northern individuals and cultures do. It is also significant to underline the seamlessness between language and the body in what I would tentatively call a Vodu theory of being. The realness of the flesh and of the material world and the profound "here-ness"of words in their physical power, whether spoken or written, are basic to the psychic and social reality of trance.

WE DO THE WORK OF FETISHES, SMALL GODS, MADE THINGS

In the everydayness of life Vodu women all want their own little house, even a single room of palm frond walls and thatch roof, with a sand floor and no furniture other than a bed, some tiny low stools and tables, perhaps a trunk or a couple of the huge enamel bowls with lids (from China) for articles of clothing—wax-dyed cloth (*pagne* or *avo*), some brief tops, and underwear (made in Europe). A few pots and pans are required, some clay containers, bottles, plates, glasses, spoons, a jigger for *sodabi* (local palm alcohol). Ritual objects abound, including talcum and perfume for ancestral and nature spirits who stay in the house. Strands of trade beads are significant—necklaces and bracelets—and small gold earrings, all handed down matrilaterally, "grandmother jewelry" (*mamadjonu*). "Tchamba" bowls and bracelets from the north are visible if the woman "has Tchamba in her family." Women with greater means will have a modest adobe or concrete block house, perhaps two rooms, with a cement floor and a tin roof. Women's huts and houses, or their quarters in big compounds, are necessarily full of children and the stuff of raising children. All of this is home in the sense of the house, *afeme*. Many of the ingredients of home come from elsewhere, from foreign sites, others' homes, other women's cultures, Muslim lineages, northern ones—Kaybe, Losso, Tchamba, Hausa.

WE TAKE ON NECESSARY TASKS, LOCAL JOBS

The tiny house or material home of an Ewe or Mina woman is in some cases part of an extended and broadly shared *afeme*, a lineage compound. The latter

may be composed of numerous huts or minimal houses (each inhabited by different wives, sons or daughters, aunts or uncles, cousins, etc.), often strung together around a central open space, with a common yard where much domestic work, including cooking and childcare, is done collectively. The lineage is patrilineal; however, most Vodu women have as much decision-making authority in the home and in the village as their men do, especially after they have given birth to a couple of children or after they have been acknowledged as spirit hosts. Many of them are market women, doing business at the port or in the capital or along the coast. They inevitably have more cash than do their fisherman fathers, husbands, brothers, and sons, and purses are separate between husband and wife. A woman may choose to practice financial solidarity with her husband or kinsmen, or she may prefer to invest more individually, for the sake of her children's future, or with other women in market activities.

Afeme is also the word for home and family in a yet larger sense, but it is still a place—a village or neighborhood, an ethnolinguistic region (although all regions are inhabited by speakers of several, if not many, languages other than the dominant one). It is also true that in the large network of *atikevodu* villages, especially among Gorovodu and Tchamba communities, Vodu adherents consider themselves to be members of a "big family." As "Vodu children" they are at home in any and every Vodu event, ritual, three-day festival, or seasonal ceremony. They have hundreds of mothers and fathers, brothers and sisters, children, ancestors. They also have ten or twelve possessing spirits (more, if we count all of the denizens of the Gorovodu and Tchamba pantheons) who are also their mothers, fathers, and grandparents, and one of whom may be their spirit husband (whether the spirit is male or female, and whether the spirit host is male or female). It is important to remind ourselves that these spirits were once human beings, usually said to have been *amefeflewo* (bought persons). They were taken from their homes in the Kabye mountains or in the Tchamba villages or the Hausa *sahel*. They were "given new homes" in southern lineages and most often became ancestors to new generations of Ewe and Mina (the latter unworried about, but highly interested in, the uncanny foreignness of many of their mothers and a few of their fathers).

WE REVEL IN LAUGHTER AND LOVE SWOONS, VOICE LEAPING, BODIED AND BODIED AGAIN

So when the southern hosts, descendents of possessors of slaves, are in turn possessed through trance by the northern, Muslim, corporate spirits of these same slaves, the Ewe and Mina lineages are engaged in a process of reciprocity and continuing indebtedness. They (many more women than men) provide their minds and bodies as homes for these fetish beings, these "made

gods." They maintain in their material homes and in the Vodu home (*trox-ome*) little sacred items from the north, metal bowls, Muslim rosaries, and medicines, as well as clothing for trance—red batakalis and fezzes, gauzy white tunics and veils, blue-black indigoed boubous and scarves. The returns for such remembering, such honor and respect, such gifts of enjoyment and incor-poration, include healing and dispute management, as well as splendid perfor-mance and enjoyment, thanks to the talents and generosity of the Gorovodu and Tchamba slave spirits, who are now deities. These rewards fall to the entire "big family" of worshippers in the village (and all persons attending the ceremony) and are brought into their midst thanks to the "work" (*edowowo*) of the spirit hosts (Vodu in the host's mind/body) and of the spirits.

LACKING POWER TO BANISH HORROR, WE MAKE MAGNIFICENCE AND TRUTH

Gorovodu celebrations—planned as a *fetatotro* (turning-of-the-year) *woe-zododo* (welcome) or an *akepedada* (thanksgiving)—may last an entire week-end, three days and nights. Members of the "big family" from other villages are invited, including those in neighboring Ghana, Togo, or Benin. Drum-mers begin playing before there is a great crowd assembled. Participants begin to arrive and take their places on long benches surrounding the ceremonial ground. Important visitors are seated in chairs near the fetish house, which they enter upon their arrival to thank the material Vodus (fetishes) for their safe arrival, or for the greatness of the festival that is about to occur, or for having healed a member of the family recently. Everyone is offered drinks while the drummers continue to heat up the atmosphere. The attendants begin to sing one *brekete* song after another and to dance. (*Brekete* is the name of the dance steps and particular drumming rhythm that are characteristic of Gorovodu and Tchamba ritual; often the word is used as a synonym of *Gorovodu*.) Eventually someone goes into an agitated trance and begins to dance compellingly, in a different manner. A *senterua* (helper for those in trance) administers to the person, now considered to incarnate an erstwhile enslaved person from the north, a god. After the trance state has become calmer the person/spirit is taken into the Vodu house and dressed in a cos-tume that represents the possessing deity (different spirits require different colors and different accoutrements).

. . . OVER AND OVER AGAIN, COPIES UNIDENTICAL

Often many people go into trance during large gatherings of this kind, as many as thirty at a time. A person might be in trance for an hour during the morning drumming, then go to sleep for several hours and at the afternoon drumming go into trance again. The same person might then rest and eat

after coming out of trance only to go back to the midnight drumming and succumb once again to the voluptuous demands of the Vodus. The spirit hosts doing this "work" of becoming the northern gods over and over again provide the bodies and minds for the spirits to heal, arbitrate disputes, and, notably, to give immense pleasure, even rapture, to those attending. It is also said, thus, that the ceremonies give pleasure to the spirits and are a form of payment for debts incurred.

There is a ratio of about ten women spirit hosts to one man host in many villages, but in some large ceremonies there are almost as many men as women in trance. One could argue that the north is treated as male and the south as female in this scenario, given that the spirit hosts are called *trosi* (*vodusi* in older Vodu orders), and the term is usually translated as "wife of the spirit." The spirit host, whether a woman or a man, is in the wifely position of "receiving" her husband spirit, whether a male or female Vodu. S/he is h/er home in the south.

FLYING LOW, SEEING EVERYTHING THAT HAPPENS

In what follows I tell stories about several Vodu girls and women, all of whom are concerned with maintaining a family relationship with spirits from the north. Not all are concerned about maintaining what we might suppose to be the usual borders of home and family in the strict sense. A good example of this is little Dovi, eight years old the last time I saw her, in 1999, during a big Gorovodu festival about twenty miles down the road from her own village. Dovi said that earlier that morning she had noticed some irregularities inside the Vodu shrine. "I saw a *trosi* in trance drinking alcohol, and you know that is never, never done. S/he [but in this case a man] will be punished by h/er spirit husband!" She shook her head sadly and clucked her tongue. Dovi always made it her business to pierce the farthest reaches of the sacred places. Tiny, she was never in anyone's way. And no one could make her leave even if they tried. She possessed authority for reasons unknown. Priests would say she already incarnated the Vodus—she didn't have to wait for trance to carry their power around with her. She told me that morning that she was planning to go to Gorovodu festivals in Ghana the next weekend. I asked her who would take her—her mother? her sister? (Her beautiful older sister was regularly possessed by Nana Ablewa, a Muslim grandmother Vodu, also called Ala, or Allah, according to some.) She answered that she needed no one to take her. She would insinuate herself into one of the groups from her village who would be taking the bush taxis to the border. She would virtually hide in someone's skirts. She would slip across the border into Aflao unnoticed, part of the collective body moving across. "I need to be in the ceremonies," she reported gravely. "If I don't go my head will be bothering me." Dovi asked no one's permission to go and come, to cross state borders, to proclaim on Vodu law, to

judge her classificatory mothers and fathers, even priests. She didn't need much food. Dovi still refused to go to school. Her refusal was easier than beginning to attend school only to be refused entrance after a few weeks or months, given that her mother could never pay even the paltry sum required at the one-room school in the village. Her home was wherever she could comfortably travel and be accepted. Her family was the network of Gorovodu villages spread out along the Ghanaian, Togolese, and Beninese coast.

KOKOSATSI EATS ALL, YET IS NEVER EATEN

Da Kossiwa, a woman who was about fifty years old when I last saw her, was and is also at home in the entire spread of Vodu villages. In the fall of 1999 she was recently married to a man half her age who apparently worshipped her, judging by the constant attention he paid her when I was in their presence. As she was no longer able to have children, one might wonder whether the young man would keep her as his wife. She said that he knew very well she could bear no heirs for him. He had told her he would simply take pleasure in "going to the farm, but not harvesting."

Da Kossiwa was a favorite visitor at big Vodu festivals, a favorite member of the big family of Gorovodu adepts. She never failed to achieve trance during ceremonies, and when she did, the drummers were energized and the entire attendance went into a sort of overdrive. The consequence was a state of communitas turn by turn sublimely serious, leaving people with their mouths open in wonder, and then suddenly bursting with hilarity, burlesque performance, laughter, and utter fun. Da Kossiwa incarnated (and inspirited) Banguele Ketetsi, the hunter/warrior Vodu from the northern savannah (evoked in the introductory poem) whose nature spirits were the Kpalime vulture and the wild cats, very particular members of the Vodu family. This Vodu of hot death, violent demise, tragic accidents, roadkill, war, and slave trading continues to protect his worshippers from the sorts of violent death that the persons whose spirits compose him had risked and sometimes suffered. Given the years of dictatorship and sporadic state terror in Togo, Da Kossiwa's possessing spirit is one of the most called upon to protect travelers, homes, families, and, in particular, children, as well as individuals embarking on difficult paths. Banguele Ketetse is arguably the most uncanny, the most *unheimlich* of all the Gorovodus, a true "hot bush spirit," and a very strong deity, one who does not forgive as easily as a home vodu would.

AGAINST FEAR WHICH EXHAUSTS, WE CAN ONLY RAVISH THE ATTENDANCE

Da Kossiwa has insisted to me on numerous occasions that she is a man. When I ask her what that means, she evokes the fact that her husband spirit

is a very manly warrior; then she insinuates that the personality of this Vodu sticks to her even when she is not in trance. People refer to her as "Da Kossiwa Banguelesi." She also refuses to take orders from anyone, including Vodu priests and literal husbands. She maintains herself socially in a manly position, superior, for example, in ritual respects to her new young husband, who accepts her authority. She goes into trance every chance she gets. Even while in prison, where she remained for four months several years ago, unjustly accused of murder by "witchcraft" (aze), she was protected by her spirit husband who "came upon" her often, thereby frightening the police at the jail. We might say that Da Kossiwa is indeed at home in trance, right there where the unheimlich, the uncanny foreign, the disquieting strangeness, is made present for a time. She once told me in a whisper that trance with her northern warrior spirit was like being in love—"You want it all the time." Although being with a lover may indeed be a way to be at home, the thrill of passionate desire is often linked with the uncanny, with one's being pierced with longing for the Other, a theme dear to Catholic mystics, but also to Vodu people. Da Kossiwa is not only interested in the northern nature of her spirit husband and thus a component of her own personality. She is also interested in contemporary northerners and Muslims and has befriended Muslim women who have married into southern lineages, helping them give birth with her Vodu medicine.

WE NESTLE IN THE FEATHERS OF THE VULTURE

Another spirit host I have had the pleasure of working with for many years, whom I here call Believe, is the spirit wife of the Gorovodu Sunia Compo, a home Vodu. Very different from Da Kossiwa, Believe is serene and delicate in trance. Believe has not only always loved men and loved love affairs; she has also longed to be able to count on a man as a real partner, to help her emotionally, ritually, and financially. Unfortunately, she has encountered failure in this regard except for her second husband, who loved her very much but who died, leaving her with two children they had together and another from a previous marriage. Her last marriage brought her three children and years of difficulty, for her husband was jealous of her relationship to her possessing spirit. This husband established another home and family in Senegal and has for all practical purposes abandoned Believe and her children. Unable to have the kind of marriage she needs, Believe, now nearing fifty years of age, invests in her tiny compound in a Gorovodu village, in her market activities, and in Vodu festivals where she encounters numerous women friends, also spirit hosts.

Believe told me a dream she had in which someone carried her across a river. "In the very middle I was dropped into the water and could not swim. I struggled and struggled and was drowning. I cried out. A tremen-

dous black bird flew down to me and took me on its back. It was at one moment a huge duck. (Sunia Compo always eats Duck.) Then it was a vulture (Kokosatsi, one of the avatars of Banguelé Ketetsi). On the river bank I saw someone in a red garment and turban from the north. This person asked me what had happened. When I explained, the person warned me that I must be very, very careful, for someone wanted to hurt me seriously." Later Believe took the dream to a *bokono* (Afa diviner). The divination session revealed that the giant black duck was Wango the water spirit (perhaps originally from the northern province of Wa in Ghana) and the person in red was Banguele. They were the ones protecting her. Believe was soothed by this dream, by this help from afar that had become part of her own emotional home, her own head. Her efforts to provide for herself and her children were strengthened.

WE ARE WITHOUT THROUGH AND THROUGH

Believe was manifestly sad about what had happened to her last marriage, about the failure to maintain a marital home with her husband as partner. While she said she would refuse to be with her husband even if he wanted her back, for she felt he had betrayed her, she also feared that any relationship with another man would likely not last, that any new husband or boyfriend would likely bring trouble. She smiled at me as she was saying these things and added, "You know, with experience all women know these things." I think she wanted me to acknowledge the universality of women's trouble with men. I did.

Believe told me about her life with Sunia, her Gorovodu husband, who is said to be rather a hermaphrodite (including the spirit of the chameleon) with noteworthy feminine characteristics, a home Vodu. When Sunia came to her the first time, she was not even an adept of Gorovodu. Out of curiosity she had followed some of the Vodu people from a certain village to a drumming ceremony, although she had never before attended such events. After the ceremony she discovered herself in different clothing, with a senterua giving her back her earrings and the clothing she arrived in. She remembered nothing. (She always says she remembers nothing about Sunia's coming upon her; even two weeks after I wrote these field notes, when she was possessed at the ceremony we were both attending, it was her children who told her after trance was over that Sunia had come to her.) After that, as required for all spirit hosts, Believe spent ritual time inside *zogbe*, the miniature sacred grove, symbolic of the "hot bush" or the northern savannah, constructed in all Gorovodu villages. (We must remember that zogbe is curiously the most foreign *and* the most "homely" of all spaces inside Gorovodu villages, the site where the most danger is evoked *and* where one is the safest, the place where Vodu adepts go when worried about their safety.)

After the initiation rituals in zogbe Believe acquired the accoutrements of her trance gift, including charming blue boubous. When in trance she sometimes veils in the Muslim fashion. She is fascinated by the northern aesthetic, the way that Tchamba and Hausa people dress, adorn themselves, sing and dance, eat, and marry. Given that she is a market woman unafraid of distances, she has traveled to the north to visit Kabye villages, with an interest that I would qualify as anthropological, a respectful curiosity that is shared by very many Gorovodu and Tchamba adepts.

NE ME DZAGOWO TSOEKEM
(IF I HAVE OFFENDED YOU, FORGIVE ME)

Once, after a fight with her husband, after he had insulted Sunia and Believe had insulted him in turn, Sunia didn't come to her in trance for a long time. I thought she might not be unhappy about that particular vacation because, unlike Da Kossiwa, Believe says that trance is difficult work and she doesn't like for it to happen too often. Da Kossiwa told her to cast Afa (divination) to find out why Sunia wasn't coming. Afa said that Sunia was angry that Believe had spoken back in anger to her husband, returning insult for insult. From then on if he insulted her or insulted Sunia, she was to say nothing at all. "In that way the bad that people do returns against them instead of against you." So Believe promised to exercise self-restraint however angry she became, and then Sunia started coming to her again. She was greatly relieved to find trance once again. Without it she had been unsettled, unhomed.

The way Believe speaks about trance indicates much ambivalence. "It is such an honor to be chosen by the Vodu, because that indicates that your heart is clean, that you have nothing on your stomach against anyone. On the other hand, it is truly a burden, a hard job, something that keeps you from being entirely free in your life. It is a serious responsibility. You cannot speak rubbish to people after a spirit has chosen you. If you do you will be punished." When her husband insisted that she leave Gorovodu and thus refuse trance with her spirit husband, Believe was faced with the hard truth of her status. She simply could not leave Sunia Compo, the Vodu who possessed her and whom she possessed—she was married to Sunia more surely than to her husband. Home is also where one is satisfied sexually and/or spiritually.

WE KNOW WE ARE NOT OMNIPOTENT;
WE LACK AND LACK

Believe laughed one day as she commented that all men were the same. "They always think they know what is right for everybody, but they don't

even know what women think and do." She said she didn't even know of a single Togolese woman who actually accepted her husband's marriage to other women or his taking girlfriends. Many Gorovodu women do not imitate Muslim women in their supposed acceptance of co-wives, which they find inappropriate. Believe recounts the adventures of her good friend Amivi, also a spirit wife of Sunia: "If a husband has other women he can expect his wife also to run around on him. Amivi is seeing a Vodu priest now, behind her impotent husband's back. The priest told her Sunia would not mind, given the fact that she had no sexual satisfaction with her husband, and he was not even a Gorovodu adept. If he were she could not take a lover so easily [nor could he]. The husband has a lot of *dzoka* [personal sorcery] in his home. After Amivi conceived their first child he tried to make her enter into his dzoka room so that he could also 'put her inside' the juju [and thus control her]. But Amivi refused. 'I am already a *troduvi* [vodu-eating child]' she said; 'I can never enter there.' So that was that. And he refused to partake of Gorovodu." So the northern spirits also control southern husbands. And Amivi's emotional at-homeness was with her spirit husband and not with her mortal one and his dzoka. While male priests agree that the Gorovodus control their behavior and that they cannot give in to sexual license, they do not necessarily have the same discourse as these women about the gender equality in Vodu rules and regulations. I have encountered parallel discourses, men's versions and women's versions.

COLLAGE OF SEED AND SKIN . . .

Amivi, Believe, and Da Kossiwa have all constructed home in such a way that they do not have to depend on their husbands or lovers to provide for them materially. Amivi and Da Kossiwa do, however, have to share what they have with kin and affines, so they cannot claim their house as theirs alone. They all live in houses that are very modest by U.S. standards, but that indicate a modicum of financial and aesthetic flair in the context of economic misery in Togo. Amivi is the only one of the three who lives in a house bought mostly with a husband's paychecks. She lives with her husband, children, and other kin in a Lomé neighborhood in a five-room house made of concrete blocks. Her house has electricity, a refrigerator, a ceiling fan, and a modern dining room table with chairs. She has carved out a position of authority to match that of her husband, so that even in times of marital discord her house remains her home.

Da Kossiwa has managed to maintain considerable "woman's wealth," including beautiful wax-dyed print dresses and "three-piece outfits" (*pagne* or *avo*) folded and stored in enormous enamel-lidded containers from China, and mamadjonu (inherited strings of trade beads) as well as other jewelry. She lives in a modest compound left to her and her sisters by her father, and other

women live there as well—classificatory kin. Yet she keeps little shrines in
the homes of other people—a Mami Wata shrine in the house of a woman
she has known for years, a Gorovodu shrine in the house of an uncle (they
"own" the shrine together). The entire quarter is home to Da Kossiwa.

. . . OF EARTH AND ASH

Believe has a compound fenced by palm fronds in the village of Dogbeda,
which has neither electricity nor plumbing of any kind, and she cannot own
the land the compound is on, for the entire village is said to be on land owned
by members of the Lomé bourgeoisie. The center of Believe's compound is a
tiny two-room concrete block house. Believe is considered to be rich by her
neighbors. She feeds all children and elderly persons who happen to be in her
compound at mealtime. Once during a discussion with Da Kossiwa Believe
said that the two of them should have bought little pieces of land for the con-
structions of their own individual houses, so that they would not have to put
up with outside ownership of the land or with the quarrels for space
inevitably part of the kinship landscape during periods of political and eco-
nomic upheaval. "There is only one thing that I am thinking. I will get a
small piece of land and build a house for my children before I die. That is
what Da Kossiwa is also saying. That is all she needs. By now we could be in
our own houses. Until now we didn't realize that we should build our own
houses. When we got money we bought cloth. That's the thing. Now it is
late, but the gods willing, and if life goes well. . . ."

. . . SOARING AS THE BEAUTY OF SUDDEN TRUTH

On a December day in 1999 Believe and Akoko, another spirit host, and I
walked happily along a dusty unpaved street in a Lomé neighborhood, after
having just drunk some cold beer. We were going to join an enormous
Gorovodu *fetatotro* in full swing nearby. Just as we reached the ceremonial
grounds, crowded with hundreds of visitors, drummers, dancers, and some
forty people in trance, we saw a Vodu priest coming in the other direction. I
walked to meet him, bowed and greeted him in the Gorovodu fashion. Sud-
denly Akoko entered trance and began crying out, shaking violently, and
making demands of me, one of which had to do with my having suggested
that I leave early. I attempted to "cool" her as a senterua would do. "Priest,
you cannot leave!" (*Sofo, medzo o!*) she shouted at me, pulling me into the
throng on the ceremonial grounds. The drummers recognized her as a "wife"
of Nana Wango, the crocodile grandmother, and began playing and singing
her songs. Antou/Wango bade me dance with her, and although I did not pos-
sess the gift of trance, I was thrust into her space and event of ecstasy, of utter
foreignness, of uncanny otherness, of absolute rapture. A leaping dervish, she

ravished us with her dance, her body somehow turning on itself in midair, vir-tually flying here and there. Her voice, crying out her uncanny power bigger than reality, cut through the din of the festival and reached the pits of all our stomachs. We gasped in astonishment and admiration. It seemed that Akoko and the other spirit hosts, like the material fetishes, were enlivened collages *glued with blood and prayer*. Yet their agency as particular humans was immense. The lot of them, in all their individual plurality, and others with them—vodus, ancestors, the movable bits and pieces of a vast multiverse—had desired and willed themselves into particular forms, specific avatars, homes and inhabitants of a spellbinding languaged cosmos.

As always, in such circumstances, I finally left that Gorovodu celebra-tion feeling overwhelmed with the disquieting strangeness of it all, the never domesticated *unheimlich*, yet thrilled and full of pleasure, strangely energized for work, curiously at home in my head.

AGAIN AND AGAIN . . . VODUS ARE
POSITIONS TO TAKE UP, TO INHABIT . . .

Gorovodu and Tchamba practices of becoming foreign Others through trance offer a compelling example of the multiple and constructed nature of subjec-tivity and personhood in Vodu culture. One could almost say that the spirits enable one to carry home on one's back and take it everywhere one goes. The longing to bring the foreign into the family, the exaltation in embodying the northern Others, the desire to imitate the Muslim aesthetic—all of these ten-dencies are more than mere hospitality and generosity. They are also politi-cal positions about regional, linguistic, and cultural difference. They might be said to include a position about the political economy of slavery, and how the past must be recognized and constantly reconfigured in the present. They also offer an example of the possibility of experiencing difference as radically lat-eral, not hierarchized, not wrought into a chain of being that insists on inequality as the handmaiden of various sorts of differentiation. Cultural dif-ference is emphasized in these Vodu orders, even magnified, so as to construct very distinct local and northern identities, what "we" at home are like, and what "Others," far from home are like. Then the Others' identity is embraced as a foreign form of beauty and truth that one must behold and take in with full honor.

Vodu notions of personhood, home, and family in these communities thus involve a plasticity of identity and an ethics of inclusion. The person is always already plural in nature (never whole or bordered), and so are the lineage, the village, and the ethnic group. Although everyone is sure that southerners and northerners are exceedingly different from each other, purity of identity does not exist as a concept in these Vodu practices. I am not sure that it exists at all among Ewe and Mina (or that it exists in the northern regions, either).

Even gender is malleable, so that both men and women can be wives of spirits who may be female or male. Gender is not stuck to the material individual or to the social person in a rigid manner. I think that even the most intimate levels of subjectivity are plural in gender among the Vodu people. Along with this looseness of application, the male/female dichotomy continues to operate as a movable piece of the larger interpretive framework, along with north/south and foreigner/familiar binaries, ever in place so as to be permutated in different ways at different moments, in different circumstances, for the same individual (and thus for the same lineage and the same village, at other levels of complexity). Thus a biological woman who is a husband is at home in h/er body and with h/er wives, and a man-woman (of whom there are many in the south) is at home in h/er body and h/er female identity.

PATTERNS IN THE RED HARMATTAN SKY

In Gorovodu and Tchamba orders the outside—the not-home—is always running into home, the inside, for example in the case of the hot bush or the dangerous wilderness and space of transformation set up inside the village. The outside dances with the inside in the form of the foreigner gods who have access to the innerness of their human hosts at all times and who dance in and through them for the pleasure of guests and hosts alike and for the entire attendance.

The Vodu ethic of continuing to provide gifts for the spirits of erstwhile slaves provides an example of the marvelously slippery nature of individual, gender, and ethnic identity. It intimates the desirability of housing foreign Others in one's own body, in personal and shared imaginaries, in homes both material and psychic, and in the world's literal neighborhoods and communities.

RIDE A FURTIVE DANCE TO OUTWIT EARLY DEATH . . . THAT IS THE SECRET OF THE WARRIOR

Gorovodu and Tchamba leave one sad about the violent nature of history along the Slave Coast, the tragic reality of deadly conflict, the danger of being on a planet eaten by war, the very danger of being alive and thus vulnerable to sudden demise, the *dust in heaven's corridors, the wind and dread at noon*. That is why during certain Vodu ceremonies the women crouch *fetal in circles, faces pressed to the ground . . . moaning, offering*. Yet the spirits and their hosts give worshippers hope in a communal home made safe through ritual, a home enlivened with uncanny and protective denizens. Gorovodu women sing out the following words, urging all to act consciously and responsibly in this difficult world, urging confidence in the spirits of Others:

The words in the stomach
Are like a gun
Something is in the Bofra's stomach
Kunde will know what it is
The split kola cannot be eaten
 and then vomited out
You yourself entered into it
You yourself put your head inside
Be quiet
No one can do evil here
Father, I know that you are the knife
On the way, coming
Tro is on the way, coming
Wild animal never scatters fire
Kunde is on the way, coming
My lonely children
The dog catches the lion
My lonely children
My lonely children
Oh Grandfather Kunde,
Grandmother Ahlewa
Sunia, Banguele, Wango
My life is in your hands

NOTES

1. See also an article by Kodjo Koffi (2001) about the subject of slavery in the current political context in Togo.

2. As Ewe and Mina pronouns are not gendered, and because of the doubly gendered nature of so many Vodu people, I have borrowed here a strategy employed by Judith Butler (1990), the writing of "s/he" and "h/er" to represented this cleavage-cum-resistance to essential gender difference.

3. Banguele Ketetsi is very similar to the deity Ogun, treated by different scholars in a volume edited by Sandra Barnes (1989).

4. The name *Tchamba* refers to an ethnolinguistic group in northern Togo, but throughout this chapter it will refer to the spirit possession order in southern Togo named for the actual Tchamba people of the north, some of whom became bought people in southern lineages. "Mama Tchamba" is often translated as Grandmother Tchamba, and thus refers to grandmothers from the north, enslaved Tchamba women who became ancestors to today's southern Ewe and Mina worshippers.

5. I capitalize *Other* in order to formalize the idea of the utter foreignness of up-country ethnic groups, an otherness idealized during ritual and trance. In actual everyday life northerners are not always thought to be so terribly different from southerners.

6. Although Tchamba and Kotokoli or Tem people are almost all Muslim, and many Basari are, a number of groups in up-country Togo are not. Most Kabye, for example, are not Muslim. Hausa living in various parts of Togo, however, are inevitably Muslim.

7. In fact, the northerners who were enslaved and married into southern lineages were probably just as often Kabye and Losso (sometimes Asante, not so very northern)—and thus seldom Muslim—as they were Tchamba, Hausa, and Kotokoli or Tem, who are, in fact, nearly always Muslim.

8. I have met a number of such men-women, individuals born boys but whose identities have female components. Some of them merely dress as women for ritual and are female-marked in their priestly functions. There are also men who are married to women but who also behave to some extent as women; some of them have male lovers. Others live more fully as women, so that an outsider would not guess that they were born boys. They invariably say that spirits turned them into women. There are also women who have been made into men by the spirits and who thus marry wives.

BIBLIOGRAPHY

Barnes, Sandra T., ed. 1989. *Africa's Ogun: Old World and New*. Bloomington: Indiana University Press.

Brown, Karen McCarthy. 1991. *Mama Lola: A Vodou Priestess in Brooklyn*. Berkeley: University of California Press.

Butler, Judith. 1997. *The Psychic Life of Power: Theories in Subjection*. Stanford: Stanford University Press.

Geurts, Kathryn Linn. 2002. *Culture and the Senses: Bodily Ways of Knowing in an African Community*. Berkeley and London: University of California Press.

Greene, Sandra E. 1996. *Gender, Ethnicity, and Social Change on the Upper Slave Coast*. Portsmouth, N.H.: Heinemann.

———. 2002. *Sacred Sites and the Colonial Encounter: A History of Meaning and Memory in Ghana*. Bloomington and Indianapolis: Indiana University Press.

Koffi, Kodjo. 2001. Note sur le thème de l'esclavage dans la politique togolaise actuelle. *Journal de la Société des Africanistes* (Paris), tome 70, fasc. 1–2:233–37.

Masquelier, Adeline. 2001. *Prayer Has Spoiled Everything: Possession, Power, and Identity in an Islamic Town of Niger (Body, Commodity, Text)*. Durham and London: Duke University Press.

Rosenthal, Judy. 1998. *Possession, Ecstasy, and Law in Ewe Voodoo*. Charlottesville and London: University Press of Virginia.

———. 2002. Trance Against the State. In Carol J. Greenhouse, Elizabeth Mertz, and Kay B. Warren (eds.), *Ethnography in Unstable Places: Everyday Lives in Contexts of Dramatic Political Change*. Durham and London: Duke University Press.

Shaw, Rosalind. 2002. *Memories of the Slave Trade: Ritual and the Historical Imagination in Sierra Leone*. Chicago and London: University of Chicago Press.

Taussig, Michael. 1993. *Mimesis and Alterity: A Particular History of the Senses*. New York: Routledge.

NINE

Concepts of Home

GINA ULYSSE

i just left it
lying there on the table at espresso cafe
a cup lined with fizzzzlessss foam
pressing the pages down
pressing to keep them down
to keep them closed
so grandmere doesn't see them
if my grandmother ever read these words
echoing screams of Kundera's post-mid-life crisis
she would have raised her eyebrows
lowered her head rolled her eyes
stupe real loud
and with swaying hips of her womanly form
she would have walked away
with a bad taste in her mouth
 that's my critique of Immortality

i remember knees rubbing
as i tried to outrun
katia who was always the fastest
she was even faster than djeanane who was taller than all of us
blue/white checked pleated skirt twirls when i spin
 flies when i jump
 trying to reach extended branches
that were closer to the sky than they were to my head

i remember us collecting rocks
that i held onto tightly within closed fists
I remember running on paved sidewalks

 passing the Cabane Choucoune
 Le Petit Chaperon Rouge

on our way home we would stop at a pye zanman
look for the yellowish orange ones the ripe ones
we'd throw rocks like boys at the zanman
until we knocked them onto the ground
we would wipe them off our uniforms
and stuff them into our mouths
biting away flesh that was barely ripe for eating
but soft enough to let spots of juice seep through
leaving tongues tasting of sour
we weren't suppose to keyi zanman on that street
or on any street
where we would be seen acting like ti moun san fanmi
ti moun san manman
my mother never knew we did that
unless
we bit into one that was so green
that we had to spit it out quickly
carelessly
letting it stain our clothes

 when i was in jamaica this summer
i ate breadfruit and saltfish
i ate bonbonsiro
i cooked like mother or ivela would
i never measure anything
I cook like that
because that's just the way us women
at rue darguin no. 8 cooked

 at Dragon's bay villa
i skipped about in my yellow flowered dress
the blue bay
the escovitched fish
small strips of kan in a plastic bag tied with a twist
for the tourist price of 30 J
the smell of and the taste of blue mountain coffee
with carnation evaporated milk
to which i'd add spoonfuls of brown sugar

brown sugar that i'd have to demand
because raw sugar has no place on tables in hotels
it is colored
raw sugar has no place on tables in hotels
it is colored
because it is not refined
it wasn't processed in britain or in the united states
lean dark waiters in white shirts and red vests serving
uptight white american tourists who want eggs overeasy
instead of ackee and saltfish for breakfast
who sit under the almond tree
my almond tree by the bar
drinking rum punches
the almond tree overlooking the bay
the almond that i wanted to climb
i jumped trying to catch extended branches
 jumped again
my dress
rides up
glimpses of the
eternal thigh
up
again
i lost my balance
i lost my shame
as i jumped up again over and over again
trying to grab arching branches with almonds
that have not seen me for fifteen years
i didn't even check
to see if they were yellowish gold or even close
that wasn't the point
no you see
i had to knock them down from the tree
wipe them off my bathing suit
and sink my teeth into them
as soon as i possessed them
as soon as i had them in my hand
without wasting a moment
but they fell on the sand
i didn't even wipe them
i bit right into them
one at a time
because i had to

i had to because
they reminded me of the place where i came from
this place—a country—my country-a man
the zanman reminded me of this man
this man with whom i share a torrid love
a man that didn't like women
that smothered children before they were born
because in their mother's belly they promised
they'd have too much fire in their soul
they were black
he knew they'd all be blakk
he knew they were all blakk
and they promised they'd want to be free
and they promised they'd fight to stay free
because they were blakk
and he knew they knew what would happen
and he knew they knew what would happen what always happens
he knew they knew they couldn't be french
because they only speak kreyol
the knew they knew they couldn't be french
se moun andeyo yo ye
the zanman reminded me of this man
that i haven't gone back to
that i can't go back to
 that i don't want to go back to yet
that i don't want to see so t o r n
bleeding
because i don't want to believe that ayiti can
bleed
that ayiti is bleeding
 i don't want to see
 i don't want to see
her
bleed
ing
but it's always been—
he said
high
 suicide
 alcohol ism
family
 violence
 rapesrepeatedrapesofbabieschildrengirlswomenladiesgirlswomen-
 violenceagainstwomen

blood has been
shedding in
 south africa
 black blood
colored blood
 blood
a lot of pnp and jlp blood

red has always been the color of the blood that has
 c o l o u r e d
south africa

 how do you call a place home that doesn't allow you to forget
 how do you call a place home that tears you inside out
that makes you wish you could not feel
that makes you wish you could not think
that makes you wish you could not see
that makes you wish you could not remember
horror that has become an everyday commodity
a place that keeps bleeding
that keeps bleeding
even after operation restore democracy
that will continue
to bleed
until
 until there's no trenchtown
 until there's no lost city no sun city
 until there's no white power center
until there's no whites only signs in children's minds
until there's no whites only signs in children's hearts
 until the colored are free
 until white people are free
 until black people are free
 But it keeps bleeding

but we can't make it stop
or can we

 you can't make it stop
 or can you

do you turn away wallowing in guilt
delving deeper into a forgiveness
that doesn't exist
a forgiveness that ceased to exist
a forgiveness that will never exist

there's blood too much blood in south africa and it's spilling over
there's blood too much blood in south africa and it's spilling over
 blood is spilling over on necklaces
 blood is spilling over in cité soleil
 blood is spilling over in garrisons
red is the color of the blood spilling over from makeshifts boats in the
 caribbean sea
red is the color of the blood spilling over from makeshifts boats in the
 caribbean sea
there's too much blood on this country that i love
there's too much red on this country that i love
 this country that won't let children live
that kills them
in their mother's womb
so women now
give birth
to
stillborns
how do you keep yourself how do you keep yourself from wanting to touch
 from wanting to smell
from wanting to be from wanting to feel to find a peace that ceased to exist
 to find a peace that
never existed to find a peace that will never exist
to stop looking to stop looking for something
to stop looking to stop looking for anything
to stop looking to stop looking
so you can
find

List of Contributors

RUTH BEHAR is the author of *Translated Woman: Crossing the Border with Esperanza's Story* and *The Vulnerable Observer: Anthropology That Breaks Your Heart* and editor of *Bridges to Cuba* and co-editor of *Women Writing Culture*. She recently made a documentary, "Adio Kerida/Goodbye Dear Love: A Cuban Sephardic Journey," available through Women Make Movies (*www.wmm.com*). She is Professor of Anthropology at the University of Michigan.

ELIZABETH A. BOHLS, Associate Professor of English at the University of Oregon, is the author of *Women Travel Writers and the Language of Aesthetics, 1716–1818* (Cambridge University Press, 1995). She is currently finishing an anthology of travel writing and a study of identity and place in the colonial British Caribbean.

CAROLINE B. BRETTELL is Dedman Family Distinguished Professor in the Department of Anthropology at Southern Methodist University. She has served as Chair of the department since 1994. From 1989–1994 she served as Director of Women's Studies at Southern Methodist University. In addition to numerous book chapters and articles she is the author of *Men Who Migrate, Women Who Wait: Population and History in a Portuguese Parish* (1986), *We Have Already Cried Many Tears: The Stories of Three Portuguese Migrant Women* (1982, 1995), *Writing Against the Wind: A Mother's Life History* (1999) and *Anthropology and Migration: Essays on Transnationalism, Ethnicity, and Identity* (2003); coauthor with Richard Brettell of *Painters and Peasants in the Nineteenth Century* (1983); editor of *When The Read What We Write: The Politics of Ethnography* (1993); coeditor of *International Migration: The Female Experience* (1986), *Gender in Cross-Cultural Perspective* (1993, 1997, 2001), *Gender and Health: An International Perspective* (1996), and *Migration Theory: Talking Across Disciplines* (2000). She currently is Principal Investigator on

the project "Immigrants, Rights and Incorporation in a Suburban Metropolis," funded by the National Science Foundation. Her major areas of research interest are the anthropology of Europe, the anthropology of gender and family, the anthropology of religion, ethnicity, and immigration, and the intersections of anthropology and history.

DEBORAH REED-DANAHAY is Professor of Anthropology at the University of Texas-Arlington. Her recent research interests include schooling and identity in the European Union, autoethnography in rural France, and reflexivity in anthropological theory. She is the author of *Education and Identity in Rural France: The Politics of Schooling* (Cambridge, 1996), editor of *Auto/Ethnography: Rewriting the Self and the Social* (Berg, 1997), and author of the forthcoming book *Locating Bourdieu: An Ethnographic Perspective* (Indiana).

JUDY ROSENTHAL is Associate Professor of Anthropology and coordinator of Women's and Gender Studies at the University of Michigan-Flint. In addition to articles and book chapters relating to spirit possession in West Africa, she is the author of *Possession, Ecstasy, and Law in Ewe Voodoo* (University Press of Virginia, 1998).

KATHLEEN STEWART is Associate Professor of Anthropology at the University of Texas, Austin, and Director of the Amercio Paredes Center for Cultural Studies. She is currently completing a book manuscript, *Vital Impacts: The Private Life of Public Culture*. She is the author of the award-winning *A Space on the Side of the Road: Cultural Poetics in an "Other" America* and numerous essays on cultural poetics, place, gender, and Appalachia, including "The Perfectly Ordinary Life" in *Public Sentiments: Memory, Trauma, History, Action. Scholar and Feminist On Line* (2:1 Summer 2003), guest editors Ann Cvetkovich and Ann Pellegrini. "Anxieties of Influence" (coauthored with Susan Harding) in *Transparency and Conspiracy: Ethnographies of Suspicion in the New World Order*, ed. Todd Saunders and Harry West (Duke University Press, 2003); "Arresting Images," in *Aesthetic Subjects: Pleasures, Ideologies, and Ethics*, ed. Pamela Matthews and David McWhirter (University of Minnesota Press, 2003); "Scenes of Life," *Public Culture* 14:2 (2002); Machine Dreams," in *Modernism, Inc.: Essays on American Modernity*, ed. Jani Scanduri and Michael Thurston (New York University Press, 2002); "Death Sightings," *Cross Cultural Poetics* 3.3 (2000); "Real American Dreams (Can Be Nightmares)," in *Cultural Studies and Political Theory*, ed. Jodi Dean (Cornell University Press, 2000); "American Apocalypsis" (coauthored with Susan Harding), *Annual Review of Anthropology* 28 (1999); "Conspiracy Theory's Worlds," in *Paranoia Within Reason: A Casebook on Conspiracy as Explanation*, ed. George Marcus (University of Chicago Press, 1999); "Nostalgia: A Polemic," *Cultural Anthropology* 3.3 (1988):227–41); "Back-talking the

Wilderness: 'Appalachian' En-genderings," in *Un-certain Terms: Negotiating Gender in American Culture*, ed. Faye Ginsburg and Anna Tsing (Beacon Press, 1990); and "Engendering Narratives of Lament in Country Music," in *All That Glitters: Country Music in America*, ed. George Lewis (Bowling Green State University Popular Press, 1993).

BILINDA STRAIGHT is Assistant Professor of Anthropology at Western Michigan University. In addition to her work in the United States, she works with Samburu pastoralists in northern Kenya on issues relating to consciousness, gender, narrative, and material culture. Her work has appeared or is forthcoming in a variety of journals and edited collections, including *American Anthropologist* and *Anthropology and Humanism*. She is currently completing a book entitled *Elusive Souls: Miracles and Extraordinary Experience in Northern Kenya*.

GINA ULYSSE is Assistant Professor of Anthropology and African American Studies at Wesleyan University. She has written on representations of class and color in Jamaica, fieldwork conflicts, autoethnography, and reflexivity. She is currently working on *Uptown Women and Downtown Ladies*, a black feminist ethnography of the work and self-fashioning of Jamaican female Informal Commercial Importers. Her poetry has recently appeared in *The Buttlerfly's Way: Voices from the Haitian Dyaspora* edited by Edwidge Dandicat; *Jouvert: A Journal of Postcolonial Studies*; *Meridians: Feminism, Race, and Transnationalism*; and MaComere.

KATHERINE E. ZIRBEL is a cultural anthropologist and peace activist who studies narrative, experience, and political economy in Egyptian performance communities and Middle East peace activism in the United States. She has taught at Columbia University, New York University, Rhodes College, and the University of Michigan, where she received her degree in 1999.

Index

abolition, abolitionist movement
 (British), 13, 46–47, 59, 63–64
Abu-Lughod, Lila, 78
agency, 10, 27–28, 31, 77, 169
American Dream. *See* home (and
 American Dream)
Appalachia, 14, 37–40, 90, 98,
 104nn5–6, 9
autobiography. *See* life history (and
 autobiography)
autoethnography, 3, 131–132
 See also stories, storytelling; narrative

Bakhtin, Mikhail, 9, 92
Bammer, Angelika, 2, 5, 129
Bauman, Richard, 20n13, 77, 103n3
Beauvoir, Simone de, 4, 6
Behar, Ruth, xi, 3, 8, 12, 20n11, 46–47,
 92
Bourdieu, Pierre, 9–10, 142
Braidotti, Rosi, 4
Briggs, Charles, 20n13, 77, 103n3
Butler, Judith, 4, 150, 171n2

Canada, 15, 110–112, 125n6
capitalism, 30, 46, 143–144
 See also commodities; consumption
Caribbean, 12–13, 48, 60
Catholicism. *See* Christianity
Chatterjee, Partha, 19n2
Christianity, Christians, 20nn8–9, 47,
 51, 54, 56–57, 63, 75

Catholics, Catholicism, 29, 134–135,
 138, 164
 Mormans, 35,
 Protestants, 47, 104n6
 See also religion
Clifford, James, 60–61, 66n18, 71,
 125n4
colonialism, 2, 6, 20n8, 46, 63, 129
commodities, 27, 31
 slaves as, 55
 See also capitalism; consumption;
 slavery
consumption, 12, 31, 50, 143–144
 See also capitalism
control (of women), 11, 13–14, 72, 82,
 134
 See also gender; women
Csordas, Thomas, 10, 20n14, 21n15
Cuba, x

Davidoff, Leonore, 50–53, 65n5, 9
Dawson, Andrew, 8, 126n13, 129
Deleuze, Gilles, 20n10, 41n3
Descartes, Rene, 6, 10, 20nn8, 9
desire, 12, 15, 28, 31, 102, 136,
 140–142, 145, 164
 See also home (and desire); spirit
 possession (and desire)
deterritorialization. *See* displacement,
 dislocation
displacement, dislocation, exile, ix–x, 2,
 7–8,13, 17–18, 19n6, 46, 58–61,